LEGENDARY AUTHORS

and the Clothes They Wore

LEGENDARY AUTHORS

and the Clothes They Wore

TERRY NEWMAN

HARPER DESIGN

An Imprint of HarperCollins Publishers

CONTENTS

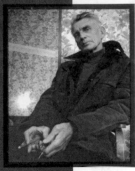

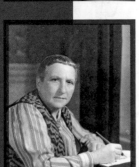

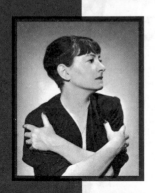

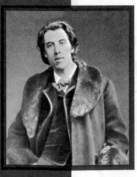

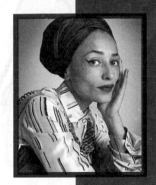
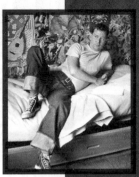
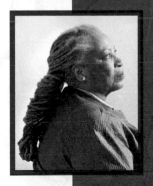
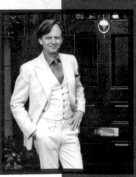

INTRODUCTION

Where would fashion be without literature?

—Diana Vreeland, *D.V.*, 1984

Legendary Authors and the Clothes They Wore is a book with what may seem like an audacious premise—to tie together the heavyweight value of, for example, Samuel Beckett with a discussion of the fact that he wore Clarks Wallabee shoes. However, in reality, persona is closely connected with how you dress, and the fact that the man who wrote *Waiting for Godot* liked his shoes classic, comfortable, and enduringly modern says a lot about his personal taste and therefore his personality. The distinctive individuals included in this book are not just fabulous writers: they looked fabulous, too.

The fast-paced fashion world is always in a state of change: it works according to the season, but designers are continually searching for a signature essence that endures and that defines their look. Chanel is a house with an instantly recognizable quality, and this has a lot to do with the durable idiosyncrasies of Gabrielle "Coco" Chanel herself. Watch her being interviewed and you witness the domineering power of her personality: she's a single-minded, sharp-edged, creative businesswoman. She was always right, as far as she was concerned, and she didn't waste time letting disappointments get in her way. The

original Chanel wardrobe was created for this kind of independent, effortlessly stylish, deliciously difficult kind of customer. The brand endures today because it was built on the driving intensity and disposition of a woman who knew what she liked—and what she liked is sewn into the company's DNA, with its chain-metal detailing and perfectly fitted sleeves. Authenticity is crucial to longevity, and that's why character is the key to looking great: feeling and believing what you do, say, and wear translates into nonnegotiable charisma. And when you are an original who goes your own way and can write about it all as well, the allure ratchets up a notch. This is why fashion houses often look to authors for inspiration, and this is why authors who dress to please themselves, outside of the constraints of being "fashionable," are captivatingly compelling. Reading a fashion collection can be like reading a book: it's a gold mine of influences, references, research, and creativity. An author's work is similarly a composite of their life, values, imagination, talent, and distinctiveness. Some of those magical ingredients inevitably seep into their wardrobe, and an examination of what our favorite authors wore is as enthralling a story as any told.

Fashion houses are constantly mining literature and its intellects for ideas and credibility. Quentin Crisp, Donna Tartt, Hunter S. Thompson, and Virginia Woolf and her Bloomsbury set, to name but a few, have all inspired catwalk collections. New Zealand designer Kate Sylvester's autumn/winter 2015 show was driven by her reading of Tartt's *The Secret History*, while the Urban Safari collection of British designer Henry Holland was influenced by the sartorial style of Hunter S. Thompson. And fashion houses have aligned themselves with literature by selling books: Marc Jacobs, Rei Kawakubo, and Karl Lagerfeld all have stores that include on the shelves collectible art volumes and esoteric, hard-to-find reading material. Reading is fashionable. It sounds irritating, especially to those who don't like to be in fashion, particularly, but books are becoming the most interesting accessory. What you read is as important as what you wear. And what authors wear is source material for designers' creativity. The literary and fashion worlds are therefore synchronized, and the geek chic of librarians is a look that is set to prevail.

Likewise, many of the most interesting authors assimilate some essence of clothing into the plot and circumstances they write about. From *Ulysses* to *The Second Sex*, from *The Bell Jar* to *In Search of Lost Time*, novels that capture the communicative creativity of clothes have a challenging, thought-provoking dimension of vision and inner complexity. The rich intricacy that comes from the added element of knowing what your favorite characters wear and, even better, how they feel about the clothes they wear brings the reader closer to the author's narrative. Similarly, it's satisfying to know that James Joyce was once so enthusiastic about Irish tweed that he worked as a cloth salesman, and Gertrude Stein's impeccable taste in art and culture extended to mentoring fashion designers—she encouraged and supported the couturier Pierre Balmain when he first embarked on his career in Paris. That Virginia Woolf worried about bad hat days is also a comforting fact for the dedicated reader and follower of style.

Delving into authors' wardrobes and the way they write about clothes is also a glimpse into the world they inhabited and their moment in time. In Colette's memoir, *Looking Backwards*, she writes about leafing through *Vogue* in 1941, reading a page describing a gown "in black faille, decorated with pale blue ornamentation." She goes on to talk about existing on war rations of eggless mayonnaise and shoes without leather, and she laughs at the irony of a fashion magazine expecting her to wear velvet dresses and the like in such conditions. Just after the war, Nancy Mitford enthuses about the impossible beauty of Dior's New Look. The full skirts and yards and yards of unrationed fabric it took to create the belle epoque–like corseted fantasies seemed miraculous in comparison to the ugly, lean years of make-do-and-mend. Proust's fin de siècle society backdrop reveals the complicated etiquette of dressing for lunch and dinner, which was expected in all the high-society circles he mixed in, while years later, Hunter S. Thompson's *Hell's Angels* explores subculture in a postwar society where the expected norms are being thoroughly thrown to the wind. Fashion is a history book as well as a mirror, and the incidental assimilation of who is wearing what, where, why, and when adds density to a cultural read.

Strands of fashion run through literature, both in the words writers put on the page and in the clothes they put on their backs. Quite often, the two were intrinsically linked. Edith Sitwell was an eccentric, experimental poet and actually looked rather eccentric and experimental, too, in ornate costume jewelry and black floor-sweeping capes. Sylvia Plath's work revealed her troubled soul; however, her wardrobe enabled her to appear in control and well balanced—she wore precise, neat, and prettily prim 1950s separates and print dresses that worked as a shield for her psyche. She used clothes to hide what she was feeling; dressing preppily disguised her anxieties. Clothes concealed and guarded the reality of her emotions—by wearing a twinset and pearls, she was able to fit right in with normality even when she was experiencing her worst depressions. When she was unraveling and distraught, clothes were a way of buttoning up, keeping things in, and facing the day. William S. Burroughs, meanwhile, was a wild transgressor who lived life to the tune of his own song and rarely cared or concerned himself with what the mainstream thought of him or wanted. His words were an avant-garde elegy that gave insight into his madly hallucinogenic sensibility and vision. To keep suspicion at bay, he looked conversely straightedge, nerdy, and conformist: a total disguise, and a uniform that let his imagination do the wandering. Hunter S. Thompson, however, sent clear signals to the world. His anarchic rebelliousness of mind, body, and spirit was apparent in his thoughts, words, and deeds, and in his safari-suits-and-shades dress sense.

Fashion is instant language.

—Miuccia Prada, from "25 of the Best Fashion Quotes of All Time," by Krystin Arneson, *Glamour*, 2011

The connection between the wardrobes and viewpoints of all these legendary writers may not seem at all obvious on first glance, but rifle through their drawers, and personalities appear and evolve. Djuna Barnes, Colette, Joan Didion, and F. Scott Fitzgerald are renowned authors who articulate not just with words but also with what they wore, and more often than not, they wore their hearts and words on their sleeves.

SAMUEL BECKETT

He can't think without his hat.

—Samuel Beckett, *Waiting for Godot*, 1952

Samuel Beckett's unfussy elegance is testimony to the grace of steadfast unfashionability. If he were alive today, designers such as Margaret Howell, A.P.C., and most probably Comme des Garçons would be trying to lure him their way for an ad campaign or a catwalk appearance. Of course, he would say no: he said no to everything. Even when he won the Nobel Prize in Literature in 1969, he didn't turn up to receive it. The *New York Times* wrote that "Mr. Beckett could not be reached for comment on the prize. He was reported by his Paris publisher to be out of touch in Tunisia, and Nobel officials were unable to say whether he had received word of the award." Even back in 1959, the prospect of attending a ceremony that would have awarded him an honorary degree from Trinity College Dublin was not enticing. He wrote in a letter to the Irish scholar Abraham Leventhal published in *The Letters of Samuel Beckett: Volume 3, 1957–1965*: "I have no clothes but an old brown suit, if that's not good enough, they can stick their Litt.D. up among their piles." The writer and socialite Nancy Cunard, however, knew flair when she saw it, and in 1956 called Beckett "a magnificent Mexican sculpture."

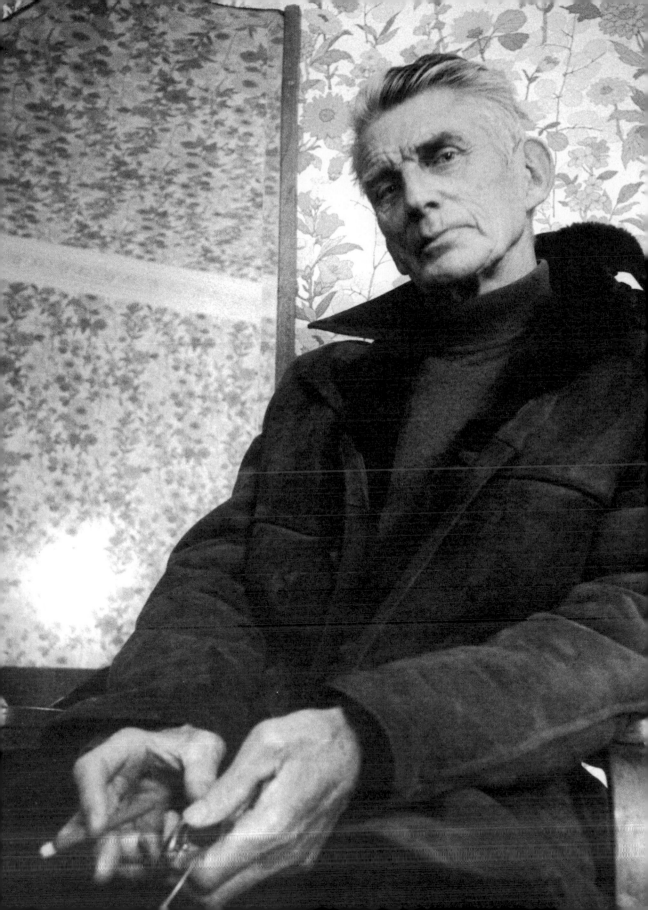

Beckett's coolness is a phenomenon that few can compete with. His work fathomed the absurdity and desperateness of life, while his demeanor and disposition were curiously enigmatic. Stylistically, he was equally sparse and restrained. He worked a seductive-utility look that has been as enduring as his literary opus. Beckett broke new ground with his writing methods, and he also manifested an abiding, classy, and sustainable pick of clothes. His day wear of choice included a signature turtleneck shirt, a shrug-on trench coat, Clarks soft, practical, and stylish suede Wallabee boots, timeless round spectacles, a rugged Aran sweater, and tidy shirts and ties. It's a classic wardrobe that today is featured in designer menswear collections and rolled out in glossy magazines as a blueprint of style for the contemporary man; built long and lean, Beckett carried it off with composure.

Beckett was born on Friday the thirteenth—April 13, 1906—an unlucky day to those who are superstitious. The day also happened to fall on Good Friday. He loved the irony.

When Beckett attended the Portora Royal boarding school in Enniskillen, Northern Ireland, he became the light heavyweight boxing champion there.

Beckett is the James Dean of modernists. Like Dean, he was downright handsome, and in addition, Beckett's familiar rock-star-quiffed hair was akin to the slicked and shaped version sported by immortal maverick Dean. It's a nonchalantly seductive signature style that cries out for a hand to run messily through it while, of course, contemplating more important business. Beckett's pivotal play, *Waiting for Godot*, was published in 1952, just a couple of years before Dean's *Rebel Without a Cause* hit the silver screen. Dean's character, Jim Stark, implores: "I don't know what to do anymore. Except maybe die." The final line from Beckett's character Pozzo in *Waiting for Godot* articulates the same viewpoint, but with even more desperate expression: "They give birth astride of a grave, the light gleams an instant, then it's night once more." Beckett styled his hair in a quiff for the first time when he was seventeen; it was a cut he kept in place for the rest of his life—it tastefully became finer as he grew older and his hair became tinged with white.

It sometimes happens
and will sometimes
happen again that I
forget who I am and
strut before my eyes,
like a stranger.

—Samuel Beckett, *Molloy*, 1951

Samuel Beckett with actress Eva Katharina Schultz, whom he directed in the role of Winnie in his play *Happy Days* at the Schiller Theater in Berlin, 1971.

He had a sense of humor too, and, *Waiting for Godot* has a slapstick element as well as a sensitive seam of empathy for the wider world. It seems that Beckett's boots are the key to man's consciousness. The character Estragon battles daily with his footwear, in the same way that mankind battles daily with the struggles of existence.

A compassionate man, Beckett was awarded the French military honor the Croix de Guerre for his resistance services during World War II in France, although he dismissed his bravery as "boy-scout stuff." He also encouraged Harold Pinter as a young playwright in the same way that he had been guided by the biggest fish in the literary sea, James Joyce. As detailed in *The Letters of Samuel Beckett, Volume 1: 1929–1940*, In the early 1970s, Beckett used a now classic leather Gucci hobo holdall as his day-to-day man bag. he wrote in 1937 to his friend the Irish poet Thomas MacGreevy and disclosed how he was paid more often in kind than cash from his mentor: "Joyce paid me 250 francs for about 15 hrs. work on his proofs. . . . He then supplemented it with an old overcoat and 5 ties! I did not refuse. It is so much simpler to be hurt than to hurt."

GEORGE SAND

Which of us has not some sorrow to dull,
or some yoke to cast off?

—George Sand, *Winter in Majorca*, 1855

Born Amantine-Lucile-Aurore Dupin in Paris in 1804, George Sand lived her life in what was then a way most scandalous to her contemporaries. She earned her own living as an author, and she divorced her husband and fell in love with men and women. Sand lived independently and came and went around Paris and other parts of France as she pleased—quite often dressed as a man if she felt like it, and very often smoking a cigar. She is the epitome of feminism for many women today. She questioned society and rejected its sexual categories. She succeeded in life in a world where only men were expected to have careers and ambition and to achieve what they wanted. Sand decided she would have it all, too.

For a woman so wild, Sand was also a true voice of romanticism: she was an individual who sought to express her passion and energies through the art of her words, and she intensely loved the emotions evoked by nature. She adored the simple elegance of the countryside. In the introduction to her 1846 book, *The Devil's Pool* (*La Mare au diable*), she wrote her philosophy of life: "Look at what is simple, my

Opposite:
George Sand,
1864.

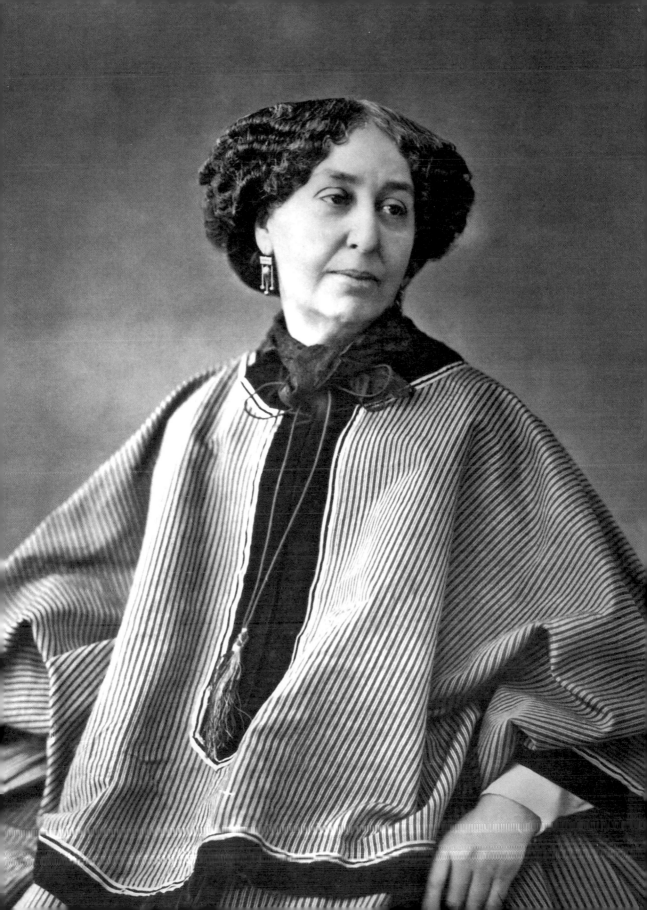

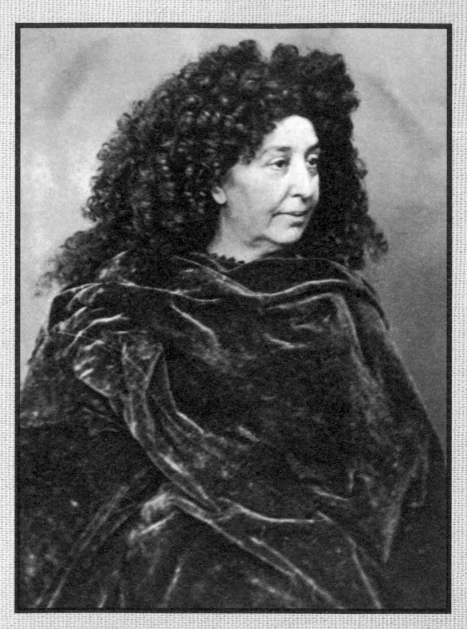

George Sand draped in velvet, mid-1880s.

kind reader; look at the sky, the fields, the trees, and at what is good and true in the peasants; you will catch a glimpse of them in my book but you will see them much better in nature." She intended to "write a very touching and very simple story."

Her two other significant pastoral novels, *Fanchon, the Cricket* (*La petite Fadette*, 1849) and *The Master Pipers* (*Les Maîtres sonneurs*, 1852), reflect the idyllic childhood she experienced at her grandmother's estate in Nohant, in the Berry region. She moved there after her father died in a horseback-riding accident when she was four years old. When she was eighteen her grandmother died, and she inherited five hundred thousand francs and the house. She was placed under the guardianship of a distant uncle and, in order to have control over her money, hastily entered into marriage with the illegitimate son of a French baron, François Casimir Dudevant, in 1822.

Sand thought that Victor Hugo's 1862 book, *Les Misérables*, contained too much Christianity.

Sand's father, Maurice Dupin, was related to a former king of Poland; her mother, Sophie Delaborde, was the daughter of a bird keeper and breeder.

She started wearing boys' clothes to go shooting when she was young. It was a habit she became notorious for in later life, although when she was twenty-three and beginning to explore her own writing style, she began a journal she called *Voyage en Auvergne* reminiscing about her holidays in Auvergne. She described herself as a sixteen-year-old in typical bucolic fashion: "I was fresh looking, though dark. I was like those wild flowers which grow without any art or culture but with gay, lively coloring."

Vanity is the most despotic and iniquitous of masters, and I can never be the slave of my own vices.

—George Sand, *Jealousy: Teverino*, 1845

In Sand's autobiography, *Story of My Life* (*Histoire de ma vie*), she reflects on the eccentric clothing choices that she made her signature style—the practicality of her approach was modern and far beyond the norms of how an aristocratic young woman was expected to behave and attire herself in the early nineteenth century. Floppy white shirts, waistcoats, and tailored suits tread the catwalk today in women's wear, but back in the 1830s Sand broke ground and convention by her appropriation of menswear. She describes the practicalities in *Story of My Life*: "Fashion helped me in my disguise, for men were wearing long, square frock-coats styled *à la propriétaire*. They came down to the heels, and fitted the figure so little that my brother, when putting his on, said to me one day at Nohant: 'It is a nice cut, isn't it? The tailor takes his measures from a sentry-box, and the coat then fits a whole regiment.' I had 'a sentry-box coat' made, of rough grey cloth, with trousers and waistcoat to match. With a grey hat and a huge cravat of woollen material, I looked exactly like a first-year student." However, George was never pigeonholed by her wardrobe—she was fluidly adept at sartorial quirks and, ever the radical, would quite often on a whim wear pearls and gowns to the opera if she felt like it.

> Little Marie still wore that head-dress, and her forehead was so white and so pure that it defied the white of the linen to cast a shadow upon it. Although she had not closed her eyes during the night, the morning air, and above all things the inward joy of a soul as spotless as the sky, and a little hidden fire, held in check by the modesty of youth, sent to her cheeks a flush as delicate as the peach-blossom in the early days of April.
>
> —George Sand, *The Devil's Pool*, 1846

Language is a prostitute
queen who descends and
rises to all roles.
Disguises herself,
arrays herself in fine
apparel, hides her head
and effaces herself.

—George Sand, *Indiana*, 1832

JOHN UPDIKE

There's more to being a human being than having your own way.

—John Updike, *Rabbit at Rest*, 1990

Without blaring fanfare, John Updike has quietly become revered as one of the greatest American writers of all time. He spent his life publishing prolifically, spotlighting the backstories of existence and bringing to life the happenings of the twentieth century as lived by the unseen and previously unheralded average, unremarkable characters of American suburbia. A characteristic example is his short story "A&P," which appeared in *The New Yorker* in 1961 and details staid moments and rebelliousness at the checkout of the local grocery.

Rabbit, Run, published in 1960, was the first novel in a series of four books about Updike's character Harry "Rabbit" Angstrom. The stories are a narrative of America from the 1950s through the 1980s and document each decade in the life of his hero and his family, and with them the reality of the average American dream. His protagonist starts off as a basketball star and ends up as a car salesman, although the final novel, *Rabbit at Rest*, does see him dress up as Uncle Sam in a town parade in a final flourish of slight celebrity. Rabbit's authenticity triumphs in many more ways, and today he is seen in the way Updike intended: he was "typical."

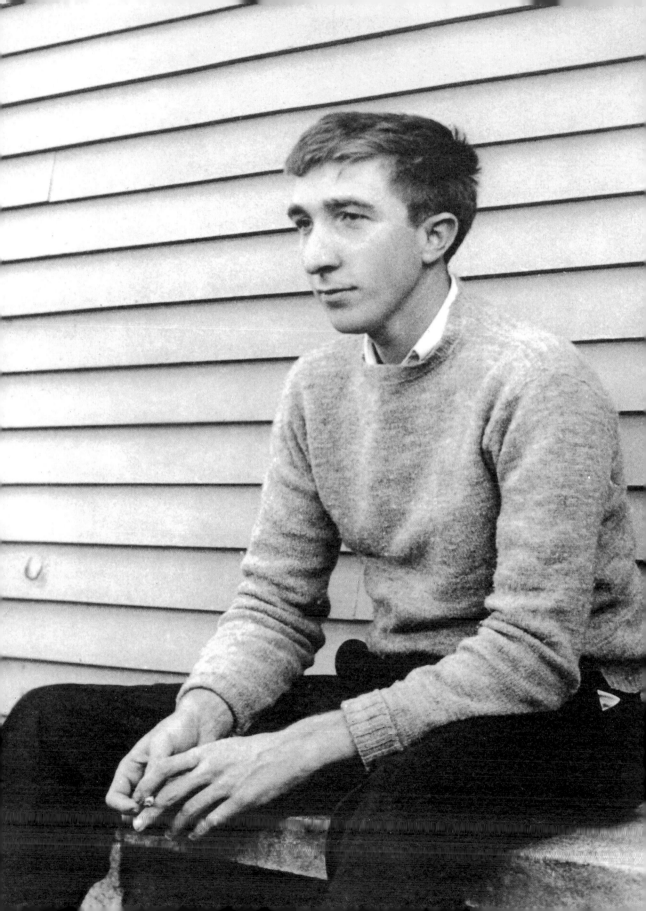

In 1957, Updike happily moved with his wife, Mary Pennington, and budding family from New York to Ipswich, Massachusetts, and he admitted in a 1968 *Paris Review* interview: "I did leave without regret the literary demimonde of agents and would-be's and with-it nonparticipants; this world seemed unnutritious and interfering." Now living just up the road from Boston, he plunged into his new normal with gusto, famously taking lovers and fully running with the social pleasantness that comes from a cheerfully insulated routine.

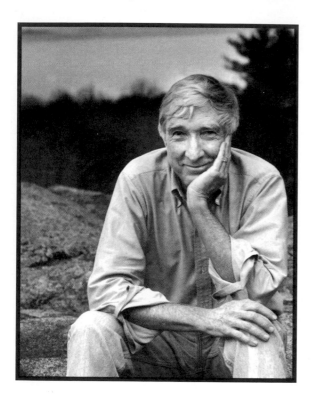

Above:
John Updike
at home in
Beverly Farms,
Massachusetts,
April 1991.

Couples, Updike's 1968 novel, is a debauched and droll dance of social opacities. Like his *Rabbit* books, the background of *Couples* is vividly historical: the assassination of Kennedy and the sexual revolution set the scene for the action. The cushion of life in New England gave Updike even more conventional American archetypes to study and scrutinize. The life he portrayed in *Couples* mirrored his own. In Louis Menand's *New Yorker* feature analysis of Updike's biography by Adam Begley, he talks about *Couples* being about the "'post-pill paradise' of the nineteen-sixties" with all its trials and tribulations. Updike himself divorced his wife in 1974 after an affair and married his mistress, Martha Ruggles Bernhard, in 1977. He lived with her in a mansion in Beverly Farms, twenty miles north of Boston, until he died in 2009.

Updike's own sartorial theme was average plus. His gangly height lent itself to a preppy dash, and all his life his wardrobe manifested as smart, carefully conventional separates. As with his writing, his sartorial style revealed normcore with flair. His single-breasted,

straight-leg suits in the 1960s echoed a modernist vibe, and his youthful floppy hair, cut short at the back and sides and with bangs in front, was a clean look that had a lot in common with the emerging Italian-style Riviera chic that had its moment in mens-wear pre-Woodstock. As he grew older, the character of his clothes rarely varied, and tweed jackets, cable sweaters, button-down shirts, and khakis were all staples he established as his own distinguishing closet components. In 2012, *GQ* magazine named him a style icon, and his way with clothes has become a model of menswear and tidy chic in the twenty-first century.

Updike wanted to become a cartoonist when he was a child, and in 1954 he won a Knox Fellowship to study at the Ruskin School of Drawing and Fine Art at Oxford University.

In walks these three girls in nothing but bathing suits. I'm in the third check-out slot, with my back to the door, so I don't see them until they're over by the bread. The one that caught my eye first was the one in the plaid green two-piece. She was a chunky kid, with a good tan and a sweet broad soft-looking can with those two crescents of white just under it, where the sun never seems to hit, at the top of the backs of her legs. I stood there with my hand on a box of HiHo crackers trying to remember if I rang it up or not. I ring it up again and the customer starts giving me hell. She's one of these cash-register-watchers, a witch about fifty with rouge on her cheekbones and no eyebrows, and I know it made her day to trip me up.

—John Updike, "A&P," 1961

ARTHUR RIMBAUD

One must be absolutely modern.

—Arthur Rimbaud, "A Season in Hell," 1873

Articulating the doctrine of a live-fast-die-young youth, Arthur Rimbaud was a libertine who ran away to Paris from his small French hometown of Charleville when he was fifteen. In his famous "seer" letter of May, 1871, he wrote to his friend Paul Demeny that he believed he could only become a "visionary" poet by a "rational derangement of the senses," which he did with fruitful abandon, throwing himself into a world of constant absinthe drinking and hashish smoking, going around town unwashed and lice-ridden, and embarking on an affair with Paul Verlaine, a poet who was ten years older than he was and who had a pregnant wife. Rimbaud was a compound sum of teenage kicks, the sublime, the gutter, and the beautiful.

Born in 1854, Rimbaud's story and work became iconic reference for beatniks, hippies, punk-rock-and-rollers and artists more than a hundred years later: his devotees famously include Victor Hugo, who called him an "infant Shakespeare," Jim Morrison, Patti Smith, the Clash, Henry Miller, and Allen Ginsberg. Rimbaud's refusal to write any more verse at the age of twenty-one was his final anarchic flourish: instead, he joined the Dutch army, deserted, and finally

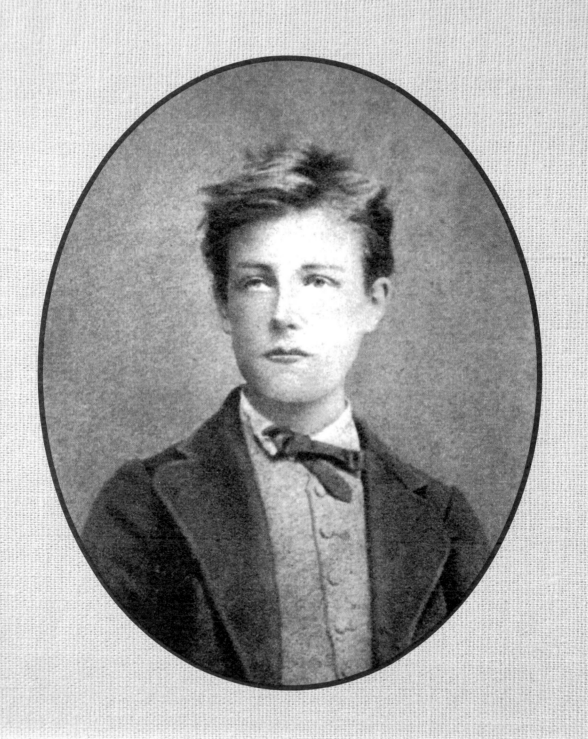

disappeared to Africa, where he spent the rest of his life in Ethiopia making money doing a little bit of this and that—selling elephant guns, coffee, and spices.

Verlaine saw in Rimbaud a wild and insolent teenager with piercing blue eyes and a reckless nonchalance: all the things that make up the DNA of a Hollywood heartbreaker were wrapped up in Rimbaud's countrified casualness. Plus, he was a dazzling poet. The two became inseparable.

Rimbaud's poem "My Bohemian Life (Fantasy)," written when he was sixteen, rests for a moment on the role of clothes for the freethinking writer; in tune with Verlaine's keen grasp of the value of an untidy tangle of an outfit, Rimbaud's verse celebrates the worth of a deconstructed jacket and a pair of trousers that needs patching. Rimbaud knew that his clothes told the story of him—where he was now, in thought and word and moment. The adolescent bard was nothing if not sincere, and his clothes markedly reflected this. The reason that fashion followers are drawn to grunge and pre-distressed designer wear is because it feels underground—a disheveled look that explodes with the allure of youth and carefree chaos. It's a fashion statement today, but for Arthur Rimbaud it was the faithful face of an artist.

Rimbaud was a member of the National Guard during the Franco-Prussian War.

Rimbaud wrote the poem "The Seekers of Lice" about the aunts of Georges Izambard, his teacher from the Collège de Charleville, because they used to sit and pick nits out of his hair.

When living in Ethiopia, Rimbaud became best friends with Ras Makonnen, a governor of the Harar district, who was the father of Emperor Haile Selassie, whom the Rastafarian movement believes is God incarnate.

By age seventeen, he was well on his way to looking the part of the genuine vagabond poet he aspired to be. Wearing a scrawny tatter of a bow tie, he had become a serial runaway and spent time in a prison in Paris for fare dodging and homelessness. Clothes and appearance were an essential part of the vagabond fixation if only insofar as they were as radical and rebellious as he was becoming.

Idle youth, enslaved to everything; by being too sensitive I have wasted my life.

—Arthur Rimbaud, "Song of the Highest Tower," 1872

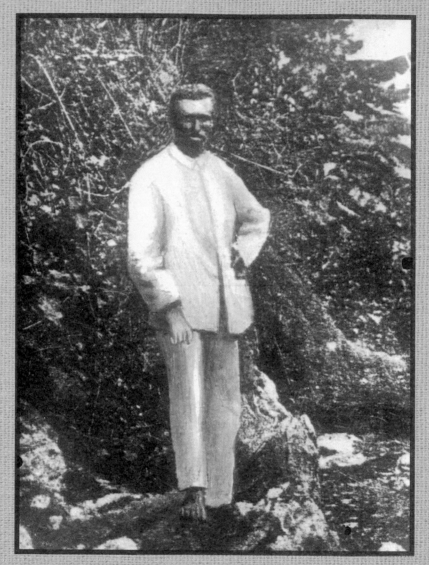

Arthur Rimbaud, Harar, Ethiopia, 1883. He moved there reportedly to work as a coffee merchant, but it was really to rest and restore his nervous constitution.

"I'm now making myself as scummy as I can. Why? I want to be a poet, and I'm working at turning myself into a Seer. You won't understand any of this, and I'm almost incapable of explaining it to you. The idea is to reach the unknown by the derangement of all the senses. It involves enormous suffering, but one must be strong and be a born poet. And I've realized that I am a poet. It's really not my fault."

In 1886 Verlaine collated a selection of Rimbaud's pieces, titled *Illuminations*. Years later, these opuses would inspire wave after wave of freethinkers: existentialists including Albert Camus and Jean-Paul Sartre, who were drawn to the metaphorical poem "The Drunken Boat"; Dadaists, who would be roused by Rimbaud's dissent against society; and surrealists, who would champion his embrace of irrationality. The fledgling voice of a sixteen-year-old and all that he conveyed in a fan letter to the poet Théodore de Banville still thrills and provokes anyone who has been a creative outsider: "I'm almost seventeen. The hopeful and dreary age, as they say, and I have begun, a child touched by the muse, sorry if it's banal,—to express my beliefs, my hopes, my feelings, all those things proper to poets,—I call this spring . . . Ambition! Oh mad ambition!"

Rimbaud's nickname for his mother was "mouth of darkness" because she was so strict and always trying to keep him in check.

GERTRUDE STEIN

These were nice days in those dark days,
and then . . . he brought us back a breath
of our dear Paris, and also darning
cotton to darn out stockings and our
linen, that was Pierre.

—Gertrude Stein, "People and Ideas: Pierre Balmain—New Grand Success of the Paris Couture,
 Remembered from Darker Days," *Vogue*, 1945

In 1934, the lights in Times Square broadcast that "Gertrude Stein has arrived in New York," as noted in Lucy Daniel's book, *Gertrude Stein*. She had just published *The Autobiography of Alice B. Toklas*, and the bestseller had driven an American lecture tour. The book told all about the adventures of Gertrude's life, but from the perspective of her lover, Alice. Stein arrived in New York from Paris for the lecture tour wearing a handmade Hermès coat she had treated herself to from the profits of *The Autobiography of Alice B. Toklas,* and recounted in the 1937 sequel, *Everybody's Autobiography*: "I bought myself a new eight cylinder Ford car and the most expensive coat made to order by Hermès and fitted by the man who makes horse covers for race horses. . . . I had never made any money before in my life and I was most excited." The *New York Times* was fascinated by her appearance and described it

Opposite:
Gertrude Stein at
her desk, 1936.

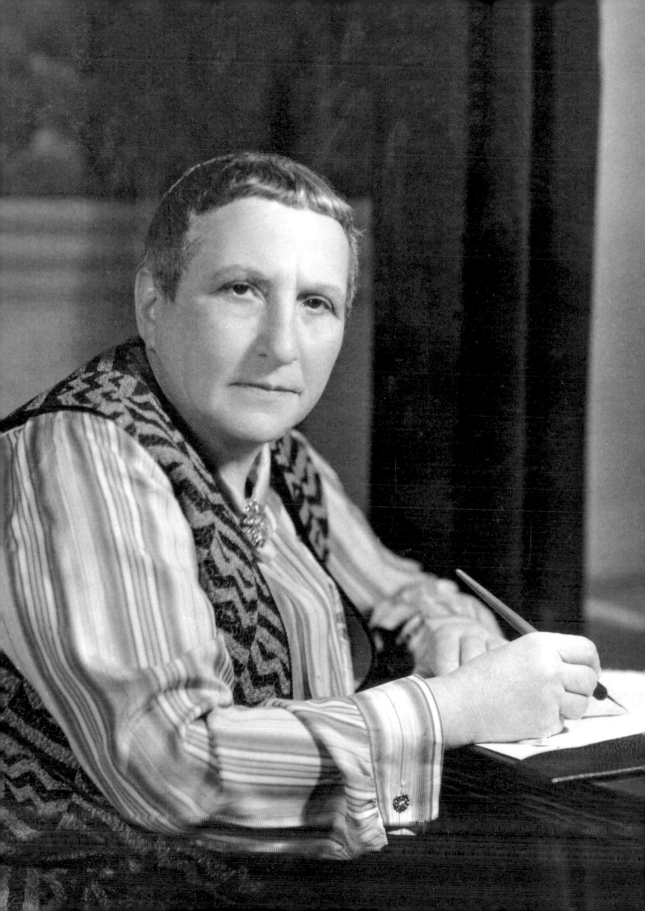

at length, reporting in 1934 in an article titled "Gertrude Stein Arrives and Baffles Reporters by Making Herself Clear": "[She was] dressed in rough tweeds. . . . Her feet were in thick woolly stockings and round-toed, flat-heeled oxfords. A brownish tweed suit covered a cerise vest of voluminous proportions and a mannish shirt of cream and black stripes. The hat was a Stein hat . . . a gay hat which gave her the appearance of having just sprung from Robin Hood's forest."

Her writing style was as extraordinary as her sartorial manner; her progressive and full-strength wardrobe was her signature. She wore capacious caftans and sandals, gold brocade vests, and immense lapis lazuli pendants. Her hair severely clipped in a monk's version of an elfin cut, she was almost never without a hat. Picasso's 1905 painting *Gertrude Stein* shows the writer in characteristic style, wearing a brown velvet cap and matching rolling robes, and a white pirate shirt with an amber clasp at the neck.

Stein's daily routine was punctuated by profound tête-à-têtes with artists and writers such as Pablo Picasso, Henri Matisse, T. S. Eliot, Djuna Barnes, James Joyce, Ezra Pound, Jean Cocteau, Georges Braque, and Ernest Hemingway. She poured all this life into her autobiographies, mesmerizing readers with its fly-on-the-wall study of the genius and domestic details of her exotic, creative network of confidants. Her most fruitful connection was with Picasso. His cubist period ran parallel to Stein's own cubist approach to literature. Throughout their relationship, the pair experimented and played with artistic ideas, possibilities, and philosophies together.

> She was a golden brown presence, burned by the Tuscan sun and with a golden glint in her warm brown hair. She was dressed in a warm brown corduroy suit. She wore a large round coral brooch and when she talked, very little, or laughed, a good deal, I thought her voice came from this brooch. It was unlike anyone else's voice—deep, full, velvety, like a great contralto's, like two voices.
>
> —Gertrude Stein, *The Autobiography of Alice B. Toklas*, 1933

It was in Paris that
the fashions were
made, and it is always
in the great moments
when everything changes
that fashions are
important, because
they make something
go up in the air or
go down or go around
that has nothing to
do with anything.

— Gertrude Stein, *Paris France*, 1940

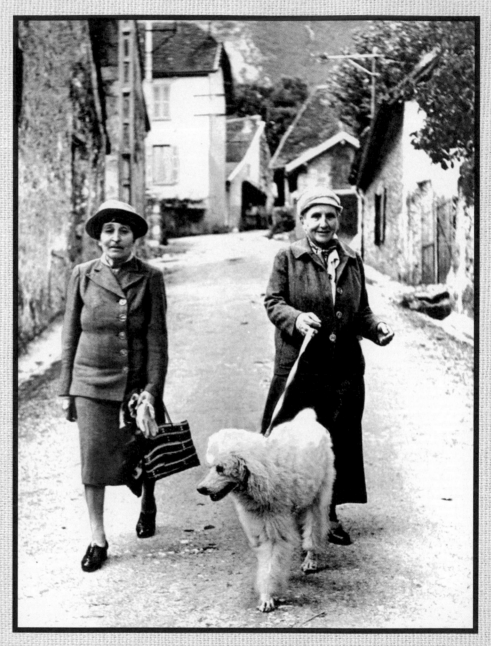

Gertrude Stein, with Alice B. Toklas, walking her dog, Basket, on a village street in the mountains of eastern France, 1944.

In her 1940 book, *Paris France*, Stein explains the symbiotic relationship between a fabulous hat and the vitality of a nation: "It is funny about art and literature, fashion being part of it. Two years ago everybody was saying that France was down and out, as sinking to be a second rate power etc etc. And I said but I do not think so because not for years not since the war have hats been as various and lovely and as French as they are now. . . . I do not believe that when the characteristic art and literature of a country is active and fresh I do not think that country is in decline. There is no pulse so sure of the state of the nation as its characteristic art product, which has nothing to do with its material life. And so when hats in Paris are lovely and French and everywhere then France is alright."

Stein's writing was powerfully influential, and Samuel Beckett studied her literary experimentations with keen attentiveness. In a 1937 letter to his friend Axel Kaun, he wrote: "Gertrude Stein's logographs come closer to what I mean. The fabric of the language has at least become porous." Both the style and substance of Gertrude Stein were complex, unorthodox, and untried: her writing is difficult, her sense of fashion was nonconforming, and her taste was visionary—and permanent.

Stein's favorite food was roast beef. She wrote seven pages about it in her book of poems, *Tender Buttons*.

Stein began blazing a sartorial trail when she was studying at Radcliffe College, the women's annex to Harvard, in 1893—she always wore black and never the customary corset of the time.

Henri Matisse gave Stein a drawing of his wife putting on a hat because she admired the way his wife did so.

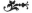

PATTI SMITH

My imagination is always fertile.
I'm either thinking of my own things,
or constantly engaged by the things
that other people do.

—Patti Smith, salon.com interview with Peter Machen, 2015

Patti Smith is a sinuous talent whose abilities flow from one magical project to another. Her uncompromisingly artistic approach to life has meant that she has been creating and collaborating organically for more than sixty years. Her dress code reflects the essence of her individuality. She vibrates with an authenticity that is unmatched, and to listen to her sing or recite one of her poems is to feel the texture of life.

Born in Chicago, Smith grew up poor. She spent her first few years in Philadelphia and then New Jersey. It was there that, bereft of culture, her elegant intelligence spurred on a searching spirit as a teen. After a couple of soul-destroying jobs in factories and an unplanned pregnancy, she left for New York in 1967: "At twenty years old, I boarded the bus. I wore my dungarees, black turtleneck, and the old gray raincoat I had bought in Camden. My small suitcase, yellow-and-red plaid, held some drawing pencils, a notebook, *Illuminations*, a few pieces of clothing, and pictures of my siblings. . . . Everything awaited me," she wrote in her 2010 memoir, *Just Kids*.

Opposite:
Patti Smith,
mid-1970s.

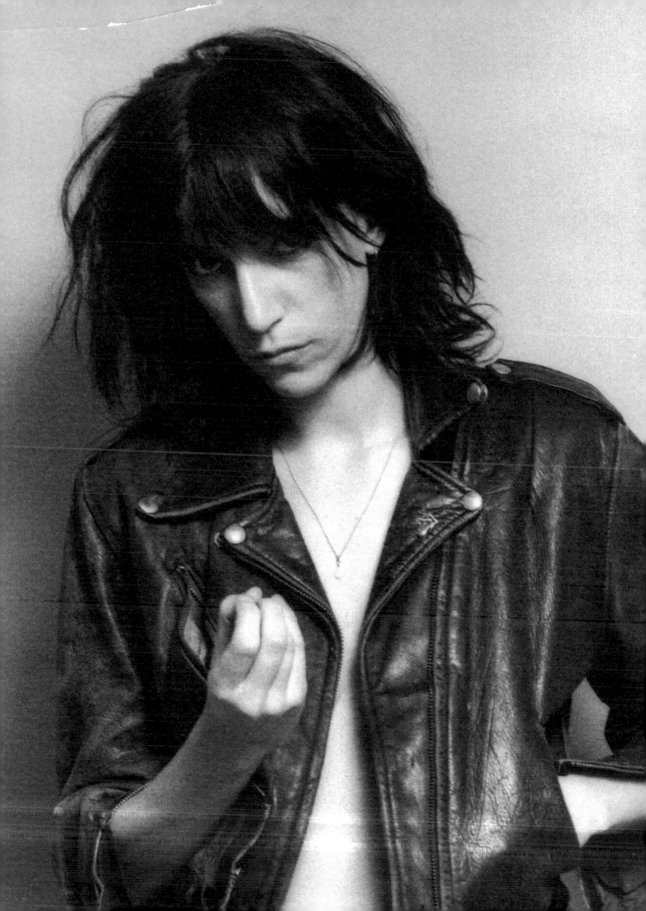

Smith's striking androgyny today seems a well-worn, comfortable characteristic. However, growing up, she found her appearance inexplicable until she discovered art. As detailed in Victor Bockris's unauthorized biography, she says: "Art totally freed me. I found Modigliani, I discovered Picasso's blue period, and I thought, 'Look at this, these are great masters, and the women are all built like I am.' I started ripping pictures out of the books and taking them home to pose in front of the mirror."

Smith's favorite books as a child were fairy tales by Hans Christian Andersen and the Raggedy Ann stories.

When she was a teenager, she imagined that Arthur Rimbaud and Bob Dylan were her boyfriends.

In August 2014 she performed a cameo role in Season 4, episode 1 of the TV crime drama *The Killing*, playing a neurosurgeon.

Smith wrote the song "Nine" that appeared on her 2012 album, *Banga*, for Johnny Depp instead of giving him a birthday present.

Equally, the femininity expected of her growing up unnerved her. In a 2010 interview with the *New York Times* she remarked: "Even as a child, I knew what I didn't want. I didn't want to wear red lipstick. When my mother would say, 'You should shave your legs,' I would ask, 'Why?' I didn't understand why we had to present a different picture of ourselves to the outside world." The photographer Robert Mapplethorpe famously shot the mesmerizing cover of her debut album, *Horses*, in 1975. The image shows her wearing a white shirt and black suit, and it's a look that encapsulates her stylish attitude even now. This was, she admits, no big deal: "It was just the way I always dressed," she said in an interview with Greg Kot for the *Chicago Tribune* in 2014.

No big deal to Smith was a signature style that has bathed sartorial sensitivities with freedom, grace, and inspiration ever since. Smith had not founded her look easily, though, and it didn't crystallize into confidence until she hit the Big Apple. She reflected in an interview with PBS: "I had been made fun of a lot growing up, because I was a skinny kid with long greasy braids who dressed like a beatnik. I didn't really fit in where I grew up; I didn't look like the other girls — I didn't have a beehive. And in New York, suddenly I just

I decided I wanted to be a writer when I read *Little Women*. Jo was so great. I really related to her. She was a tomboy, yet guys liked her and she had a lot of boyfriends. She was a real big influence on me, as much an influence as Bob Dylan was later. She was so strong and yet she was feminine. She loved guys, she wasn't a bull or nothing. So I wanted to write. I had always been a daydreamer.

—Patti Smith, from "Patti Smith: A Baby Wolf with Neon Bones," by Nick Tosches, 1976

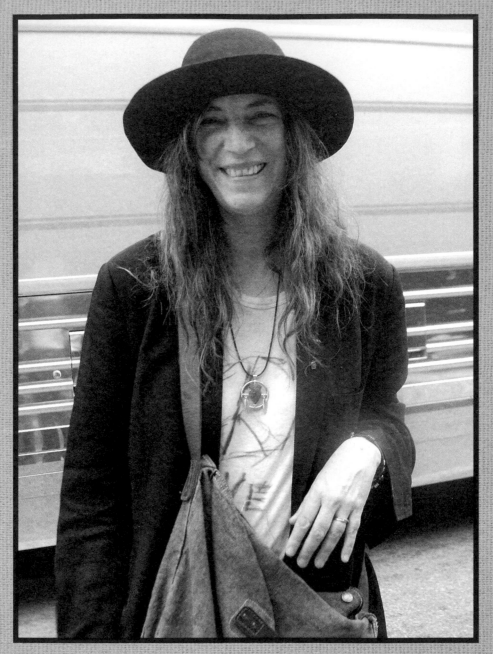

Patti Smith backstage at Lollapalooza, Grant Park, Chicago, 2007.

blended in with everybody else. Nobody cared. I didn't get stopped by the cops. I wasn't yelled at from cars. I was just free. And I think that's what New York represented to me more than anything—freedom."

Smith's poetry in the early 1970s felt unconventional. Mapplethorpe encouraged her to both write and perform her verses, and, significantly, some of her later writing would celebrate and serve as a memorial to his character and brilliance. Today her written work seems effortlessly modern.

Smith's literary wellspring was vented from a uniquely imaginative dedication to art. She synthesized mediums in a way that has become customary now but used to be extraordinary. She goes on to explain in the PBS interview: "as a very young girl, I learned that William Blake painted, wrote songs, was an activist, wrote these poems, had a philosophy and was a visionary. Leonardo da Vinci was a scientist and an artist. Lewis Carroll was a photographer, a writer and a poet. I was very comfortable with this idea at an early age."

Smith is number twenty-three of the twenty-seven members of the Continental Drift Society, a club dedicated to the German geophysicist Alfred Wegener.

I'm not a musician. I drew and wrote poetry for ten years before I wrote *Horses*. I published books. Why do people want to know exactly who I am? Am I a poet? Am I this or that? I've always made people wary. First they called me a rock poet. Then I was a poet that dabbled in rock. Then I was a rock person who dabbled in art. But for me, working in different forms seemed like a very organic process.

—Patti Smith, from "The SPIN Interview: Patti Smith," by David Marchese, 2008

SIGNATURE LOOKS
GLASSES

Statement spectacle wearing is
shorthand for thoughtful
intensity, and although they are
a classic scholarly adornment,
glasses have risen to seriously
fashionable heights. These authors
needed to wear them and their
favored pairs have become part
of their own unique looks.

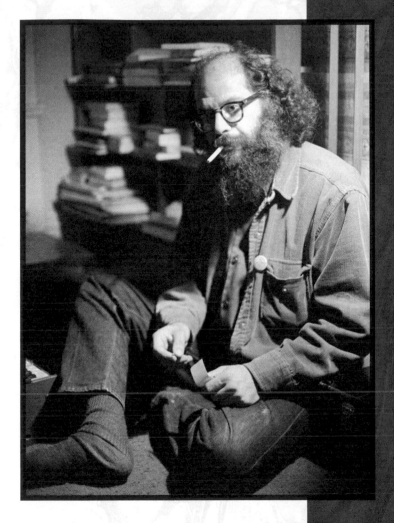

ALLEN GINSBERG

The seam of high-minded intellectualism that ran through the aims and attitudes of the beatnik set were perfectly personified by Allen Ginsberg's spectacles. The author of "Howl," which became the anthem for the artistically progressive generation, would generally wear scruffy trousers and mismatching jackets, but it was his spectacles that pulled his outfits together. Ginsberg never intended to be a style hero: he had more important issues to deal with. His glasses, however, were sacrosanct, and a practical representation of his brainpower and great insight.

Above.
Allen Ginsberg, 1970.

ROBERT CRUMB

Robert Crumb is famous as the originator of counterculture cartooning. He moved to San Francisco in the late 1960s, where he started Zap Comix and created his famous characters, who include Angelfood, Mr. Natural, and Whiteman. Crumb confessed in a 2016 interview in London's *Guardian* newspaper that he was an "outcast" at school, and "born weird." Today he wears slightly oversize, round glasses that hint at eccentricity. However, in the late 1960s he wore strong, square magnifying glasses that, along with his tall, thin frame, created a look that in the twenty-first century would be considered catwalk hip. He currently lives in a medieval château in the south of France.

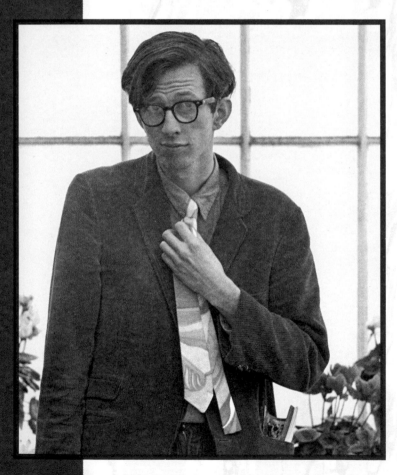

Left: Robert Crumb, San Francisco, 1969. Opposite, top: Joyce Carol Oates, 1990. Opposite, bottom: Cornel West, 2003.

JOYCE CAROL OATES

When Joyce Carol Oates, author of more than forty novels, wears glasses, her slender, delicate face gently becomes more eccentric and serious. The oversize glasses she wore in the 1970s and 1980s thoroughly swamped and overpowered Oates's appearance, to the extent that she looked like she might be wearing a disguise. Whether incognito or not, Oates's glasses look predated geek chic by decades. She looked quirky, cool, and interesting. In the twenty-first century, Oates's glasses are thin, wiry, and tinted, with small oval frames that more perfectly fit her face in a growing-old-gracefully fashion.

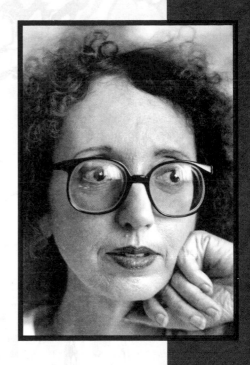

CORNEL WEST

Cornel West was one of the first black academics to become a professor at Harvard, where he works today. His most famous book, *Race Matters*, was published in 1994 and discusses the economics and politics of race in America today. West's thin-framed glasses are as elegant as his customary white shirt, black suit, and gold cuff links. West always looks immaculate, and he said in an interview with the *New York Times* that he is ever "coffin-ready. I got my tie, my white shirt, everything. Just fix my Afro nice." His glasses, however, are the serious icing on the cake. He said in his 2009 book *Living and Loving Out Loud* that his life's work is to "fuel the fire of my soul so my intellectual blues can set others on fire."

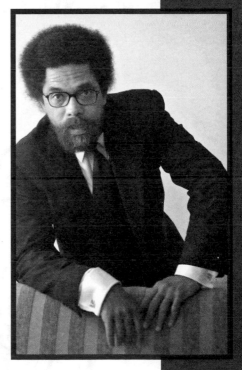

DAVID FOSTER WALLACE

Everybody is identical in their secret unspoken belief that way deep down they are different from everyone else.

—David Foster Wallace, *Infinite Jest*, 1996

The psyche of every decade is reflected in its cultural output, and it's often possible to see in retrospect a fusion of identity to an era. Fashion is an excellent starting point in distinguishing the voice of a generation. On a simplistic level, the 1980s were power-suited, and designer clothes reflected the loads-of-money spiral of consumerism that had taken hold. The postwar 1950s had optimism set into its DNA, and the clothes mirrored this, too, with cheery, cherry-pie-printed dirndl skirts and swishy ponytails. Meanwhile, the rich of the decadent, live-fast 1920s went to parties in fur-lined coats and white-tie ensembles.

The 1990s were about free-form dislocation and the survival of the masses. Dichotomies in fashion flowed easily, from grunge to heroin chic to the gloss of American designer Tom Ford, with his velvet and satin Gucci collection in 1995, to the deconstructive style codes of designer Martin Margiela's fur wigs and hoofed tabi boots in 1994. Wallace's writing style, dissecting and delivering a barrage of detail, scrutinized the world around him and anecdotally repackaged it.

Opposite:
David Foster Wallace, Champaign-Urbana, Illinois, 1996.

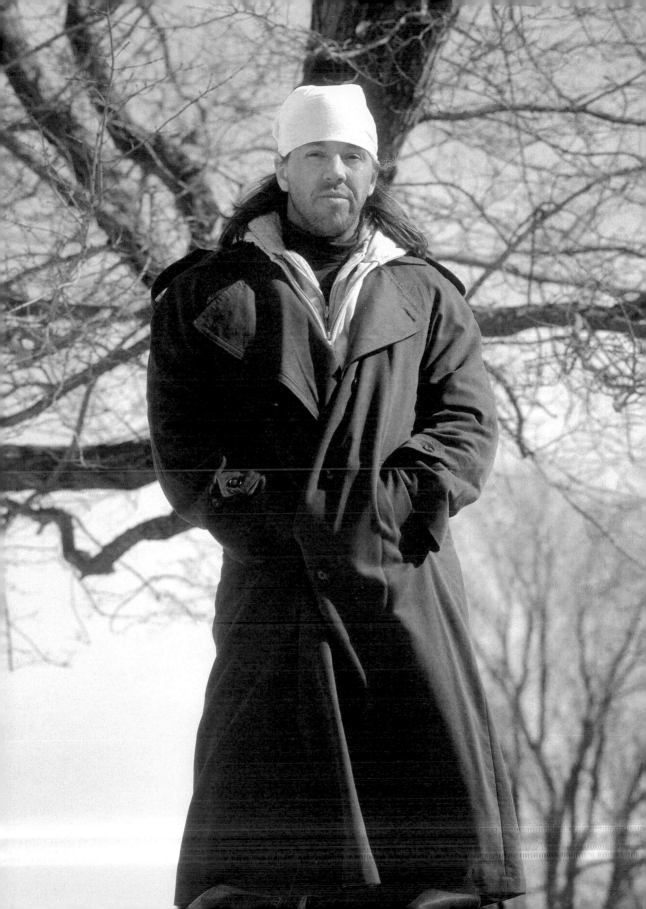

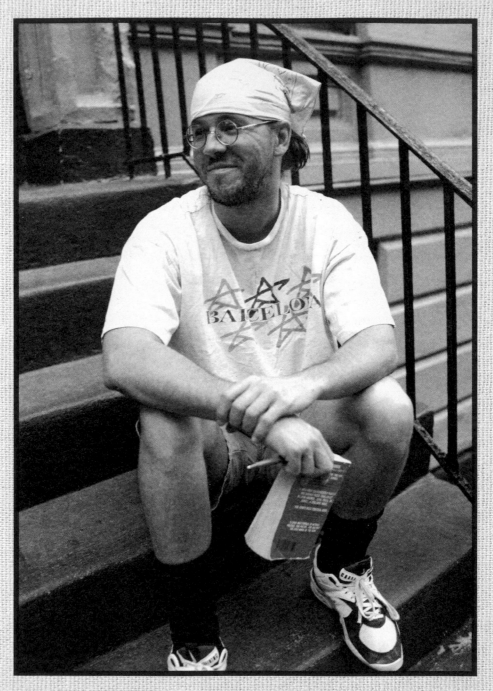

David Foster Wallace, New York City, 2005.

If you worship money and things—if they are where you tap real meaning in life—then you will never have enough. Never feel you have enough. It's the truth. Worship your own body and beauty and sexual allure and you will always feel ugly, and when time and age start showing, you will die a million deaths before they finally plant you.

—David Foster Wallace, *This Is Water: Some Thoughts, Delivered on a Significant Occasion, about Living a Compassionate Life*, 2009

He said: "Fiction's about what it is to be a fucking human being." His fiction was about the multipurpose reality of the 1990s.

Wallace had the sartorial grace of a slacker–skateboarder. His unshaven face, long, greasy hair, rumpled T-shirts, and faded denim jeans were all worn carelessly. He inhabited his clothes. His wardrobe reflected exactly what he was—the literary version of a rock-and-roll star, complete with hell-yeah bandanna. Wallace's style-setting headwear didn't come from following the season's trend forecast from *Vogue*. Instead, it symbolized the headspace of a thinking, over-articulate, spooked-out writer trying to fathom the world he was living in. It was an extension of his psyche in a way that was entirely sincere, and amid a 1990s world that swiftly became a bricolage of truths, it now seems evocative of Wallace's solitary mind searching.

There are 577,608 words in *Infinite Jest*.

David Foster Wallace's favorite book was *The Screwtape Letters* by C. S. Lewis.

Wallace grew up in the Midwest, where his home life was comfortable but his mind was turbulent. He was hospitalized, suffering from depression, while at Amherst College, and his first published short story for the college magazine was a semi-autobiographical account

of his struggle with the disease. By the time he committed suicide in 2008, he had undertaken twelve sessions of electroshock therapy and attempted suicide once before. He drank, smoked pot, and went to Alcoholics Anonymous. He gave up on his antidepressant prescription of Nardil and eventually found life too hard to bear without medication. His writing was funny, astute, sharp, and painful. He wrote with honesty, and his meta, mega texts were complex and earnest and expressed a yearning for an optimistic alternative.

Green and Mildred Bonk and the other couple they'd shared a trailer with T. Doocy with had gone through a phase one time where they'd crash various collegiate parties and mix with the upper-scale collegiates, and once in one February Green found himself at a Harvard U. dorm where they were having a like Beach-Theme party, with a dumptruck's worth of sand on the common-room floor and everybody with flower necklaces and skin bronzed with cream or UV-booth-salon visits, all the towheaded guys in floral un-tucked shirts walking around with lockjawed *noblest oblige* and drinking drinks with umbrellas in them or else wearing Speedos with no shirts and not one fucking pimple anyplace on their back and pretending to surf on a surfboard somebody had nailed to a hump-shaped wave made of blue and white papier mâché . . . Mildred Bonk had donned a grass skirt and bikini-top out of the pile by the keggers and even though almost seven months pregnant had oozed and shimmied right into the mainstream of the swing of things."

—David Foster Wallace, *Infinite Jest*, 1996

David Foster Wallace changed
prose. And prose gets changed
not that often in a century.
Hemingway changed prose, so
did Salinger and Nabokov.
David changed it too. He did
an amazing thing. One of the
things that writing and speech
can do is express what we're
thinking one thought at a time.
But we think a thousand things
at a time, and David found a
way to get all that across in
a way that's incredibly true
and incredibly entertaining at
the same time. He found that
junction.

—David Lipsky, "Getting to Know David Foster Wallace," 2008

SYLVIA PLATH

And by the way, everything in life is writable about if you have the outgoing guts to do it, and the imagination to improvise. The worst enemy to creativity is self-doubt.

—Sylvia Plath, *The Unabridged Journals of Sylvia Plath*, 1950–1962

She looked like a 1950s dream. Her preppy twinsets, double-row pearls, and summer shirtwaist dresses are images that have helped build her myth. But Sylvia Plath's clothes worked as fiction in the same way that her prose and poems told stories. She used, or tried to use, clothes as armor against the world, in order to portray a stronger, more engaged and useful self. The sartorial ideals of the 1950s seem playfully passé today, but the social reality for women then could be suffocating, as Plath recounts in her novel, *The Bell Jar*.

The uniform Plath dressed herself in appears now more like a woman playing a role in order to keep herself going. Her first suicide attempt took place in 1953, after she spent a triumphant month in New York at *Mademoiselle* magazine as student guest editor. She relished dressing up, and before coming to New York from Massachusetts she had spent precious Smith College scholarship funds on "blouses of sheer nylon, straight gray skirts, tight black jerseys, and black heeled

Opposite:
Sylvia Plath,
mid-1950s.

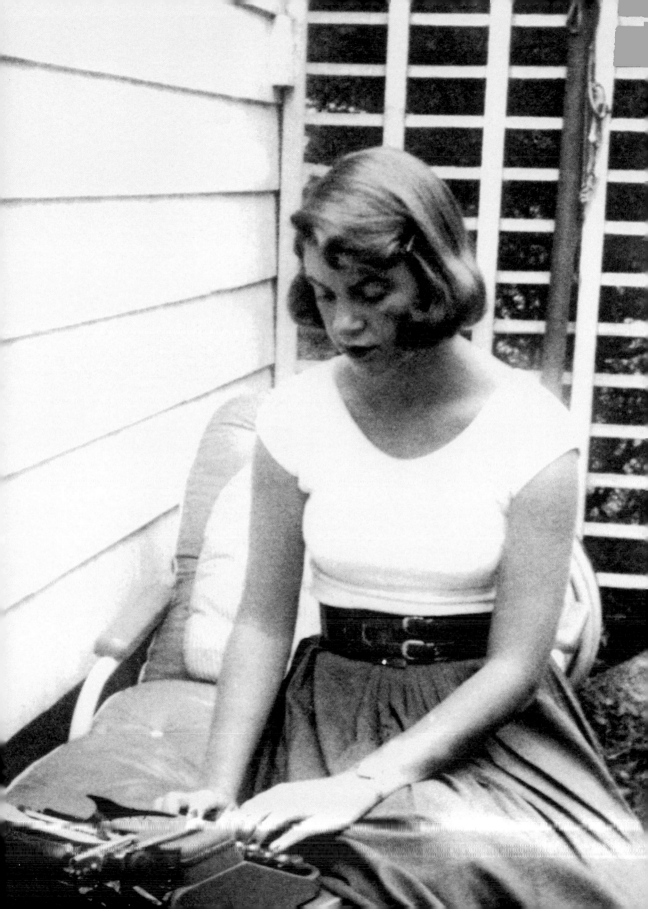

pumps," as detailed in Elizabeth Winder's book about Plath's experience. She wanted to look the part in Manhattan and intended to fit right in to the magazine world of *Mademoiselle*—at the time a crucible for the most elite and academically competitive twenty-one-year-old women in America.

Clothes equaled success, popularity, and prestige and protected her identity. They were code for Plath being in and able, yet there were cracks in the armor. Just a couple of years before her death, Plath got to know the poet Ruth Fainlight, who saw deeper than the surface and could tell that Plath's dress worked as camouflage. In a feature in London's *Guardian* newspaper in 2013, she reminisced: "My first impression was of a burningly ambitious and intelligent young woman trying to look like a conventional, devoted wife. She wore a small hat and a tight-bodiced, full-skirted shiny dark green dress—like one of my New York aunts dressed for a cocktail party. There was something almost excessive about that disguise."

Plath finished *The Bell Jar* in August 1961. It was published under a pen name, Victoria Lucas, as it told an acutely autobiographical story and she did not want to offend her friends and family. It retells Plath's time in New York, working at *Mademoiselle*, through the guise of her heroine, Esther Greenwood. On leaving Manhattan, Esther's disillusion with the superficial is concrete enough that she discards her fine clothes. It is exactly what Plath herself did before leaving the world of *Mademoiselle* to go home.

Born in Boston in 1932, Plath would return there in 1958 with her new husband, the English writer Ted Hughes, and she and her friend, the writer Anne Sexton, would attend poetry seminars held

Plath and Ted Hughes got married on June 16, 1956, in honor of James Joyce's epic *Ulysses*, which transpires in a single day, June 16, 1904. June 16 is known as Bloomsday and is celebrated worldwide, through people's reenacting various portions of the story.

Plath said she'd "rather live in London than anywhere else in the world" and in 1959 rented a flat in Primrose Hill, near Regent's Park, where the poet William Butler Yeats had also lived.

Writers and artists are the most narcissistic people. I mustn't say this, I like many of them But I must say what I admire most is the person who masters an area of practical experience, and can teach me something.

—Sylvia Plath, from *The Poet Speaks: Interviews with Contemporary Poets*, by Peter Orr, 1966

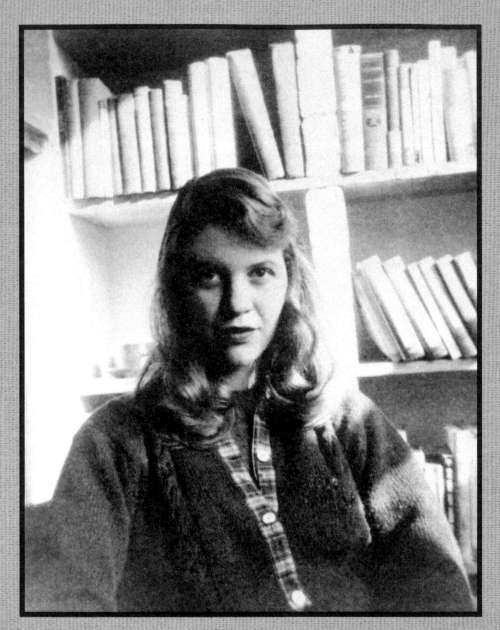

Sylvia Plath, 1957.

by the poet Robert Lowell. Sexton is credited with encouraging Plath to find her "confessional" voice, and around this time Plath's writing became more mature and developed.

Plath's pained and angry voice was not simply a response to a society that frustrated her, it emerged from her depressive psychosis and possibly from the sudden death of her father when she was eight years old. The confusion and grief Plath experienced was never resolved, and at the time of his death, she announced, "I'll never speak to God again." Her poem "Daddy," written in 1962, wraps up with the line "Daddy, daddy, you bastard, I'm through." A few months after she wrote the poem, she succeeded in her final suicide attempt at her apartment in London, leaving her two small children alone.

Plath watched the obscenity trial of D. H. Lawrence's *Lady Chatterley's Lover* from the press gallery in London's Old Bailey court.

It was my last night.
I grasped the bundle I carried and pulled at a pale tail. A strapless elasticized slip which, in the course of wear, had lost its elasticity, slumped into my hand. I waved it, like a flag of truce, once, twice. . . The breeze caught it, and I let go.
A white flake floated out into the night, and began its slow descent. I wondered on what street or rooftop it would come to rest. . . .
Piece by piece, I fed my wardrobe to the night wind, and flutteringly, like a loved one's ashes, the gray scraps were ferried off, to settle here, there, exactly where I would never know, in the dark heart of New York.

—Sylvia Plath, *The Bell Jar*, 1963

EDITH SITWELL

I wouldn't dream of following fashion . . .
how could one be a different person every
three months?

—Edith Sitwell, from *The Last Years of a Rebel*, by Elizabeth Salter, 1967

The aristocratic writer Edith Sitwell, who recited her avant-garde poems through a Sengerphone and set them to music, was an awkward bird of paradise whose visually arresting image is as much remembered as her literary work. Stylewise she was akin to the Italian surrealist, artist, and designer Elsa Schiaparelli. Like the Italian fashionista, drama was key to Sitwell's over-the-top look, as was her arts-and-craftsy bohemianism. She had a compelling sartorial magnetism. Sitwell's signature turban was a handsome, exotic, and utopian disguise for an unconventionally beautiful woman.

The theatricality of Edith's dress sense mirrored her literary approach. In 1922 she performed *Facade*—a series of spoken poems—for the first time. From behind a thick curtain at her home in London, Sitwell intoned conceptual verses set to music. She claimed that Stravinsky inspired the rhythms of her work, and many today see her as the originator of modern rap. The ethereal and poignant cadence of Sitwell's language is as desolate and liberated as her persona.

Opposite:
Edith Sitwell,
1937.

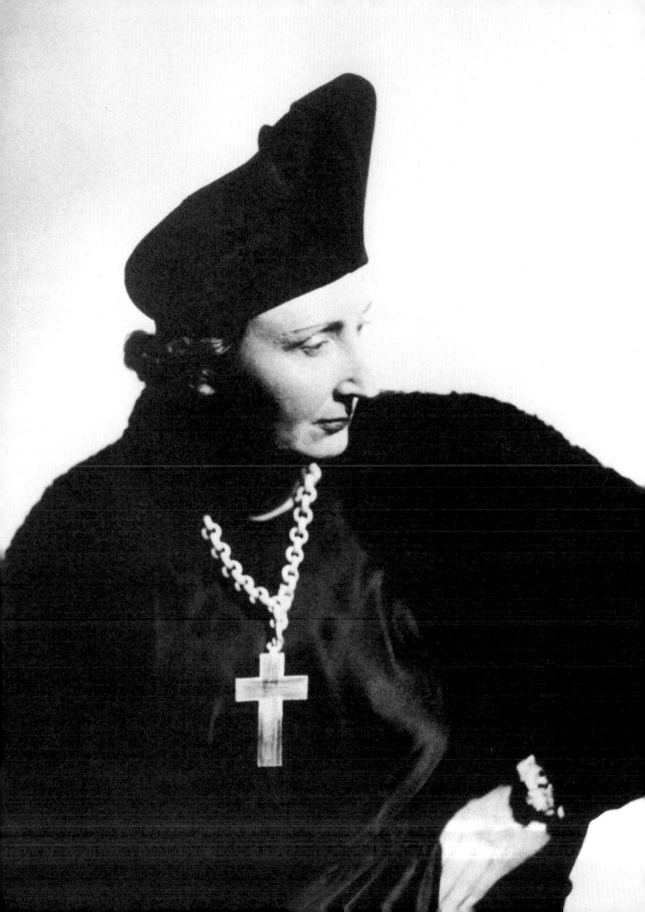

Sitwell was born at the end of the nineteenth century in Scarborough, a far-flung northern seaside town in England near the Peak District. She grew up on a country estate called Renishaw Hall, where she was clad in an iron corset commissioned by her father to correct a spinal deformity. Educated at home, she fell in love with the French writings of Arthur Rimbaud. In her 1965 autobiography *Taken Care Of*, she calls herself a "changeling on the parental estate" and declared that her parents never wanted her.

However, the worlds of fashion and literature grew to love Sitwell. In 1914, when she escaped home and moved to a tiny flat in Bayswater, London, Chanel was opening her first dress shop and ushering in the streamlined and effortless flapper-girl look that would dominate the 1920s. Sitwell, however, spun 180 degrees away from this, having already begun to move outside of the mainstream; she cultivated her own highly ornate style instead. At eighteen, she had been given four pounds and bought herself a black velvet dress. She loved velvets and the fabric became an essential component of her wardrobe for life. She would even buy furnishing fabrics for their heavy weight and have them tailored into frocks.

Sitwell died in 1964, the same year that Mary Quant presented the miniskirt in London and designers Elie Saab and Anna Sui were born.

Sitwell did not enjoy reading William S. Burroughs and in 1959 when *Naked Lunch* was published she wrote a number of letters about it to the *Times Literary Supplement* saying: "I do not wish to spend the rest of my life with my nose nailed to other people's lavatories, I prefer Chanel No. 5."

Contemporary American designer Rick Owens wrote in *Vogue Paris* in 2014 that Edith "turned herself into a myth. I like when people haven't the advantage of beauty and invent something singular from scratch." And her appeal continues to resonate at the highest echelons of the fashion industry. Marc Jacobs's Dark Swans autumn 2015 collection was inspired by Edith's hairstyle; Isabella Blow, Alexander McQueen's muse and a onetime *Vogue* editor, usually arrived at the *Vogue* offices "dressed as . . . an Edith Sitwell figure," reflected Anna Wintour in an article in *The Independent* in 2007.

The trouble with most
Englishwomen is that
they will dress as if
they had been a mouse in
a previous incarnation,
they do not want to
attract attention.

—Edith Sitwell, as quoted in *Edith Sitwell: Fire of the Mind:
an Anthology*, 1976

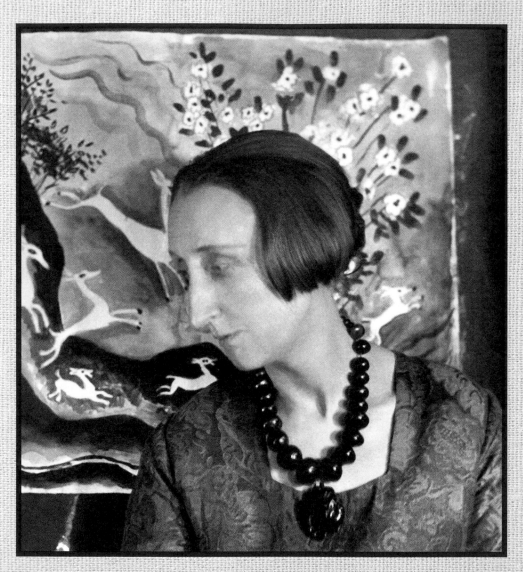

Edith Sitwell, late 1920s.

Sitwell's unapologetic guise was fuel for a driving and necessary sense of being an outsider. "Why not be oneself? That is the secret of a successful appearance. If one is a greyhound, why try to look like a Pekingese?" she asked in *Fire of the Mind*, an anthology of her work. And although during her lifetime both her work and her dress sense were ridiculed and revered in equal measure, it is with the benefit of hindsight that her aesthetic has become a perpetual touchstone for the creative community. Jean Paul Gaultier, Dries Van Noten, and John Galliano's love of the exotic and otherworldly have informed and shaped their signature styles in the same way that it shaped Sitwell's wardrobe.

She wore brocaded silk gowns and headdresses; she wore the heaviest of aquamarine and topaz rings on her long, elegant fingers and looked like a

When Sitwell was four years old she was asked what she wanted to be when she grew up, and she said: "A genius." She was sent to bed as punishment.

medieval princess. "I feel undressed without my rings," she declared in 1959 on the BBC program *Face to Face*, and later asserted: "I can't wear fashionable clothes. If I walked round in coats and skirts people would doubt the existence of the Almighty." Sitwell's clothes were always out of tune with the convention of her times, and until her death in 1964 she never looked to routine. Her costumes were designed for a long time by the gay Russian painter Pavel Tchelitchew, with whom she was in love. They were his vision of Sitwell as a Poiret-esque Plantagenet noblewoman that she adopted for all her life.

F. SCOTT AND ZELDA FITZGERALD

Everybody's youth is a dream, a form
of chemical madness.

—F. Scott Fitzgerald, "The Diamond As Big As the Ritz," 1922

Style icons to countless admirers, many of whom may never have read anything written by either of them: such is the scale of F. Scott and Zelda Fitzgerald's celebrity. F. Scott Fitzgerald's touchstone novel, *The Great Gatsby*, has been adapted into a movie a number of times. Baz Luhrmann's version in 2013 captured the Technicolor sparkle of a decade swirling with casually spent dollars and frenzied parties. The fabric of F. Scott Fitzgerald's stories are the dreams of directors and designers alike; film and fashion never tire of the magic and tragic appeal of the narrative of both the Fitzgeralds' lives and their writing. Kate Moss's Zelda-inspired wedding in 2011 warranted an eighteen-page shoot in *British Vogue*; her bridal gown was 1920s-style bias cut and her traditional ring a copy of Zelda's and Scott's.

F. Scott Fitzgerald's writing pierced the bubble of the American Dream, and all the glitter and grief that could come with it. According to Andrew Hook's biography, F. Scott admitted in January 1922 in a letter to his friend, the American writer Edmund Wilson, that the "most enormous influence . . . in the four and a half years since

Opposite:
F. Scott and
Zelda Fitzgerald
on the French
Riviera, 1926.

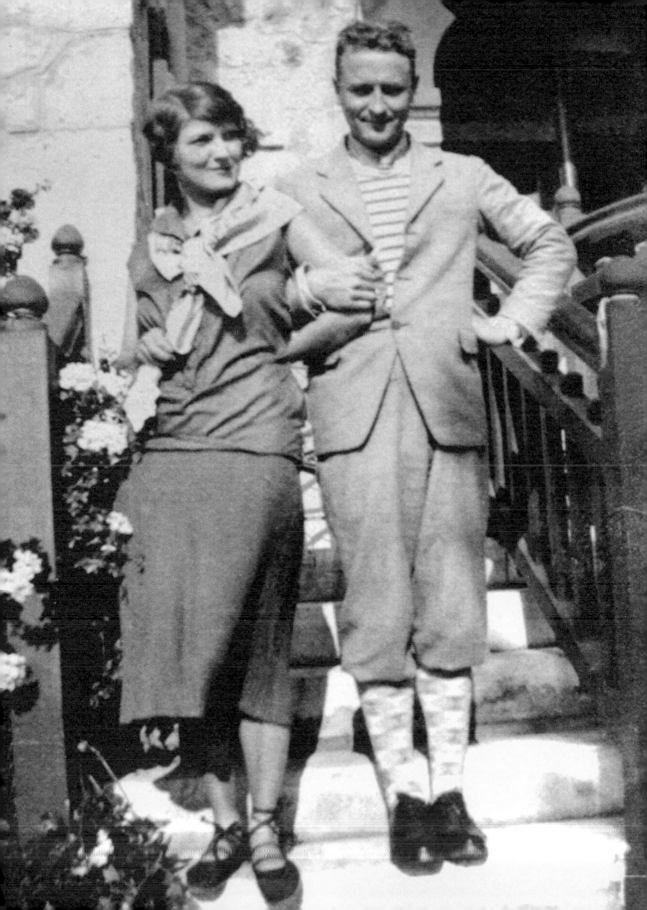

I met her has been the complete, fine and full-hearted selfishness and chill-mindedness of Zelda."

The Fitzgeralds lived a fast, flapperish lifestyle—they spent money like water, holidayed all year round, trashed hotel rooms, drank until they fell over, and danced and dropped their friends without care. Their way of existence ultimately corroded them. Their fashion sense has become symbolic of an age when finery and excess were chic.

Before coming to New York to be married in 1920, Zelda lived the relaxed life of a Southern belle. She arrived in New York with a trunk of organdy frocks and velvet lounging pants. F. Scott Fitzgerald decided she needed to sharpen up her look. He sent her shopping with an old friend, Marie Hersey, who guided her toward the French designer Jean Patou's effortlessly chic, simple designs and his thoroughly modern, slender silhouettes. It wasn't long before Zelda's city wardrobe took off and her small-town trousseau was left behind. Her curly bobbed hair was Marcel-waved to perfection and to parties she wore dresses trimmed with sequins and fur and tailored to make her look string-bean slim and enviously flat-chested. Scott himself was very rarely seen without a three-piece tweed suit, pocket handkerchief, and tie; his silver-screen-handsome charm was accentuated by the fashionable middle part in his pomaded hair. In the same way that fashion built their characters and helped them show off what they wanted the world to notice, it also operates in their writings, where mood and personality are delicately parallel to the clothes described. Fashion is key to what Fitzgerald first termed the Jazz Age. Vivacity, aspiration, magnificence, and melancholy are all central motifs in *The Great Gatsby*, published in the throng of all the decadence in 1925—and the Fitzgeralds personified the moment.

To be blasé, beautiful, and rich was the raison d'être of F. Scott Fitzgerald's cultivated crowd. He wrote about the destructive and the divine. The signature ingredients of an F. Scott Fitzgerald story were

The Nintendo video game *The Legend of Zelda* is named after Zelda Fitzgerald.

F. Scott Fitzgerald was named after one of his relatives, Francis Scott Key, who composed "The Star-Spangled Banner."

I am that little fish
who swims about under
a shark and, I believe,
lives indelicately on
its offal. . . . Life
moves over me in a
vast black shadow and
I swallow whatever it
drops with relish.

—Zelda Fitzgerald, letter to F. Scott Fitzgerald, 1932

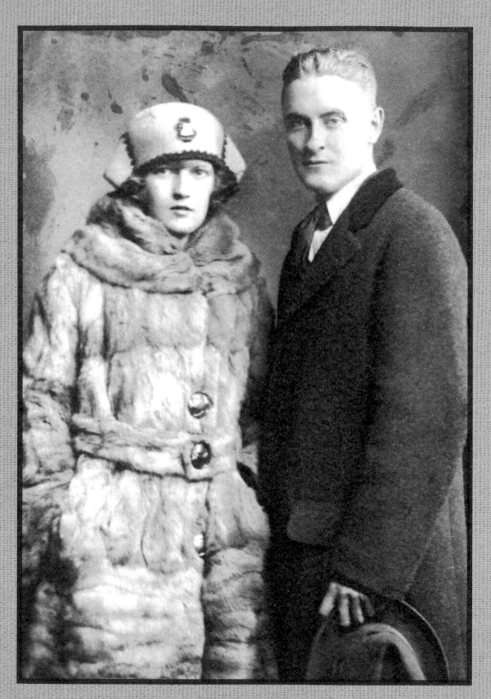
F. Scott and Zelda Fitzgerald, 1921.

passion, panache, cash, and catastrophe. The way Zelda ran about town, jumped into the Washington Square Park fountain, and flirted with men other than her husband while spending money on furs and champagne has become a standard for a 1920s caricature.

But the reality is that Zelda and F. Scott Fitzgerald lived a devastating dream. Scott Fitzgerald suffered a heart attack and died in Hollywood at age forty-four while trying to work as a screenwriter and to write his last, unfinished book, *The Love of the Last Tycoon*. At forty-seven Zelda died in a fire at Highland Hospital in Asheville, North Carolina, while undergoing treatment for mental illness. Neither lived the golden life in the end: Scott Fitzgerald never believed he would leave an author's legacy, and Zelda's frustration with her fate only served to compound her psychosis.

F. Scott Fitzgerald's *This Side of Paradise* sold out its first printing in three days.

Zelda Fitzgerald and Tallulah Bankhead were first-grade classmates.

Scott Fitzgerald's autobiographical Amory Blaine in his novel *This Side of Paradise* evidences some of the shiny self-worth the author possessed. The philosophy and flair of the "slicker" persona is something Scott aimed for in the real world, and his fictional definition most definitely resembled him: "He dressed well, was particularly neat in appearance, and derived his name from the fact that his hair was inevitably worn short, soaked in water or tonic, parted in the middle, and slicked back as the current of fashion dictated."

MARCEL PROUST

Fashions, being themselves begotten of the desire for change, are quick to change also.

—Marcel Proust, *Within a Budding Grove*, 1919

Born in 1871 in Auteuil, a district of Paris, Proust was a belle epoque dandy who wore beautifully laundered white gloves and a cattleya orchid boutonniere, an extravagance purchased daily from the expensive Parisian florist Lachaume on Rue Royale. He observed and embodied the sartorial niceties of the era—his hair was beautifully waved and slicked, and his mustache flourished with the finesse of the time. His ties were secured with a sweeping bow, artistically knotted just on the right side of elegant. He "wore a coat lined with fur" and was said to often wear it to dinner parties. He was regularly spotted with it at the Ritz, having tea.

As a young man Proust suffered from asthma and was generally in poor health, but he suffered with poise. Inspired by the English watercolorist, art critic, and art patron John Ruskin, Proust lived his life to the artistic backbeat of the art nouveau, but his work *In Search of Lost Time* (*À la recherche du temps perdu*; earlier translations were called *Remembrance of Things Past*) has become known as the most important modernist novel of the twentieth century.

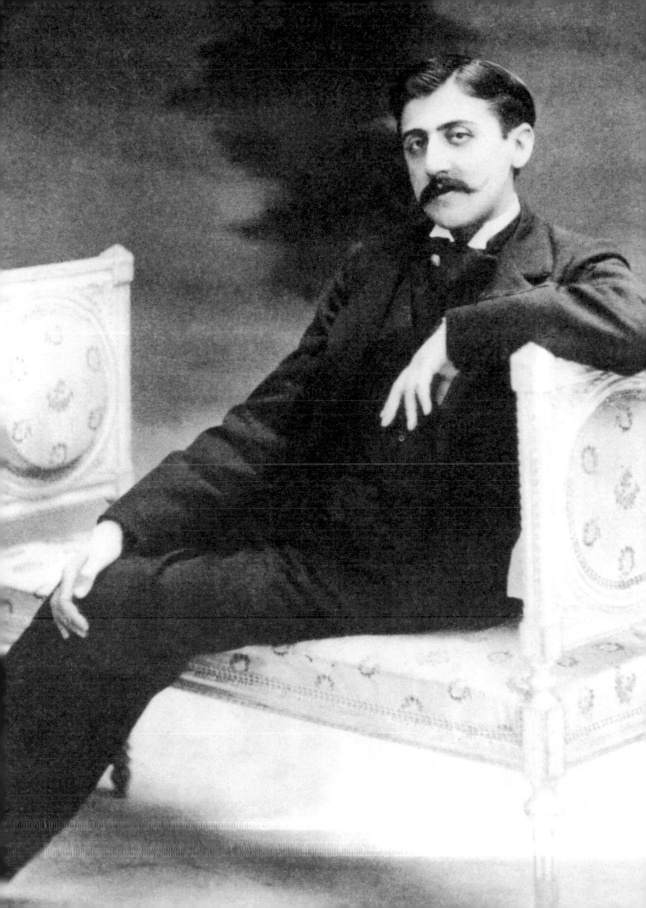

In Search of Lost Time is an exquisite and winding journey into Proust's soul and mind. It's a tunnel of an experience for bibliophiles who dare take the challenge of reading the entire seven parts: it's more than three thousand pages long and meanders around the question of the meanings of life, love, and art. Published between 1913 and 1927 (the last section after Proust's death), it was a novel that delved into the mind and described thinking. It was also a novel that took the value of clothes and their wispy, otherworldly resonance and incisively assessed their significance.

Proust's heroine from *In Search of Lost Time*, Albertine, is said to be based on his secretary, Alfred Agostinelli.

While in prison for theft and petty crime, playwright Jean Genet read Proust and, in 1944, was inspired to write his poetic and fluid novel *Our Lady of the Flowers* about the underworld of Paris.

In Proust's early notebooks, he wrote about toasted bread and honey as a memory trigger, rather than the famous madeleines of *In Search of Lost Time*.

In this novel, Proust mainly depicts fashion in the context of the styles seen in the chicest salons at the end of the nineteenth century, when embellished and impossible elegance was the purpose of design. The finest trimmings and fabrics and the most delicate of accessories, including hats, which were almost always adorned with ever-increasing numbers of feathers and flowers, were the day wear staples of the noble glitterati. Spanish designer Mariano Fortuny created his Grecian column dress, Delphos, in 1907. Made from pleated silk, its pillar like shape was a contrast to the more complicated corseted silhouette of the day. Proust's description of its aura, in *Swann's Way*, is sublime.

Fortuny was of special interest to Proust. He was married to the sister of Proust's friend Reynaldo Hahn, and his artistic work is used as a metaphor in *In Search of Lost Time*. The narrator, Marcel's, adoration of Venice, the sliding sentiment of longing, and the transformation of his lover, Albertine, are all channeled into the clothes Albertine wears. She has a quirky unconventionality, but when "captive" in volume five, she wears designer Fortuny gowns that Marcel buys her because the

We do not succeed in
changing things according
to our desire, but gradually
our desire changes.

—Marcel Proust, *The Fugitive*, 1925

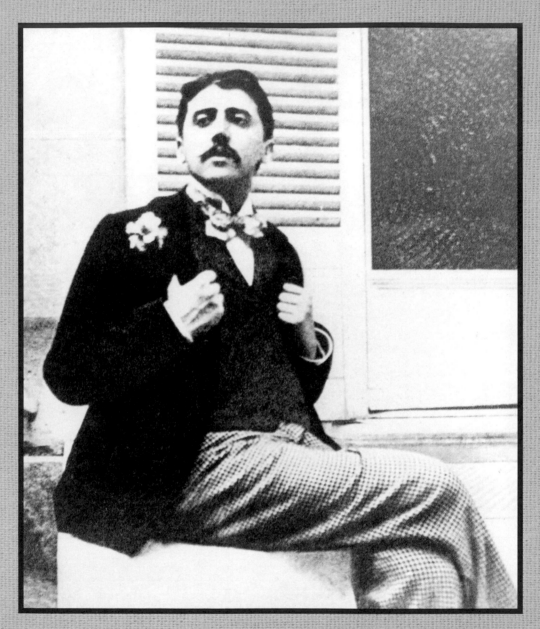

Marcel Proust, Paris, 1905.

"best-dressed woman in Paris," the Duchesse de Guermantes, is a fan. Proust's use of fashion in this volume is complex and intricate: his attention to fabric, cut, and construction indicates individuality and social position, but also memory and nostalgia.

Proust is a cult read among scholars and style setters alike, and he is the only author whose designer status has been sanctified by fashion's own head of the church, Yves Saint Laurent. Saint Laurent designed a number of gowns for Marie-Hélène de Rothschild's ball celebrating the centenary of the author's birth in 1971, including a taffeta creation for English actress and musician Jane Birkin. The cream dress had poofy leg-of-mutton sleeves; an enormous bow was tied to the back and edged in lace. It sounds like a monstrous bridezilla horror, but unlike the belle epoque furbelows, it was graceful and easy to wear and looked wonderful as she danced the evening away.

The Fortuny gown which Albertine was wearing that evening seemed to me the tempting phantom of that invisible Venice. It swarmed with Arabic ornaments, like the Venetian palaces hidden like sultanas behind a screen of pierced stone, like the bindings in the Ambrosian library, like the columns from which the Oriental birds that symbolized alternatively life and death were repeated in the mirror of the fabric, of an intense blue which, as my gaze extended over it, was changed into a malleable gold, by those same transmutations which, before the advancing gondolas, change into flaming metal the azure of the Grand Canal. And the sleeves were lined with a cherry pink which is so peculiarly Venetian that it is called Tiepolo pink.

—Marcel Proust, *Swann's Way*, 1913

SIGNATURE LOOKS
SUITS

The legacy of the suit is its
ability to relax a wearer into
a sartorial comfort zone while
still maintaining a sense of
polite formality. You never need
to worry wearing one: a suit does
all the looking-good work for
you. The way these authors sport
a suit, however, goes to show
it's not what you wear that matters
as much as how you wear it.

T. S. ELIOT

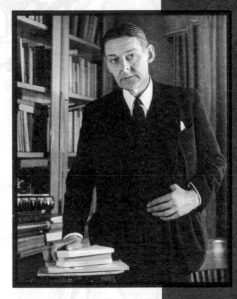

A classic, complete three-piece suit and tie was the wardrobe of choice for T. S. Eliot, who was almost never seen wearing anything else. He buttoned up and strode out in impeccable style, looking elegant, gracious, and well-bred. His most famous poem, "The Waste Land," was published in 1922, a time when the Jazz Age was beginning to encourage the young postwar generation to throw caution to the wind and live life with abandon. Eliot's synthesis of the mood of the time in this poem would become one of the most complex and modern responses to the futility and disorientation of the era.

GAY TALESE

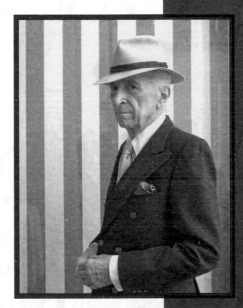

Even as a young boy, Gay Talese wore handmade bespoke suits: his father was a tailor. He wears suits daily and admits to having "about a hundred." Often accessorized with a statement fedora and a thick cigar, Talese's personal style is impressive, smart, and full of sophisticated panache. His essay "Frank Sinatra Has a Cold," published in *Esquire* magazine in 1966, has been called one of the "most influential American articles of all time" and reads more like a short story than a feature. He was instrumental in popularizing the genre of literary journalism. Talese takes notes every day on cut-up pieces of shirt cardboard, snipped to fit perfectly into his shirt pocket so they don't rustle the lines of his outfit.

Top: T. S. Eliot, 1950.
Bottom: Gay Talese at home in New York City, 2014.

BRET EASTON ELLIS

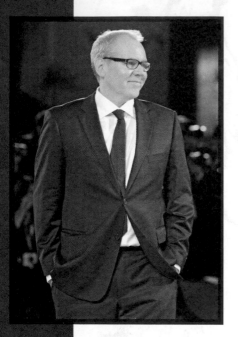

In 1984, when Bret Easton Ellis sold his debut novel, *Less Than Zero*—named after an Elvis Costello song—he was only twenty-one and at Bennington College in Vermont. In true 1980s style, Ellis wore a wide-shouldered suit and looked more like a yuppie than one of the wasted L.A. kids of his book. Style, satire, and substance, however, are Ellis's forte, and the suit has become one of his trademarks—along with provocative, decade-defining literature, including *American Psycho*, a satirical overview of modern life and all its designer-styled decadence. Ellis himself has confessed that his favorite going out to an event suit is a "low-end" Hugo Boss.

EDGAR ALLAN POE

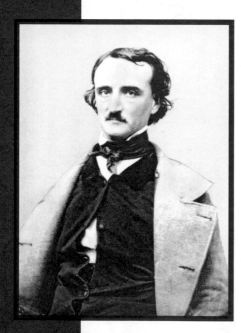

One of the first American writers to develop the gothic storytelling genre, Edgar Allan Poe was usually distinguished by his suit: a three-piece, buttoned up and tidily tailored. In 1860, his acquaintance Lambert Wilmer said: "I never saw him in any dress which was not fashionably neat with some approximation to elegance." His suits were always black. To some extent he manifested very much as the bizarre, romantic artistic writer he is remembered as.

MARK TWAIN

In his 1905 essay "The Czar's Soliloquy," Mark Twain remarked: "There is no power without clothes. It is the power that governs the human race." Twain's favorite clothing color was white. At the age of seventy he wrote in his autobiography that abandoning his white suit in October was saddening to him: "Little by little I hope to get together courage enough to wear white clothes all through the winter, in New York." It was an outfit Twain cherished and that he in turn used to represent his favorite characters. In his landmark 1884 novel, *The Adventures of Huckleberry Finn*, Huck describes Colonel Grangerford, the refined gentleman who takes him in, wearing a suit "made out of linen so white it hurt your eyes to look at it." Twain valued an impressive outfit.

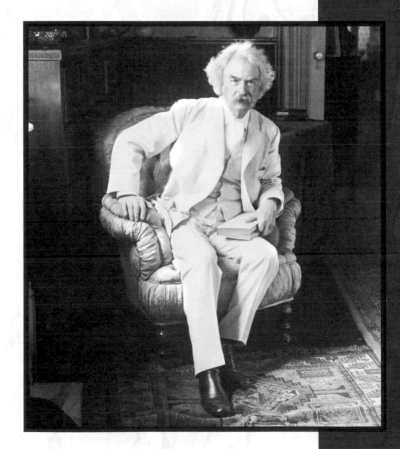

Opposite, top: Bret Easton Ellis attends the premiere of *The Canyons*, for which he wrote the screenplay, at the 70th Venice International Film Festival, 2013. Opposite, bottom: Edgar Allan Poe, 1849. Right: Mark Twain, 1905.

JACQUELINE SUSANN

Everyone has an identity. One of their own, and one for show.

—Jacqueline Susann, *Valley of the Dolls*, 1966

Opposite:
Jacqueline Susann
charting out her
novel *The Love
Machine* in her
writing room at
her Central Park
South apartment
in New York City
in the mid-1960s.

Even though Jacqueline Susann wasn't the prettiest girl when she entered a beauty competition at the age of seventeen in Philadelphia in 1936, she won a silver cup thanks to some kindly, friends-of-the-family judges. Even though Susann wasn't the best actress Broadway has ever seen, she crawled her way to the middle and became a reasonably famous show-business face in New York in the 1940s and 1950s, fronting her own fashion television series and starring regularly in the comedian and actor Morey Amsterdam's show as Lola the Cigarette Girl. And even though Susann wasn't the greatest writer ever, she became the world's hit author in 1966 when her second book, *Valley of the Dolls*, was published, smashing the bestseller list for twenty-eight weeks and staying in the top ten for an enviable sixty-eight. More than thirty million copies have sold worldwide to date, and her novels have been turned into Hollywood films and miniseries. Her life has inspired biopics—*Isn't She Great* (2000) starred Bette Midler as Susann, and the movie ran with the tagline "Talent isn't everything."

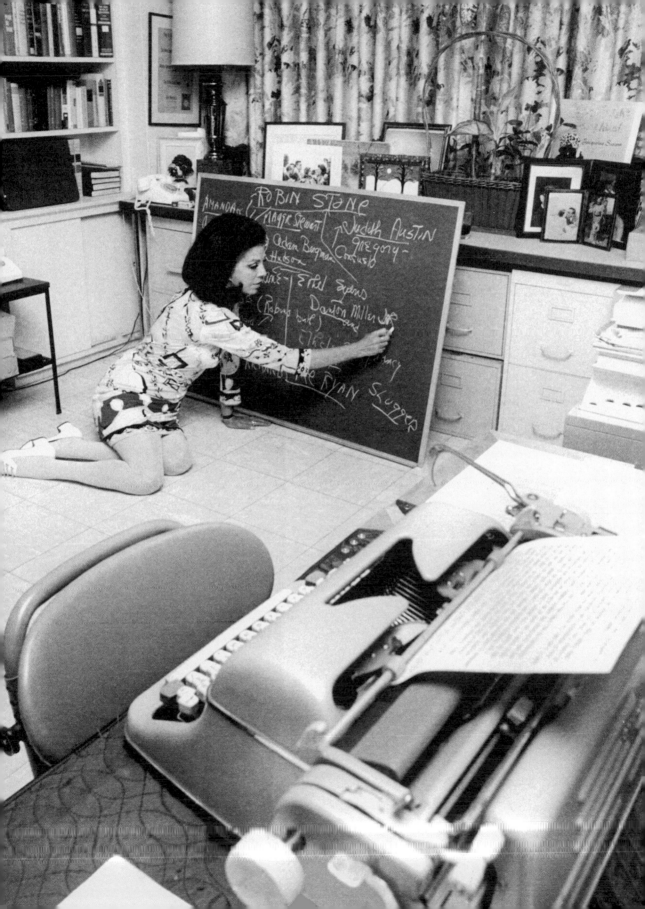

But Susann was talented. She was also audacious, courageous, larger-than-life, and—most important for a writer—a trailblazer. She wrote ballsy plotlines about women's sex lives for an audience that was still becoming aware that women had them. Susann refused to create happy endings for her heroines: she insisted that life wasn't about happy endings and preferred to tell it like it was. She wrote in clichés and stereotypes we are familiar with today, but in 1966 she was the first woman author to plunge her readers into a risqué reality many of them had never dreamed of before. Her characters are straightforward and vulnerable: Neely O'Hara, a Broadway star, is overweight and takes pills to help her slim down. She becomes addicted to them, as well as to alcohol. Jennifer North is a starlet who gets breast cancer and commits suicide rather than admit to her fiancé she needs a mastectomy and will lose her "finest assets" as he sees it. Susann's approach drew readers in. All the literary critics in the world couldn't argue with her success, and as she said in the *New York Times Magazine* in 1973, "A good writer is one who produces books that people read—who communicates." Over the years, she reached out to the masses who adored her and her storytelling books.

In her high school yearbook, Susann wrote that her ambition was to own a mink coat.

In 1970 Susann's office in her apartment at 200 Central Park South had pink patent-leather walls and Pucci curtains.

Susann typed with only three fingers and used a chalkboard to plot her stories and develop characters.

Never let anyone shame you into doing anything you don't choose to do. Keep your identity.

—Jacqueline Susann, *Valley of the Dolls*, 1966

Susann came to New York right after finishing high school in 1936. She wanted to be an actress and, like Anne, another character in *Valley of the Dolls*, wanted freedom and adventure. More than anything, though, she wanted to be famous. Susann was striking, gregarious, and driven. Her tall, slim figure was designed for the glamour of the silver screen. When she got married in 1939, she wore a puff-sleeved lace gown and matching halo hat, her hair parted at the side and set in a prewar roll: she was the ultimate ladylike ideal. As she was increasingly seen around town, Florence Lustig, Grace Kelly's favorite designer, started giving her bugle-beaded designer cocktail wear for club-hopping and show appearances.

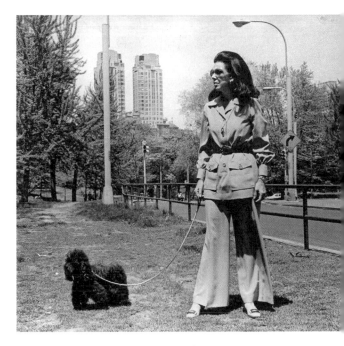

Above: Jacqueline Susann walking her poodle in Central Park, New York City, late 1960s.

Susann was voted Best-Dressed TV Actress four times by the National Fashion Academy and was always camera-ready: primed with a smile, a twirl, and a sassy remark. Wardrobe-wise she is most famous for her 1960s Pucci shifts, with flared sleeves worn with a chain-metal belt and geometric earrings. Susann's flippy back-combed bouffant was hair-sprayed firmly into place, and her black eyeliner, overarched eyebrows, and long eyelashes smoothed together a glamour-puss presence that has iconic value all on its own.

Susann's 1960s wardrobe was of its time, but she made it all her very own: jeweled bib-front tunics, white crocheted minidresses, patent dolly shoes, butterfly-collared floral shirts, and jumpsuits were all mix-and-match favorites she modeled with self-assurance. Susann wasn't deconstructed in any way: she had energy and zing; she was showbiz incarnate, and she always dressed to impress.

FRAN LEBOWITZ

Here's the problem with being ahead of
your time . . . by the time everyone gets
around to it, you're bored.

—Fran Lebowitz, in Martin Scorsese's documentary about her, *Public Speaking*, 2010

Opposite:
Fran Lebowitz
at the Vanity
Fair Party to
celebrate the
2009 Tribeca
Film Festival,
New York City.

Fran Lebowitz was twenty when she started writing for Andy Warhol, whom she met when she went for an interview at The Factory for a job at *Interview* magazine. It was the early 1970s, and almost immediately she started writing a column for his publication, which was at the center of the fashion and art worlds. She socialized with the Factory crowd, the New York designer glitterati that included Calvin Klein, Betsey Johnson, and an underground of emerging artists, including Keith Haring and Jean-Michel Basquiat. In 1981, Warhol threw a party for her at the best disco on earth, Studio 54, in honor of the publication of her second book, *Social Studies*—a collection of dry and droll essays that compile her thoughts about living and surviving modern life. It is similar in tone to her first book of essays, *Metropolitan Life*.

The Lebowitz style of writing doesn't falter or alter: she always writes with a heavy dose of irony, wit, and precision. In her 1981 parody "The Four Greediest Cases," Lebowitz takes the annual

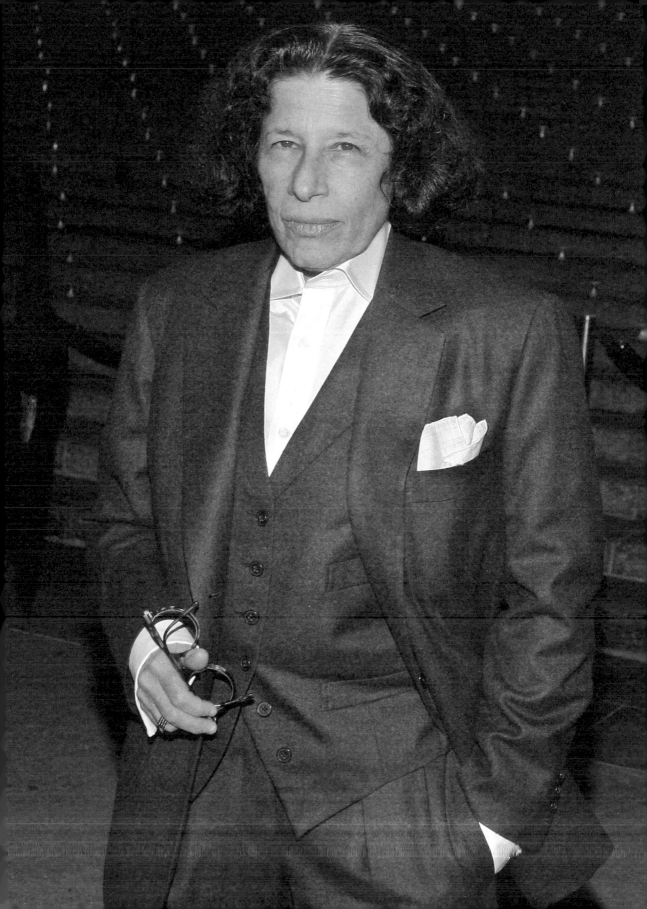

New York Times Neediest Cases charity campaign and spins it to become a tale of excess and vacant consumer consumption.

Her consistent literary approach is mirrored by her sartorial one. *Vanity Fair* called her "a New York–based satirist and waistcoat enthusiast." In the twenty-first century, her wardrobe still works a timeless,

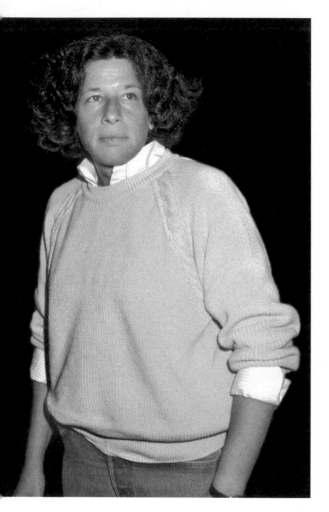

masculine vibe: in 2008 it was celebrated by *Vanity Fair*, who inaugurated her into their International Best-Dressed Hall of Fame. Lebowitz generally wears men's clothes. It's been said that the only person ever to see her in a dress was her mother.

She found her signature sartorial style as quickly as she found literary success on arrival in NYC back in 1970. The only thing that has really changed in the Lebowitz wardrobe since then is her shirt supplier. She switched from Brooks Brothers to Hilditch & Key when Brooks stopped making the shirts she liked best. Hilditch and Key are based in London's gentlemen's quarter on Jermyn Street, and their shirts are $150 a pop. Royalty and the ultrasuave order from them; their motto is: "A shirt shouldn't shout . . . it should whisper. It should elicit a barely discernible nod of admiration from those in the know." Fran Lebowitz is in the know.

In Kathleen Hale's 2015 *Elle* magazine interview with Lebowitz, she revealed her sober and unruffled relationship with clothing: "When I was young, I wore sweaters. Crewneck sweaters, with button-down shirts and jeans, every single day. And I think at a certain point in my twenties, I decided that was childish. So I gave away all my beautiful sweaters." Maturity and androgyny are the keynotes of Lebowitz's look. She is meticulous and modern. She buys

Above:
Fran Lebowitz,
New York City,
1987.

her suiting from bespoke Anderson & Sheppard—the British tailor that dresses Prince Charles. They're known for their American fit: unstructured and loose fitting, understated—and impeccably so. She matches her Jermyn Street shirts with denim jeans and cowboy boots.

Again, she is particular about the style and shape: "I don't like the pointy toe or the square toe. I have the only pairs I know of that are wingtip cowboy boots," she boasted in *Elle*.

Lebowitz's life is fashionable. She eats at the swankiest dinner tables and talks to elegant people. She has had front-row seats at the catwalk shows of designer friends Carolina Herrera and Diane von Furstenberg during New York Fashion Week and has moved new-generation fashion names such as J.W. Anderson and Victoria Todorov to create collections inspired by her perfected persona. Martin Scorsese made a documentary about her in 2010 called *Public Speaking*. Lebowitz provokes the great and the good because she personifies New York smart. She is an expert on taste, and she likes the finest things in life.

Lebowitz doesn't collect anything apart from books, and she has a good selection of them about the secretive society the Masons.

Lebowitz owns a silver cigarette case that once belonged to the writer John O'Hara.

I'm interested in the profoundly superficial; people's innermost thoughts are never as revealing as their jackets.

—Fran Lebowitz, "Fran Lebowitz Isn't Kidding," interview by Cynthia Heimel, *New York* magazine, 1981

JOE ORTON

I'd the upbringing a nun would envy and
that's the truth. Until I was fifteen I was
more familiar with Africa than my own body.

—Joe Orton, *Entertaining Mr. Sloane*, 1964

Joe Orton's lawless outlook on the world animated his writing, his love life, the clothes he wore, and the pranks he pulled off. Orton's wardrobe was as infused with attitude as his writing. It was not so much what he wore but how he wore it that counted: denim, fake fur, and leather boldly thrown on with an insolent assertiveness that challenged and defied. He was gay, sexy and seductive, and not shy about it. Orton was unapologetic and as out, and on his terms, as it was possible to be prior to the decriminalization of homosexuality in the United Kingdom in 1967.

Orton was a playwright, and his theater debut, *Entertaining Mr. Sloane*, was first performed in 1964. Its menacing satire was a slap in the face to a society Orton had begun to deride with a passion after spending six months in prison for defacing library books. Orton's confrontational stance was fundamental to his psyche and his success as a writer. He despised hypocrisy and used black humor to stab away at it. *Sloane* tells the story of desperate siblings Kath and Ed, who end

Opposite:
Joe Orton at
his flat on Noel
Road, Islington,
London, 1967.

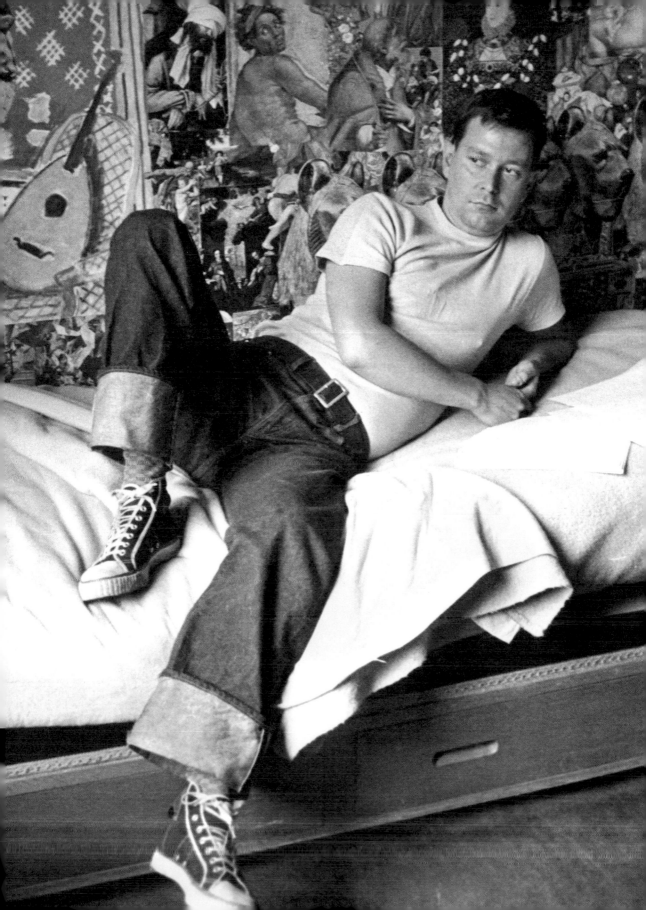

up sexually sharing Mr. Sloane, a homeless juvenile delinquent whom they blackmail after he kills their father. The wretched ménage à trois plotline is an unconventional farce and an unlikely laugh-a-minute performance. Reviews in the *London Evening News* pronounced it "a real shocker." A year later the play moved to America, where the *New York Times* said it was "disgusting" and should be "thrown into the Atlantic." Tennessee Williams, however, loved the show and came to see it twice. The production cemented Orton's profile as an uncompromising and new-wave dramatic voice.

Orton, who was born in Leicester in 1933, hit his stride in London in the mid-sixties: Carnaby Street, with its new boutiques and designer showcases, was the epicenter of the fashionable world, and swinging London's youthful energy animated society's soul. Counterculture was growing in the United Kingdom, and it thrived in this lively zone of central London. Orton's momentum ran parallel to the vivacity of the Beatles, Mary Quant, and David Bailey. British society was shifting. The Profumo scandal in 1963 had tarnished England's political reputation, having exposed the affair between Secretary of State for War John Profumo and nineteen-year-old Christine Keeler, who also happened to be having an affair with a Russian military attaché. The old guard was no longer impervious to criticism, while at the same time working-class voices and outsider ideals were steaming onto center stage.

`When Orton was seventeen, he took elocution lessons to get rid of his working-class Leicester accent so he would better fit into the theater world.`

`When Orton's mother died in 1966, he took her false teeth to the production of his play Loot and suggested they be used as a prop.`

Paul Gorman points out in his book *The Look* that Malcolm McLaren and Vivienne Westwood took Orton's life philosophy and built the punk movement inspired by his anarchic attitude. Their shop at the bottom of Kings Road was renamed Sex in 1974, influenced by a March 1967 entry in Orton's diary: "Sex is the only way to infuriate them. Much more . . . and they'll be screaming hysterics in next to no time." Westwood and McLaren created a T-shirt in tribute to Orton, based on the title of a play he planned but never wrote, but which did

The kind of people who
always go on about
whether a thing is in
good taste invariably
have very bad taste.

—Joe Orton, *Transatlantic Review*, Spring 1967

Joe Orton standing before a poster for his play *Loot*, 1967.

become the title of his biography by John Lahr. The shirt, Prick Up Your Ears, was a provocative design—a screen print of a homosexual orgy—created to annoy, aggravate, and undermine the status quo, aiming to do exactly what Orton wanted to do in the world himself.

His rough casualness was virile: he refused to fit into the 1960s stereotype of a fey gay man. Orton's regular uniform was denim jeans worn with enormous cuffs, tight white T-shirts, leather jackets, army surplus caps, and Converse sneakers. In the theatrical world, his informal sartorial signature set him apart from the typically booted-and-suited brigade. Orton wore exactly what he wanted and did exactly what he wanted. The raging promiscuity he enjoyed and detailed with such delight in his diaries eventually incited such jealousy in his long-time lover, Kenneth Halliwell, that he clubbed him to death. Orton was only thirty-four. However, Orton made the most of his short life. He declared in a television interview that he even "liked prison." In a 1967 interview with British director Barry Hanson, Orton said: "I think there's a certain section of England that's marvellous. You can call it swinging London, but it just sort of expresses something that is there, a splendid liberalism, but only in a certain little bit of London. I mean, in New York, when Dudley Sutton was in *Sloane* and had to have his hair dyed, it was very embarrassing. People actually passed remarks in the street, whereas they wouldn't here. You can do all sorts of things in London, and long may it be so."

SIMONE DE BEAUVOIR

Dressing up is feminine narcissism in concrete form; it is a uniform and an adornment; by means of it the woman who is deprived of *doing* anything feels that she expresses what she *is*.

—Simone de Beauvoir, *The Second Sex*, 1949

S imone de Beauvoir not only inspired women to think from a radical perspective, she also encouraged them to live from a radical perspective—to think about life and what they wore and what it said about them and how they felt about the world. She was the mother of existentialism and the mother of the beatnik scene, too. De Beauvoir stood for the rejection of conformity and the necessity that all women find an artistic, creative, and, most important, cerebral self.

After World War II, Paris's intellectual and artistic elite, including Albert Camus and Jean Cocteau, would gather on the Left Bank to talk about life. At the age of thirty-six, de Beauvoir was at the center of the fun. However, in the book that made her an international name, *The Second Sex*, she talks about the grief of getting old, but she goes on to say in *The Coming of Age,* "there is only one solution if old age is not to be an absurd parody of our former life, and that is to go on pursuing

Opposite:
Simone de Beauvoir,
1947.

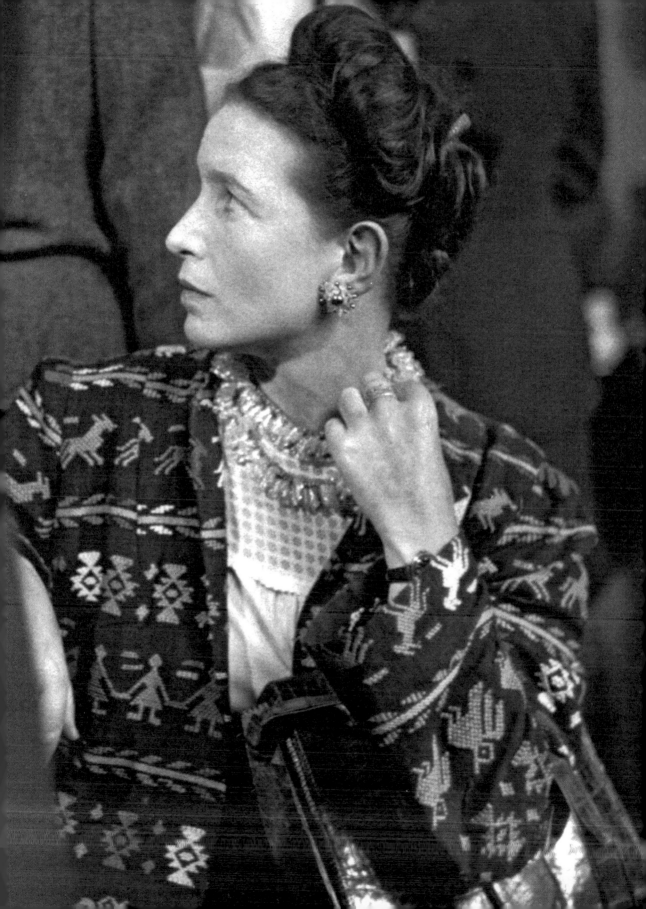

ends that give our existence a meaning." So "maturity" didn't stop her hanging out until the early hours with the likes of singer Juliette Gréco, who was still only twenty at the time. De Beauvoir felt at one with originality, and this core quality infused her own fashion choices.

De Beauvoir met Jean-Paul Sartre in 1929, when they were both studying for the competitive aggregation in philosophy, one of France's leading graduate program exams, which they sat for at the École Normale Supérieure in Paris.

> Costumes and styles are often devoted to cutting off the feminine body from any activity: Chinese women with bound feet could scarcely walk, the polished finger-nails of the Hollywood star deprive her of her hands; high heels, corsets, panniers, farthingales, crinolines were intended less to accentuate the curves of the feminine body than to augment its incapacity.
>
> —Simone de Beauvoir,
> The Second Sex, 1949

In Deirdre Bair's 1990 biography of de Beauvoir, she writes that Sartre called de Beauvoir "the badly dressed one with the beautiful blue eyes." She was certainly in and out of step with the times. During the war, rationing and patriotism generally restricted overt fashion statements, and after the liberation in 1944, times were still lean. If de Beauvoir's hair was not held high in her signature chignon, it was usually held together in the wartime fashion of a looped turban—a trick women used to keep their hair neat while supplies of all kinds were low. Most dispensed with this when the world started to get back to normal, but de Beauvoir found the style useful, and it became part of her look. One of her beatnik legacies was the reassurance that utility styling could be sexy.

It wasn't until 1947, when Dior presented the New Look and laid the foundation for the female silhouette of the 1950s with his cinched waists, upholstered uni-bosoms, and frothy petticoats, that fashion gained a real spotlight again. At the time, it was the ideal antidote to the thin years of the war. In *The Second Sex* (1949) de Beauvoir declared

There are women who
make of themselves a
nosegay, an aviary;
there are others
who are museums,
still others who
are hieroglyphics.

—Simone de Beauvoir, *The Second Sex*, 1949

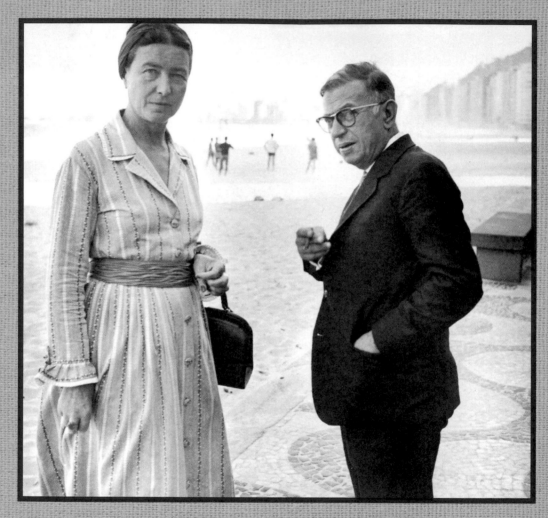

Simone de Beauvoir and Jean-Paul Sartre at Copacabana Beach, Rio de Janeiro, 1960.

that "the least practical of gowns and dress shoes, the most fragile of hats and stockings, are most elegant," and Dior and his finery represented the shackles of the Other. She preferred her own thing, and it is this attitude that went on to draw the kindred spirits of laissez-faire beatnik-dom to her way of thinking.

In her most celebrated book, *The Second Sex*, de Beauvoir explores why women's status in society is subordinate to that of men. She writes about the representation of women by men, but also the objectification of women by women. What is particularly fascinating is her rigorous antifashion zeal. She talks about how for a woman to "care for her beauty, to dress up, is a kind of work." She was willing to do the "work of fashion" herself and was rarely without a polished manicure, went on a pro-abortion march in a fur coat, and was described in *The New Yorker* by Janet Flanner and Stanley Edgar Hyman in 1947 as "the prettiest Existentialist you ever saw; also eager, gentle, . . . modest."

Until the age of fourteen, de Beauvoir wanted to become a nun.

In 1959 de Beauvoir wrote a book called *Brigitte Bardot and the Lolita Syndrome*. It's out of print today and a collector's item.

De Beauvoir recognized in *The Second Sex* that a "woman can use dress to communicate her attitude to society," and while at the time she argued that this could be repressive, today it's seen as an artistic choice. De Beauvoir dressed and looked intelligent: she looked smart in a silk tie and pleated skirt, teaching a class, she looked majestic in her fur coat at Café de Flore, and she looked effortlessly beautiful in a sharply tailored velvet suit at home. The fact that the way she came across was never a singular priority is intrinsically captivating, and an essence that cool hunters still chase today.

Although de Beauvoir and Sartre were partners all their lives, and are now buried side by side in the Montparnasse Cemetery, they never lived together.

SIGNATURE LOOKS
HAIR

The microscope of fashion is fully
focused on hair: the starting
and finishing flourish of a look,
it can make or break an outfit.
Tresses and curls also declare a
moment in time like nothing else,
not just with the cut but the
color, the lengths, and the products
used. These authors are exceptions
to any hair rule: their cuts exist
on a different level.

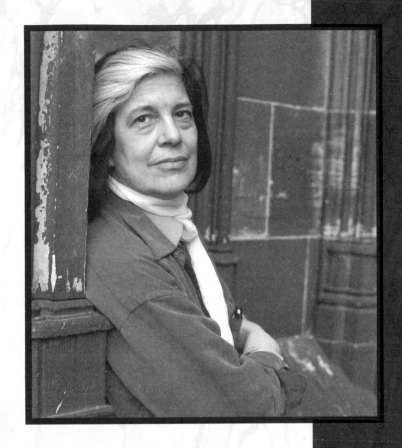

SUSAN SONTAG

Born in New York in 1933, Susan Sontag studied at Harvard, Oxford, and the Sorbonne and became a novelist, playwright, peace activist, and academic. Her trademark was the streak of white running through her dark hair. Defying society as ever, Sontag grew more seductive with age. Rather than mask the grays, she made them a classic feature. As presumptuous a look as Cruella de Vil's in *101 Dalmatians*, Sontag's stripe was blatant and bold. She knew that it looked great and added edgy value to her thick, glossy locks. Sontag was beautiful, and in later years, in an increasingly androgynous way. She grew into loose suiting teamed with flappy shirts and tennis shoes—accessorized, of course, with a scarf and that monochrome streak in her hair. This look, from the 1990s, is the one for which Sontag will be remembered.

Above:
Susan Sontag, 1993.

KARL OVE KNAUSGAARD

Born in Oslo, Norway, in 1968, Knausgaard's hair is almost as legendary as his six-volume, 3,600-page autobiography, *My Struggle*. He has a long silver mane that defies the need for a comb. His locks spiral and sit where they want in a devil-may-care fashion—exactly the way a rock star's might look, windswept in precisely the most riotous way. Knausgaard has been called the Proust of Norway and reportedly wrote twenty pages a day when he was putting *My Struggle* together. It's a long list of his life, and the absorbingly banal detail he captures has become cult reading.

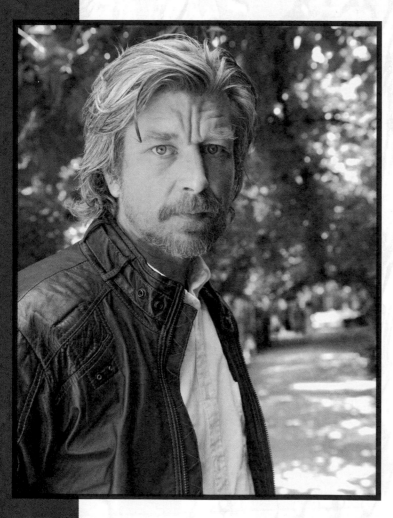

Left: Karl Ove Knausgaard, Paris, France, 2012. Opposite, top: Malcolm Gladwell, 2014. Opposite, bottom: Michael Chabon, 2013.

MALCOLM GLADWELL

Corkscrew curls like Malcolm Gladwell's are the kind you can't pay to get. It's all in the luck of the DNA draw, and his high forehead and natural waves are the result of a happy marriage between an English father and a Jamaican-born mother. When Gladwell decided to grow his hair long, it inspired his second book, *Blink*, published in 2005. He said his "wild" hair started to get him pulled over by the police, and he received more speeding tickets than he'd ever gotten before. *Blink* is a book about thinking without thinking, and, like his first book in 2000, *The Tipping Point*, it has become a bestseller the world over.

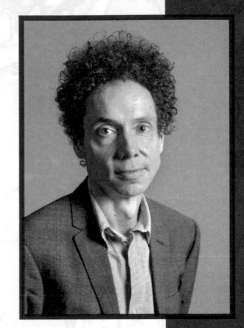

MICHAEL CHABON

Romantic and Byronesque, Michael Chabon's wavy locks are floppy and carefree. In its current silvery stage, his untamed hair has the edge of a rock-and-roll poet to it. The Gap wanted to use Chabon in an advertisement, but he said no and reflected in a 2001 *Rolling Stone* interview: "I only take pride in things I've actually done myself. To be praised for something like that is just weird." Chabon may not focus on the stylish nuance of his look, but that's also why the Pulitzer Prize–winning author and screen-writer is a bit trendier than he gives himself credit for. Nonchalance is a good look.

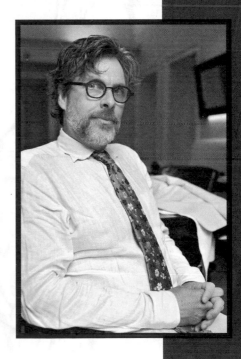

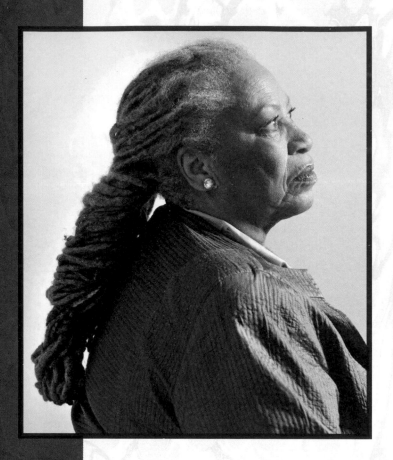

TONI MORRISON

The first African American woman to win the Nobel Prize for Literature, Toni Morrison had an unhurried journey to authordom—she didn't publish her first novel, *The Bluest Eye,* until she was thirty-nine years old. Her signature dreadlocked hair similarly came later in her life. Her silvery natty dreads are symbolic of a powerful cultural identity and also evoke the Rastafarian roots and vibe of the king of cool, Bob Marley. To many, dreadlocks also run deeper as characteristic of a spiritual counterculture, but to Morrison they are no signifier of anything but herself. She said in a 2012 interview in *The Guardian,* "I'm not a stereotype; I'm not somebody else's version of who I am." She wears her dreadlocks with self-assured and transcendent elegance.

ERNEST HEMINGWAY

The Ernest Hemingway style that has inspired look-alike contests and clothing brands is not the Hemingway of Paris in the 1920s, where he hung out with Gertrude Stein and Ezra Pound as a fresh-faced literary novice working as a journalist for the *Toronto Star*. Born in 1899 in Oak Park, Illinois, the Nobel Literature and Pulitzer Prize–winning man of later years, who sailed the Caribbean seas and safaried in Africa, will long be remembered for the rugged charm of his craggy beard, full of character and mirrored by a muscular writing style that was direct but with hidden depths. A steely fisherman and hunter, Hemingway naturally took to wearing Aran sweaters and utility wear: a hipster uniform that invigorates twenty-first-century menswear with a sturdy reliability. His novels today similarly endure: *The Sun Also Rises* and *For Whom the Bell Tolls* are strong and classic, just like his heavy-duty facial hair.

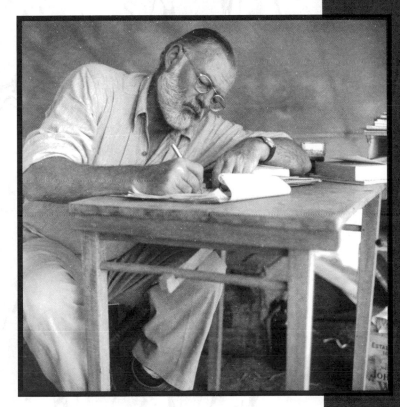

Opposite: Toni Morrison, in her New York apartment, 2008. Right: Ernest Hemingway working at a portable table while on a big game hunt in Kenya, 1952.

DONNA TARTT

Very nice clothes are not incompatible with the writer's profession in a way that they are for a painter or a dancer.

—Donna Tartt, "This Much I Know," *The Guardian*, 2003

In autumn 1992, a book called *The Secret History* was published by a fresh new writer. It arrived in a world where grunge fashion was about to go mainstream, but before Marc Jacobs launched the edgy spring 1993 collection that cost him his job at Perry Ellis. Heroin chic made the headlines. The world was tiring of supermodel Linda Evangelista and her $10,000-to-get-out-of-bed supermodel friends. Instead, the outsider was interesting, and what would become the fringe culture of the twenty-first century was falling into place.

Donna Tartt is an author whose strength lies in being outside the mainstream, yet she has still managed to have a massive audience. With that first novel, she tapped a cultural nerve and became a literary touchstone. Fast forward to today and she has published three amazing novels—all curious, strange, and formidable volumes. *The Little Friend*, published in 2002, tells the story of the death of a young girl's brother, and, as Tartt explained in an article in *The Guardian*, is a "scary book about children coming into contact with the world of adults in a very frightening way." *The Goldfinch*, from 2013, follows a boy's life

Opposite: Donna Tartt, 2014.

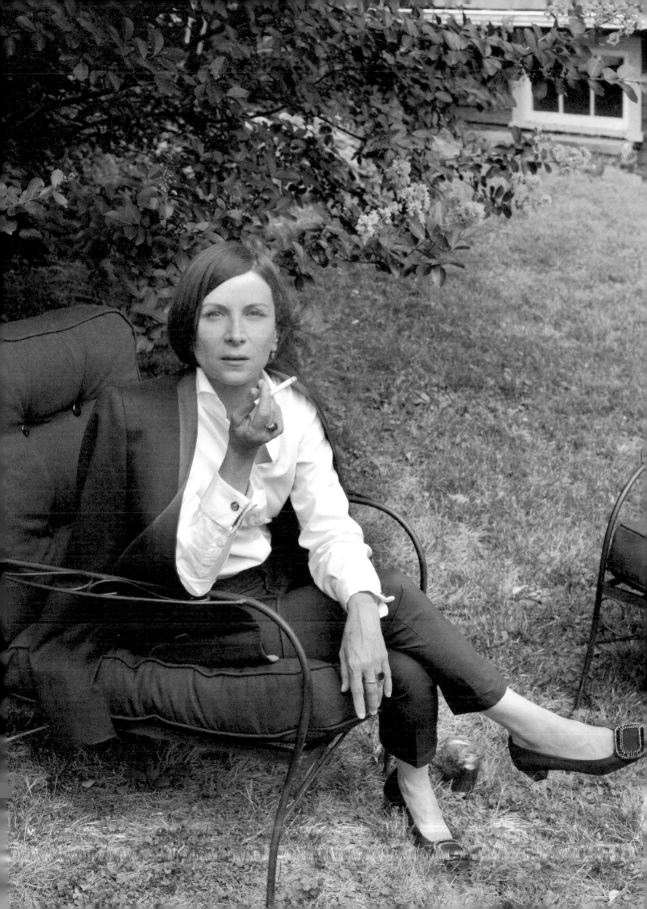

after his mother dies in the bombing of an art gallery. Bereavement, loss, and unexpected turns of existence are all examined in this opus that takes the reader on a journey determined in part by Tartt's favorite Carel Fabritius painting, for which the book is named. Her writing takes time—her novels are long—and the publication of her work has become an unusual treat.

Tartt's life has a magical narrative, too, and like most gorgeous fictional characters, her looks and fashion sense are intriguing. She resembles the actress Louise Brooks, the 1930s silver-screen flapper, and she has become known for her signature bobbed hair, à la Agatha Runcible, the giddy party girl in Evelyn Waugh's interwar novel, *Vile Bodies*. Although most recently Tartt has been seen sporting a slicked-back ponytail, there is still something unconventional and curious about her—the quirkiness is romantic, and her boyish styling

Bunny had an uncanny ability to ferret out topics of conversation that made his listener uneasy and to dwell upon them with ferocity once he had. In all the months I'd known him he'd never ceased to tease me, for instance, about that jacket I'd worn to lunch with him that first day, and about what he saw as my flimsy and tastelessly Californian style of dress. . . . Whenever Bunny, rudely and in public, accused me of wearing a shirt which contained a polyester blend, or remarked critically that my perfectly ordinary trousers, indistinguishable from his own, bore the taint of something he called a "Western cut," a large portion of the pleasure this sport afforded him was derived from his unerring and bloodhoundish sense that this, of all topics, was the one which made me most truly uncomfortable.

—Donna Tartt, *The Secret History*, 1992

I'd love to meet Oscar Wilde, because they all say he was so much more wonderful in person than on the page. From reading the journals of Tennessee Williams, I'm almost positive that if Tennessee and I had ever met, we would have been friends. And if it was a dinner date? Albert Camus. That trench coat! That cigarette! I think my French is good enough. We'd have a great time.

—Donna Tartt, "Donna Tartt: By the Book," from the *New York Times Book Review*, 2013

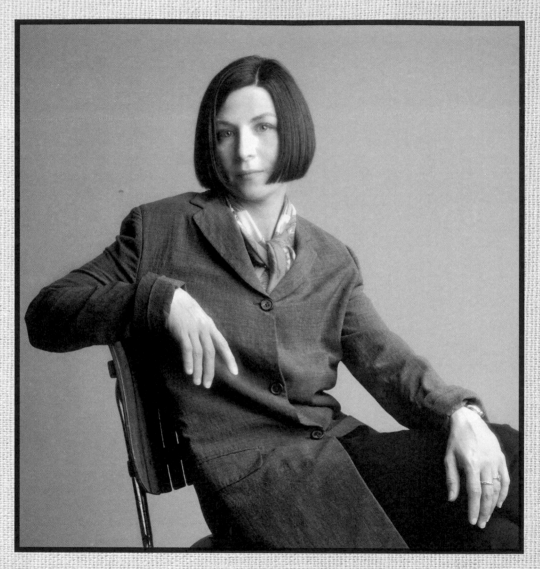

Donna Tartt, circa 2000.

> **I get very attached to coats because a coat is a comfort, you can curl up with it. I bought a beautiful cashmere coat about ten years ago and I love it. It's really like my security blanket.**

— Donna Tartt, "This Much I Know," 2003

popular. An androgynous, crisp white shirt, tailored jacket, and men's tie are staples she is comfortable with. In a 2002 interview with *The Telegraph*, she revealed, "I feel a real funniness about women's costume. To really put on high heels and a frilly dress, do you know what I'm saying? It seems kind of . . . comical." She likes to wear suits.

Tartt revealed in *Vanity Fair* in September 1992 that while she was a student at Miss Doty's Kindergarten for Girls, she decided she "should like to be an ar-chae-ologist." However, she opted to focus on writing as a freshman at the University of Mississippi after catching the eye of author Willie Morris, who told her she was a genius and went on to become her mentor. He advised her to transfer to Bennington College in Vermont, which she did, her sophomore year. It was there that she began to write her debut novel, *The Secret History*, although it ended up taking almost ten years to complete. *The Little Friend* and *The Goldfinch* followed at a slow pace, ten and twenty years later, respectively; all three books have been on bestseller lists. Today, Donna Tartt is one of the most successful contemporary writers. In *The Secret History*, clothes are wrapped up in class and can alienate. Tartt lucidly shares her finely tuned understanding of the power of clothes and the way they protect and reveal.

> Tartt is a fan of the pop groups Pulp and The White Stripes.
>
> Tartt's favorite childhood reads included *Peter Pan* and *Treasure Island*.

COLETTE

Extreme beauty arouses no sympathy.

—Colette, *The Last of Chéri*, 1926

Photographer Lee Miller's feature in a 1945 *Vogue* was head-lined: "Colette—France's greatest living writer." Miller talks about "Colette as Colette. Colette the siren, the gamin, the lady of fashion, the mother, the diplomat's wife, the author, the member of the Legion of Honor, of the Belgium Academy. Colette on top of the Chrysler building, in the St. Tropez barefoot sandals." The personas of Sidonie-Gabrielle Colette were myriad, but in all guises she was the personification of sultry, with kohl-rimmed eyes and an uninhibited disposition.

She was an untamed creature, and instinct drove her to write about the worlds she knew and the emotions of a woman as she knew them. For her, clothes were intrinsic to feeding and salving the psyche; they were dressing-up indulgences and a suggestion of the personality within. She used them to radiate character, both in her own life and in the lives of the characters she created in her writing. As a young bride at the turn of the century, Colette embodied the heroine of her *Claudine* novels, wearing a girlish sailor suit, ankle boots, and her hair in plaits that hung almost to her knees under a wide-brimmed

Opposite:
Colette, 1925.

114

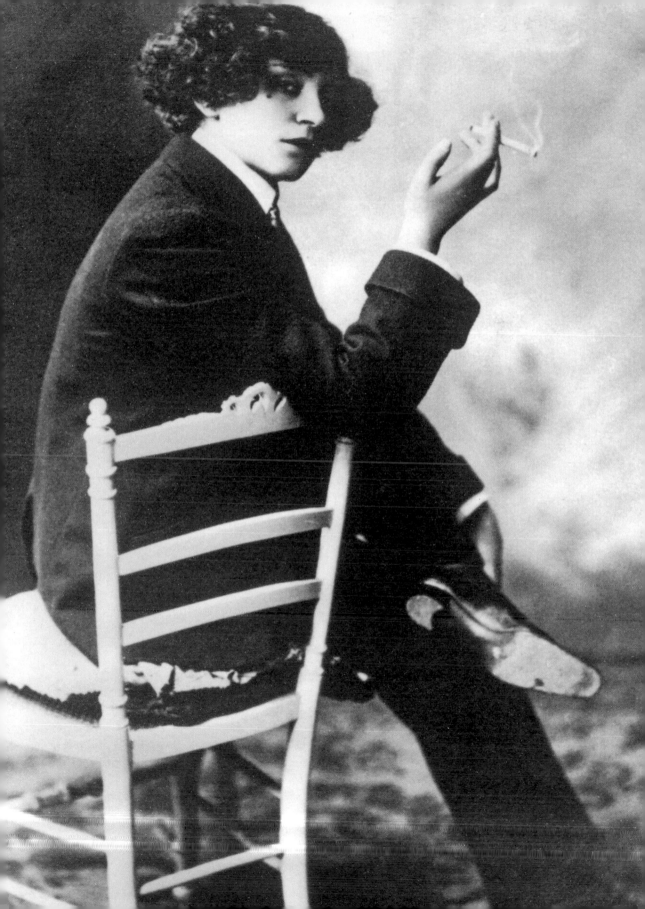

bonnet. When working in her music hall phase, she was photographed lazing on lion rugs, wearing tiger skins and an attitude. For her third wedding, to the French writer Maurice Goudeket, she wore Lucien Lelong bias-cut silk couture. As an eminent and revered novelist in her sixties, she wore busty, luxe pussy-bow silk shirts, velvet scarves, and bohemian layers—and always, always the signature kohl-rimmed eyes of her youth.

In 1925, in one of twelve articles she wrote for *Vogue Paris* (reprinted in 1958 in American *Vogue*), Colette celebrated the joy of dressing for an occasion and her disapproval of women who don't feel the need to change from day to theater or supper wear and instead want to look "just right" for every eventuality: "A few women, *soignée*, groomed, looked forward with pleasure to dressing again before dinner, after a day of running around. How many more of you, however, confine yourselves to repairing your faces in restaurant powder rooms? Then you partly open your coat, to reveal not only the ravages of the day, but a blouse of lamé? You fancy yourselves ready for the evening . . . Oh you elegant ones that expect me to congratulate you on your economy? Economy . . . peuh! Laziness!"

This reiterates the train of thought of the middle-aged courtesan, Léa, in Colette's novel *Chéri*, when she silently chastises Madame Peloux and her son (Léa's young lover), for unbuttoning and slacking off sartorially during a siesta in the heat: "As the afternoon became hotter, Madame Peloux pulled her narrow skirt up to her knees, displaying her tight little sailor's calves, and Chéri ripped off his tie—reproved by Léa in an audible 'Tch, tch.'" Léa is "disgusted" and reflects: "Never once had her young lover caught her untidily dressed, or with her blouse undone, or in her bedroom slippers during the day. 'Naked if need be, but squalid, never!'"

When Colette published her novella Mitsou in 1919, she received a note from an admiring Marcel Proust that read: "I wept a little this evening, which I have not done for a long while."

In March 1932, Colette opened a beauty salon called Société Colette. She was almost sixty years old and thought opening the shop might be a great way to meet her readers.

When she raises her
eyelids it's as if
she were taking off
her clothes.

—Colette, *Claudine and Annie*, 1903

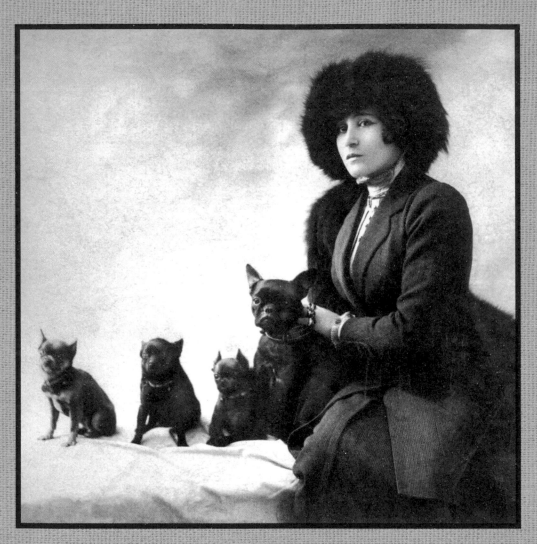

Colette, 1907.

Chéri is a story that explores the world of change, attraction, and age. It was published in 1920, but firmly set among the frills and thrills of the turn of the century. Fashion, dress sense, and the niceties of etiquette are used to pierce the consciousness of the period and grasp the complications of a shifting society. Fashions revolve, life goes on, and people adjust: "She watched the silhouettes of women passing on their way down to the Bois. 'So skirts are changing again,' Léa observed, 'and hats are higher.'" With a young man so much a part of her life, Léa spends time in reveries of growing old and all its considerations. Clothes are key: "'Beautiful,' Léa whispered on her way up to the boudoir, 'No. No longer have I now to wear something white near my face, and very pale pink underclothes and tea-gowns. Beautiful! Pish . . . I hardly need to be that any longer.'"

Colette ties the humor and sharp characterization in *Chéri* to what is worn, and her descriptions are both brutal and illuminating. Clothes reveal, conceal, and declare all the way through Colette's writing.

Perhaps seventy years of age, with the corpulence of a eunuch held in by stays, old Lili was usually referred to as "passing all bounds," without these "bounds" being defined. . . . Old Lili followed the fashion to an outrageous degree. A striking blue-and-white striped skirt held in the lower part of her body, and a little blue jersey gaped over her skinny bosom crinkled like the wattles of a turkey-cock; a silver fox failed to conceal the neck, which was the shape of a flower-pot and the size of a belly. It had engulfed the chin.

"It's terrifying," Léa thought. She was unable to tear her eyes away from details that were particularly sinister—a white sailor hat, for instance, girlishly perched on the back of a short-cut, strawberry-roan wig; or, again, a pearl necklace visible one moment and the next interred in a deep ravine which once had been termed a "collier de Vénus."
—Colette, *Chéri*, 1920

HUNTER S. THOMPSON

Play your own game, be your own man, and
don't ask anybody for a stamp of approval.

—Hunter S. Thompson, *Fear & Loathing in America*, 1971

Hunter S. Thompson's sizable persona—his essential joy-stalking soul, his delirious inimitability, and his forging, uncompromising texts—not only magnetized those he met, but has also fascinated and charmed kindred spirits the world over. The Hunter style and substance fueled not just a new way of first-person, subjectively written journalism. His approach to life and what he wore while living it has also become the stuff of legend.

Thompson reveled in his fun-filled life and had an equally screwball sartorial nature. Day to day, the six-foot-three Thompson's dress sense was more of a uniform—a uniform in which to attack and chase the day. Dark aviator shades, a khaki safari suit jacket, bold Hawaiian shirts, Converse sneakers, and very short shorts were typical Thompson wardrobe staples. The flourish of his clothes, cowboy hat, cigarette holder, and knee-high socks were as off the wall and unexpected as his performances in life with firearms: he very often autographed his books by shooting them with a gun.

Opposite:
Hunter S. Thompson
at his ranch near
Aspen, Colorado,
mid-1970s.

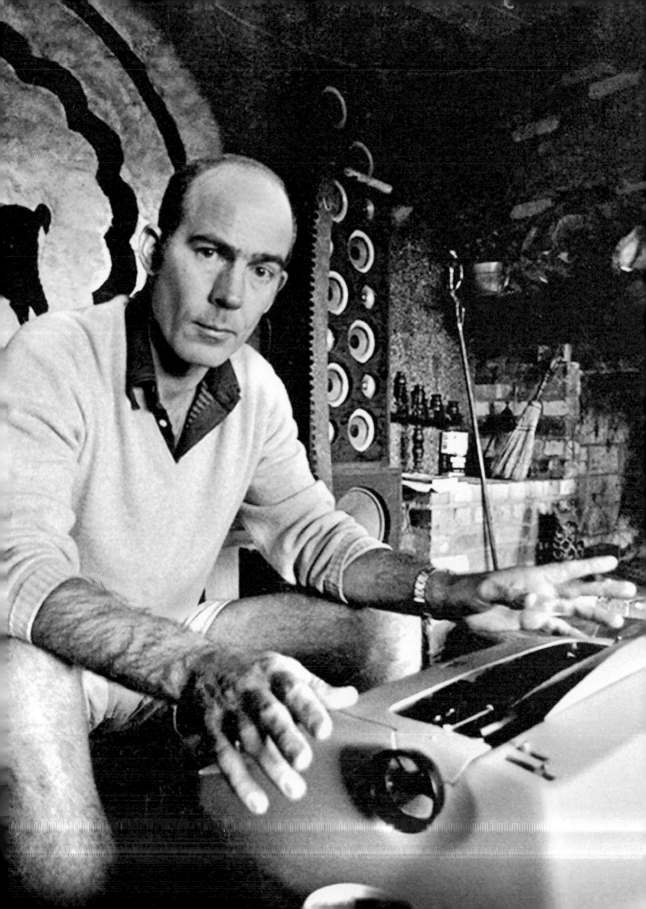

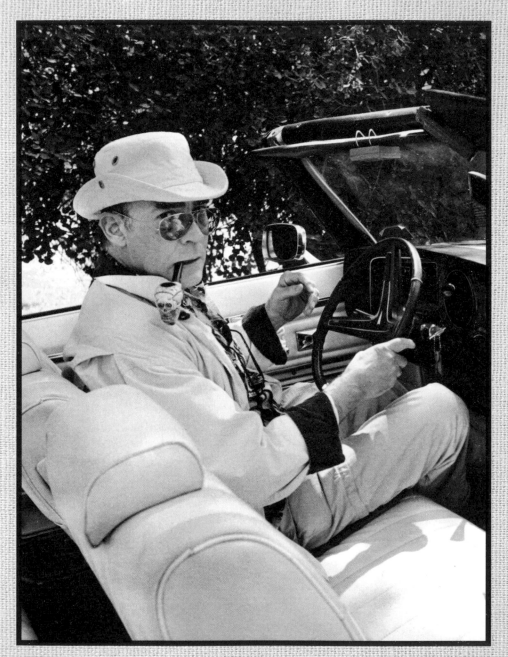

Hunter S. Thompson on the road, 1990.

As a freethinking radical, Thompson personified an outsider looking in on both counterculture and the mainstream. His sardonic and squinted view of the sixties and seventies has become synonymous with the eras. He covered Nixon's election, the Watergate scandal, and the Vietnam War; he wrote about hippies and the demise of the beatnik generation. In 1966 he published his first book, *Hell's Angels: A Strange and Terrible Saga.* Like his second book, *Fear and Loathing in Las Vegas,* his piece began as a feature for *The Nation* magazine, and after it appeared, Thompson was offered a deal to write something longer. He spent the next year living with and observing the Hells Angels he had met, and wrote afterward in the work: "I was no longer sure whether I was doing research on the Hells Angels or being slowly absorbed by them." He had spent time as a teenager typing up F. Scott Fitzgerald and Ernest Hemingway, in order to pick up the rhyme and reason of the greats, but while he was working on *Hell's Angels,* Thompson's unique style of writing kicked in. In his 2003 memoir, *Kingdom of Fear,* Thompson says he fit into a new lineage of author: "I wasn't trying to be an outlaw writer. I never heard of that term; somebody else made it up. But we were all outside the law: Kerouac, Miller, Burroughs, Ginsberg, Kesey; I didn't have a gauge as to who was the worst outlaw. I just recognized allies: my people."

Thompson owned a rescued coatimundi called Ace who learned to use the toilet and liked to play with soap.

One of Thompson's favorite books was *One Flew Over the Cuckoo's Nest* by Ken Kesey.

Thompson planned his own funeral and, before committing suicide in 2005, left a memo saying that his ashes should be launched into the sky via firework shells from the top of a clenched-fist monument he designed himself. The red, white, and blue blast can be seen on YouTube.

During the 1970s, Thompson often wore a combination of some of the following: very short shorts and sports socks, Converse All Stars, safari or bush hats, visors, aviator sunglasses, Hawaiian shirts, leather bracelets, and shark's-tooth necklaces, along with a cigarette holder and a gun as accessories. The fashion industry has embraced

these sartorial distinctions. Every so often, Thompson-style Gonzo gear emerges as a catwalk reference, with *Vogue* urging its readers to "embrace your inner Hunter." Designers harvest his style—in its 2016 spring collection, the British street wear label House of Holland dressed its models in Thompson's signature separates. Although it seems ludicrous that the identity of a Taser-toting bald guy should have sartorial sway in the twenty-first century, his uncoordinated clothing choices have nevertheless become criteria of cool.

California, Labor Day weekend . . . early, with ocean fog still in the streets, outlaw motorcyclists wearing chains, shades and greasy Levis roll out from damp garages, all-night diners and cast-off one-night pads in Frisco, Hollywood, Berdoo and East Oakland, heading for the Monterey peninsula, north of Big Sur . . . The Menace is loose again, the Hell's Angels, the hundred-carat headline, running fast and loud on the early morning freeway, low in the saddle, nobody smiles, jamming crazy through traffic and ninety miles an hour down the center stripe, missing by inches . . . like Genghis Khan on an iron horse, a monster steed with a fiery anus, flat out through the eye of a beer can and up your daughter's leg with no quarter asked and none given; show the squares some class, give em a whiff of those kicks they'll never know

—Hunter S. Thompson, *Hell's Angels*, 1966

Everybody is looking for someone who can stand up in the wind. It is lonely standing up and crowded lying down. I refuse to be an anchor for other people's dreams—but then I refuse to anchor mine to anyone else. So I have no choice but to stand up and piss into the wind.

—Hunter S. Thompson, *The Proud Highway*, 1994

DOROTHY PARKER

Gingham's for the plighted maid;
Satin's for the free!

—Dorothy Parker, "The Satin Dress," 1926

A Jazz Age writer, Dorothy Parker's work embodied her flapper contemporaries' disheveled and disordered last-days-of-Rome psyche. Parker proclaimed in the summer 1956 issue of the *Paris Review*: "Gertrude Stein did us the most harm when she said, 'You're all a lost generation.' That got around to certain people and we all said, 'Whee! We're lost.'" Dottie's way of dealing with life was to recognize the era's fear and flip it right around with a maiming comeback—shooting it down with a direct hit.

Parker's chic career—as a caption-, then features writer for *Vogue*, a theater reviewer for *Vanity Fair*, a staff writer at *The New Yorker*, and an author of short stories and poetry—was coupled with a stylish closet. At four feet eleven inches, Parker was tiny in heels, and always elegant with a tilted and trimmed hat. A woman of 1920s Manhattan, she dressed true to the smart set of the time: leopard-print-trimmed evening coats, felt cloche hats, clutch bags, and pearls. She wore her dark hair in a fluffy bob, and although she needed spectacles to work, she rarely wore them out of the office, as, of course, she remarked in

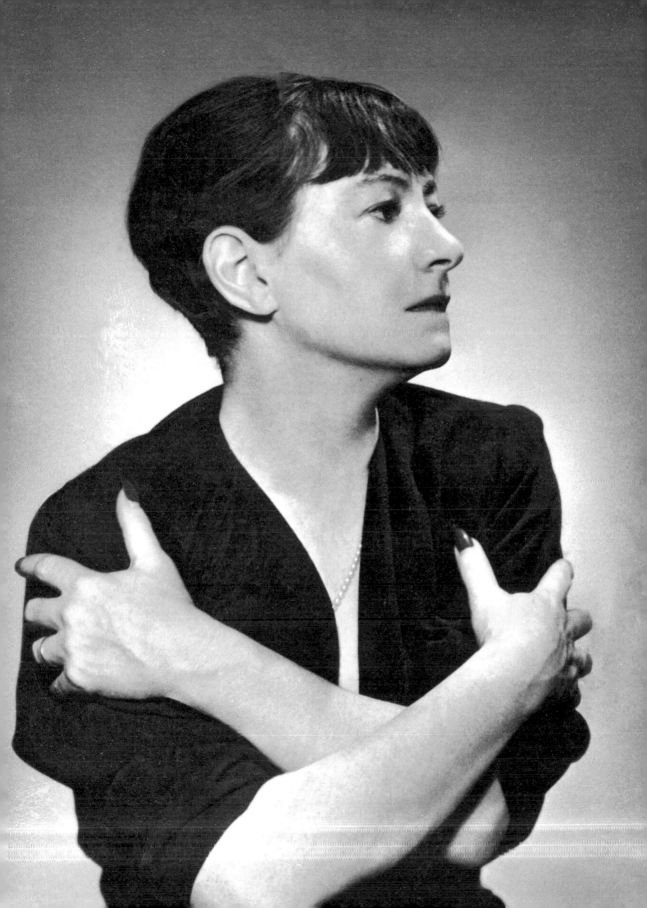

the *New York World* newspaper in 1925: "Men seldom make passes at girls who wear glasses." Parker had a keen eye for fashion, and while at *Vogue* she gave it her customary critical scrutiny, saying in the 1956 *Paris Review*: "Funny, they were plain women working at *Vogue*, not chic. They were decent, nice women—the nicest women I ever met—but they had no business on such a magazine. They wore funny little bonnets. . . . Now the editors are what they should be: all chic and worldly; most of the models are out of the mind of a Bram Stoker, and as for the caption-writers—my old job—they're recommending mink covers at seventy-five dollars apiece for the wooden ends of golf clubs '—for the friend who has everything.' Civilization is coming to an end, you understand."

Parker never graduated from high school.

Parker's first job in New York City was as a pianist for a dance school.

She was dismissive of her talents, and more eloquent and expressive than she ever gave herself credit for. In the *Paris Review* interview, she sadly reflected: "My verses are no damn good. Let's face it, honey, my verse is terribly dated—as anything once fashionable is dreadful now. I gave it up, knowing it wasn't getting any better, but nobody seemed to notice my magnificent gesture." But Parker's short stories mirror the bleak soul of New York in the 1920s and '30s: she tells tales of people spending days in delusional daydreams, who drink too much and suffer the indignities of racial prejudice.

Parker undertook to laugh at life, and she dealt with its absurdity with words. The desperate caller in "A Telephone Call" reprimands God, and the world at large, when she berates him, "You think you're frightening me with your hell, don't you? You think your hell is worse

Above:
Dorothy Parker,
mid-1930s.

than mine." Parker's hell was fresh: she attempted suicide twice, and died alone in New York, where she had lived at the Volney Hotel on the Upper East Side. She left her entire estate to Martin Luther King Jr. and the NAACP. It was only after she had been dead twenty-one years that a memorial garden was built in her honor in Baltimore at the NAACP's headquarters, dedicated with a stone that laconically reads: "For her epitaph she suggested: 'Excuse my dust.'"

Parker was also a famed regular at the Algonquin Round Table, meeting for lunch and verbal sparring with fellow literary associates such as George S. Kaufman and Robert E. Sherwood and occasionally the likes of Harpo Marx, Noël Coward, and Tallulah Bankhead. The daily ritual became famous nationwide, and Parker and her witticisms became legendary. In 1934 she married actor and screenwriter Alan Campbell and moved to Hollywood, where she worked on screenplays, including 1937's Oscar-nominated *A Star Is Born*.

Parker shot a scene with Alfred Hitchcock for the 1942 film *Saboteur*, but it was cut for another cameo featuring just the director. Parker did, however, get credit for helping to write the screenplay.

They looked alike, though the resemblance did not lie in their features. It was in the shape of their bodies, their movements, their style, and their adornments. Annabel and Midge did, and completely, all that young office workers are besought not to do. They painted their lips and their nails, they darkened their lashes and lightened their hair, and scent seemed to shimmer from them. They wore thin, bright dresses, tight over their breasts and high on their legs, and tilted slippers, fancifully strapped. They looked conspicuous and cheap and charming.

—Dorothy Parker, "The Standard of Living," 1941

QUENTIN CRISP

If I have any talent at all, it is not for doing but for being.

—Quentin Crisp, *The Naked Civil Servant*, 1968

Quentin Crisp's writing is a legacy of individualism. Of course he wrote about himself—his most significant books are memoirs that are master classes defining the art of the raconteur. Crisp was a cyclone that spins inward—constantly referring to and revealing a painstaking personality that spent years refining its core values. Crisp was unique in his dressing-up skills: what he wore bared his soul—authenticity was at the heart of his look.

Characteristic Crisp style is embodied by a fedora hat, a silky flowing scarf, a bouffant of dyed hair—red when young, blue as a "stately homo," as he described himself—and as much makeup as he could layer on. Completely bohemian with a tornado of a twist, Quentin made up dressing-up rules as he went along. Crisp insisted on recognition for what he was: an unashamed gay man. Born in 1908, when he was growing up in suburban England, homosexuality dared not speak its name, but Crisp put on his rouge, hennaed his hair, and brought it up in conversation whenever the opportunity arose.

Opposite:
Quentin Crisp,
London, 1981.

130

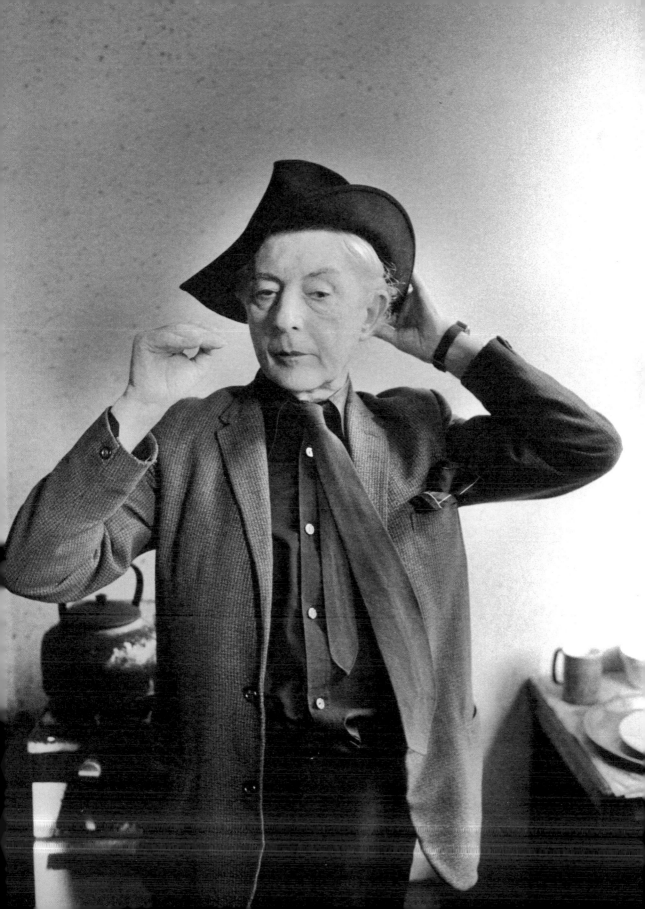

In the 1930s, Crisp spent his time in London working by day, at an electrical engineering workshop making technical drawings and as a commercial artist and, by night, writing in a studio apartment. By his own admission in his 1968 memoir, *The Naked Civil Servant*, he had "the airs and graces of a genius" but had yet to find his voice as a writer. Instead, he was more successful in grooming his appearance and indulging seriously in showing off. He wrote: "Exhibitionism is like a drug. Hooked in adolescence, I was now taking doses so massive that they would have killed a novice. Blind with mascara and dumb with lipstick, I paraded the dim streets of Pimlico with my overcoat wrapped round me as though it were a tailless ermine cape. I had to walk like a mummy leaving its tomb. . . . Sometimes I wore a fringe so deep that it completely obscured the way ahead. This hardly mattered. There were always others to look where I was going."

At age eighty-three, Crisp played the part of Elizabeth I in the 1992 film *Orlando*.

Crisp always listed his home telephone number, and often encouraged strangers to call him. He always spoke to callers and would go to dinner with them if asked.

By the time World War II began, he had mastered the art of cutting and pasting his wardrobe to fit the one-off character he had become. He explains in *The Naked Civil Servant*: "In the matter of clothes, I was supported entirely by voluntary contributions, like a hospital, and when introduced to anyone . . . I always looked at their feet to see if they were as small as mine. I hoped their cast-off footwear might be given to me. The trouble with shoes is that they are unalterable . . . I could at any time enlist the services of a certain Mrs. Markham, known throughout Soho as the greatest trouser-taperer in the world. Thus the need to visit men's-wear shops had been almost totally eliminated."

Crisp's feminized style was unique. He wore clothes that twirled around him, edifying his public on the ambiguities of identity. But his intention was not to be taken for a woman, but rather to tread his own inimitable path. In fact, drag bored Crisp. In his memoir, he recounts the story of trying it on for size: "Once, when I lived in Baron's Court, I traveled by Underground to Piccadilly Circus wearing a black silk

Style is not the man;
it is something better.
It is a dizzy, dazzling
structure that he erects
about himself using
as building materials
selected elements from
his own character.

—Quentin Crisp, *How to Have a Lifestyle*, 1975

Quentin Crisp, circa 1970.

dress and some kind of velvet cape. I went to the Regent Palace Hotel, had a drink, and talked airily of this and that with my escort, who was, I think, in a dinner jacket. Then I returned home. The evening was a triumph, in that it was boring; nothing happened. Since then I have never worn drag. Its only effect on me is to make me look less feminine. In women's clothes even a faint Adam's apple, even slightly bony insteps, are harshly conspicuous."

Crisp understood the nuances and code of clothes scrupulously. In 1930s and 1940s England, mainstream menswear was most categorically on the straight and narrow, which of course made Crisp's wardrobe adventures even more stunning. Even the wrong footwear cast aspersions on an individual's worth, as he described in *The Naked Civil Servant*: "To wear suede shoes was to be under suspicion. Anyone who had hair rather than bristle at the back of his neck was thought to be an artist, a foreigner or worse." Crisp also recollects in this memoir "a friend of mine . . . says that, when he was introduced to an elderly gentleman as an artist, the gentleman said, 'Oh, I know this young man is an artist. The other day I saw him in the street in a brown jacket.'"

Crisp moved to New York City when he was seventy-two. Despite never becoming a voice for gay rights, Quentin's decades' worth of style synchronizing has become an inspirational touchstone the world over. Crisp's life philosophy was enduring. In 1998 when he was ninety he said: "When you know who you are, you can do it, you can be it, you can be seen to be yourself. That's the point. You first have to find who you are. Then, you have to be it like mad."

JOAN DIDION

I write entirely to find out what I'm thinking,
what I'm looking at, what I see, and what it
means. What I want and what I fear.

—Joan Didion, "Why I Write," 1976

Joan Didion has told the world the story she wants to live by: she is a style hound who won a guest editorship at *Mademoiselle* in 1955, then spent ten years at *Vogue* after securing their notable student writing award, the Prix de Paris. She honed her eye for fashion at the magazine: "In an eight-line caption everything had to work, every word, every comma. It would end up being a *Vogue* caption, but on its own terms it had to work perfectly," she explained in an interview with the *Paris Review* in 1978.

Didion's style is celebrated worldwide. She was photographed as an icon by Juergen Teller for Céline's spring 2015 campaign; in 1989 she also took center stage in the Gap's Individuals of Style advertising billboards. She has been a regular in the pages of *Vogue*—wearing Armani in 2002 and talking about the nostalgia of clothes in a 2011 feature, in which she reminisces about the dress-up appeal of her mother's red-velvet, white-fur-collared Patou cape and the childhood

Opposite:
Joan Didion,
1977.

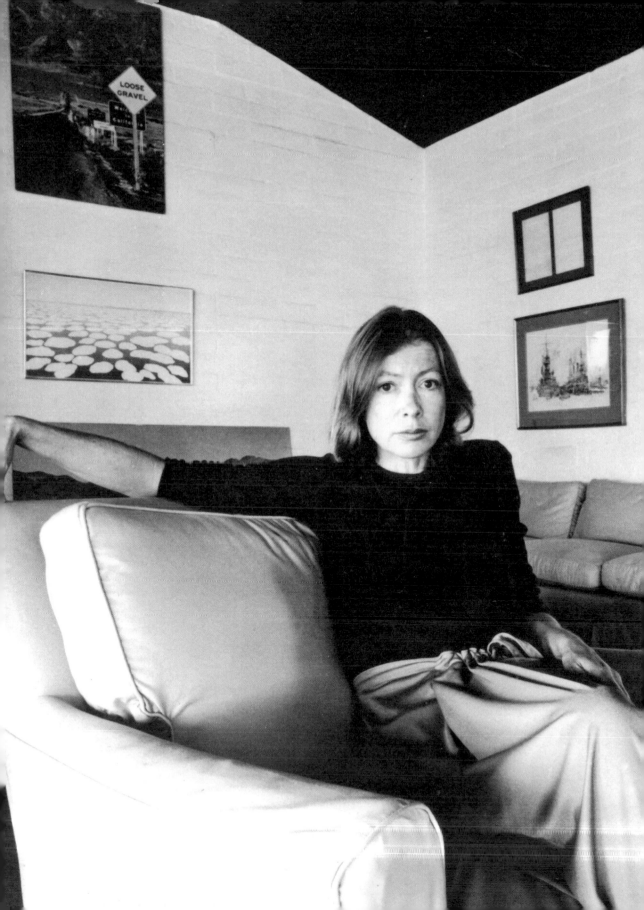

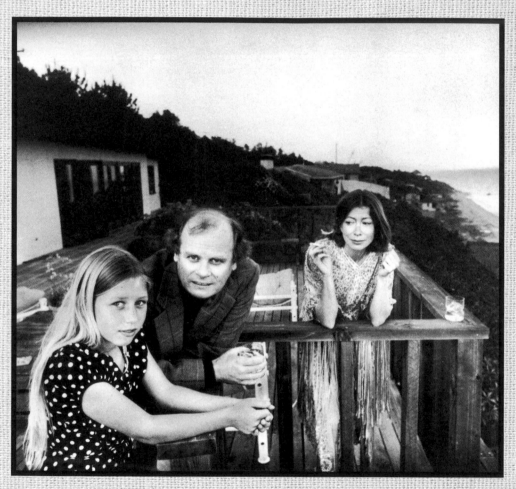

Joan Didion with her husband John Gregory Dunne and their daughter Quintana Roo Dunne on a deck overlooking the Pacific Ocean in Malibu, 1976.

fantasies she had of wearing a sable coat, dark glasses, and black silk mantilla. These fantasies have partly come true: "the dark glasses are now most definitely her trademark."

Casually cool sartorial savoir faire has always been Didion's byline. Her writing is infused with descriptive analyses of clothing as cultural consideration, and as the years rolled by, her essays have become templates of generational sensibilities. Time and again, she uses the narrative of dress as a structure to explore and examine. In her 1979 collection of essays, *The White Album*, she talks about her encounter with Manson Family member Linda Kasabian, and as a foil to the horror of the murders, Didion shares the story of buying her a dress to go to court in: "On July 27, 1970, I went to the Magnin-Hi Shop on the third floor of I. Magnin in Beverly Hills and selected, at Linda Kasabian's request, the dress in which she began her testimony about the murders at Sharon Tate Polanski's house on Cielo Drive. 'Size 9 Petite,' her instructions read. 'Mini but not extremely mini. In velvet if possible. Emerald green or gold. Or: A Mexican peasant-style dress, smocked or embroidered.' She needed a frock that morning because the district attorney, Vincent Bugliosi, had expressed doubts about the dress she had planned to wear, a long white homespun shift. 'Long is for evening,' he had advised Linda. Long was for evening and white was for brides. At her own wedding in 1965 Linda Kasabian had worn a white brocade suit."

When she was younger, Didion wanted to be an actress. She said later "I didn't realize then that it's the same impulse as writing. It's make-believe. . . . The only difference being that a writer can do it all alone."

In the late 1960s Didion had a dog she named Prince Albert.

Didion's 2005 memoir, *The Year of Magical Thinking*, written after the death of her husband, John Gregory Dunne, was sadly followed by a 2011 sequel, *Blue Nights*, in the wake of the passing of their daughter, Quintana Roo. It's a searching volume that takes the reader through the lawless emotions that materialize when a child dies. Again, Didion uses the metaphor of clothing as memory to fathom a dialogue she can delve into: "There is no drawer I can open without seeing something

I do not want, on reflection, to see. There is no closet I can open with room left for the clothes I might actually want to wear. In one closet that might otherwise be put to such use I see, instead, three old Burberry raincoats of John's, a suede jacket given to Quintana by the mother of her first boyfriend, and an angora cape, long since moth-eaten, given to my mother by my father not long after World War Two. . . . In theory these mementos serve to bring back the moment. In fact they serve only to make clear how inadequately I appreciated the moment when it was here."

With a typically easy, questioning line, Didion writes with an outsider's searching consideration of politics, popular culture, sound, and vision: her lucid discussions in print run from the "reverence for water" articulated in her 1979 essay, "Holy Water," for those who live in parched landscapes such as herself, at a home in Malibu; to the time she recounts in "The White Album" essay published in 1977 how Janis Joplin came to her house in Hollywood and "wanted brandy-and-Benedictine in a water tumbler. Music people," she reflected, "never wanted ordinary drinks." Didion intuitively details the disintegration of 1960s idealism and the bitter wariness of 1970s fallout. A 1972 *Vogue* spread shows Didion with her family near her home in California. She's wearing a maxi patchwork skirt and pigtails on the beach. Her stylish appeal is even stronger today—international fashion magazines run stories with outfits inspired by her flair and elegance. The Julian Wasser shoot of Didion smoking in front of her Corvette is seminal and a benchmark for serene, laid-back, and blasé poise. Who doesn't want hair like hers? Who doesn't want to be skinny and gorgeous like her? Who doesn't want her ethereal *Virgin Suicides*–like sensitivity and quirky intelligence? Even now, during her later years, Didion has got the package that the fashion industry craves and copies.

When Didion was working on a book, she would regularly sleep in the same room as her manuscript in order to feel closer to it.

We tell ourselves stories in order to live. . . . We live entirely, especially if we are writers, by the imposition of a narrative line upon disparate images, by the "ideas" with which we have learned to freeze the shifting phantasmagoria which is our actual experience.

—Joan Didion, "The White Album," 1979

VIRGINIA WOOLF

Vain trifles as they seem, clothes have, they say, more important offices than merely to keep us warm. They change our view of the world and the world's view of us.

—Virginia Woolf, *Orlando*, 1925

Virginia Woolf's writing often slipped in and out of the reality of the immediate world around her characters. She was a modernist author, alert to interior voice, which she assimilated into her novels with truth-telling literary evolution that was fresh and original. She explained and annotated her characters' thoughts with a fluent and eloquent logic. For a writer so attuned to stream-of-consciousness thought, she was at times petrified, absorbed, and careless of her own external appearance. It was an odd clash: to be so understanding and articulate with emotion and concept and yet personally shrink from the easy communication of clothes. They were, however, something that fascinated her.

Although she had her hair shingled, à la a flapper, in 1927, Woolf was usually to be seen with a Christina Rossetti–style bun tied messily at the nape of her neck. Long cardigans were a security for her and

Opposite:
Virginia Woolf,
1926.

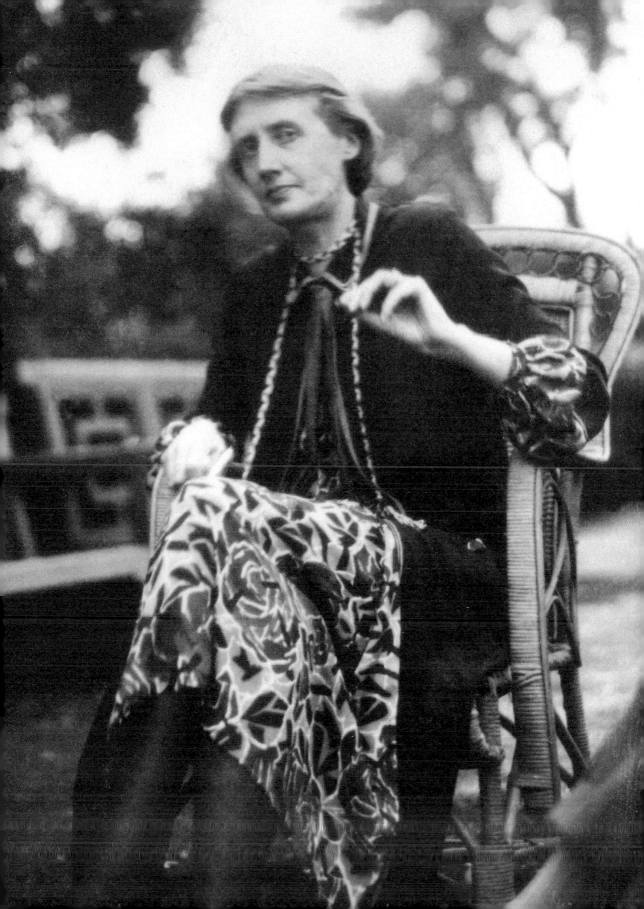

Now, where was her dress?

Her evening dresses hung in the cupboard.
Clarissa, plunging her hand into the softness,
gently detached the green dress and carried
it to the window. She had torn it. Someone had
trod on the skirt. She had felt it give at the
Embassy party at the top among the folds. By
artificial light the green shone, but lost its
color now in the sun. She would mend it. Her
maids had too much to do. She would wear it
tonight. She would take her silks, her scissors,
her—what was it?—her thimble, of course, down
into the drawing-room, for she must also write,
and see that things generally were more or less
in order. . . .

And then this dress of hers—where was the
tear? and now her needle to be threaded. This
was a favorite dress, one of Sally Parker's,
the last almost she ever made, alas, for Sally
had now retired, living at Ealing, and if ever
I have a moment, thought Clarissa (but never
would she have a moment any more), I shall go
and see her at Ealing. For she was a character,
thought Clarissa, a real artist. She thought of
little out-of-the-way things; yet her dresses
were never queer. You could wear them at
Hatfield; at Buckingham Palace. She had worn
them at Hatfield; at Buckingham Palace.

—Virginia Woolf, *Mrs. Dalloway*, 1925

became a signature, swathed around her shoulders. She epitomizes the look of the Bloomsbury set—uninhibited elegance that has become synonymous with a nonchalant, nonfussy, fluid approach to dressing. She mixed and matched sweaters and gardening skirts, printed tea dresses and fur shrugs, buckled shoes and shawls: an eccentric synthesis that preceded Prada's geek chic by seventy years or so. Her clever, idiosyncratic wardrobe suited her perfectly: graceful and willowy, her outfits hung naturally—she was a tall, birdlike creature with, Edith Sitwell observed, "thoughtful eyes." But however much Woolf acquiesced to the flowing charms of her intellectual dress, she was captivated by the lure of couture and the concept of fashion. According to *Recollections of Virginia Woolf by Her Contemporaries*, when the *Vogue* fashion editor, Madge Garland, first set eyes on Woolf she noted that "she appeared to be wearing an upturned wastepaper basket on her head. There sat this beautiful and distinguished woman wearing what could only be described as a wastepaper basket."

When Woolf was newly married to her husband, the writer Leonard Woolf, she mistakenly cooked her wedding ring into a suet pudding.

Woolf's nickname was Goat because she was playfully impish as a child. Her sister Vanessa Bell would send letters to her addressed to "Billy" (the goat).

In 1910 Woolf dressed up as a male member of the Ethiopian royalty and along with other members of the Bloomsbury set, hoaxed the Royal Navy into showing them around the *Dreadnought* battleship as visiting dignitaries.

Mrs. Dalloway, Woolf's fourth novel, published in 1925, is a literary tapestry of love, memory, and illness. Woolf deliberately uses the conduit of dress to symbolize moments in time and layers of experience. In a diary entry from the same year, she explained her approach: "My present reflection is that people have any number of states of consciousness: and I should like to investigate the party consciousness, the frock consciousness."

Woolf's "frock consciousness" method is a weaving thread throughout *Mrs. Dalloway* that sparks recall for Clarissa, who is giving a party. The plot takes place over the passage of a day and winds around the lives of the host with that of Septimus Smith,

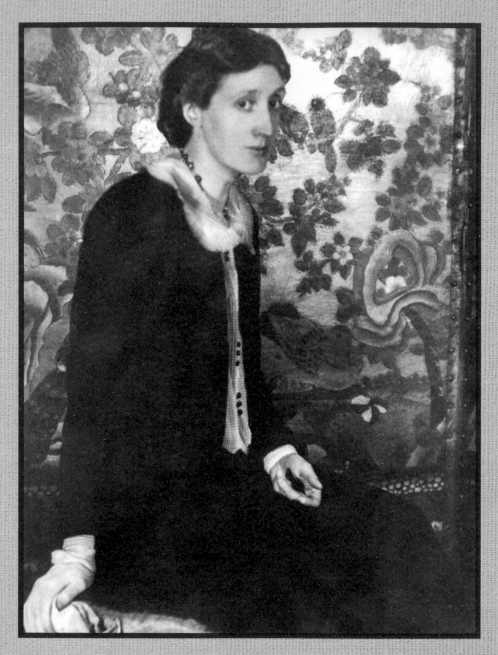

Virginia Woolf, 1930.

a World War I veteran suffering from shell shock. Mrs. Dalloway sits and mends her favorite green dress, memories drifting over her. She remembers moments that have come to define her and her present circumstances, and these moments hold her soul together.

Woolf wrote for *British Vogue* in the 1920s—at this time it was under the watch of its second-ever editor, Dorothy Todd. She had transformed it into a publication that offered an avant-garde twist to the world of women's magazines, featuring contributors such as Gertrude Stein and Parisian catwalk reports from the likes of novelist and philosopher Aldous Huxley. Todd asked Woolf to do a shoot for *Vogue* with their foremost photographers, Maurice Beck and Helen Macgregor, and she did so wearing her mother's Victorian dress. In typical Woolf style, it was both a cerebral and a sartorial statement. The dress did not fit well and was most definitely out of date—an unabashed remembrance of times past that flew in the face of fashion and invoked celebrated memories.

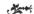

I must remember to write about my clothes next time I have an impulse to write. My love of clothes interests me profoundly: only it is not love; & what it is I must discover.

—Virginia Woolf, *The Diary of Virginia Woolf*, 1925

DJUNA BARNES

The unendurable is the beginning of the curve of joy.

—Djuna Barnes, *Nightwood*, 1936

Opposite: Djuna Barnes, 1921.

Djuna Barnes's early life was a cauldron of events that simmered and suckled her turbulent literary work. She was born in 1892 in a log cabin on Storm King Mountain in New York, overlooking the Hudson River. The poetry and rhythm of her life was encapsulated in this visceral starting place; her world was an uneven and testing environment, but it could be exhilarating and beautiful. Barnes's sinews of survival were stretched instinctively. At the age of five her difficult father, who was a prolific but unsuccessful composer and who rarely earned any money, moved his mistress into the family home. He refused to send Barnes and her eight siblings and stepsiblings to school. Instead, he educated them all himself, helped by Djuna's grandmother, Zadel, who was a writer, women's activist, and psychic medium. In her writing, Barnes expressed very little directly about her childhood—instead she provided shades and traces. More concretely, however, she told the novelist Emily Holmes Coleman that her father was "a horror of the first water, what a terrible man . . . Violence, fights and horror were all she knew in her childhood, no one loving her except her grandmother—whom she passionately loved."

Her father married her off to a much older man when she was sixteen. To escape, Barnes moved to Brooklyn with her mother, the violinist Elizabeth Chappell, and studied at the Pratt Institute for six months before leaving to work as a journalist in order to help with household finances. "You'd be foolish not to hire me," she professedly told the editor of the *Brooklyn Daily Eagle*—so they did, when she was twenty-one. Barnes's experiential approach to news writing went on to generate stories of odd originality, including a *New York World* magazine feature from 1914 called "The Girl and the Gorilla," in which she interviewed an ape at the zoo. "My Adventures Being Rescued," from the same year, recounted what it was like to be saved from a skyscraper.

Inspired by the Suffragettes in England, who went on hunger strikes to bring attention to their cause, Barnes wrote an article in 1914 for *New York World* magazine called "How It Feels to Be Forcibly Fed." She went through the agony of force-feeding to understand what it was like in order to complete the feature.

Barnes's aura and appearance mirrored her skillful and strange approach to writing. In and around the bohemian cafés of Greenwich Village in 1912, Elizabeth Wilson writes in *Adorned in Dreams* that Barnes was openly laughed at by children who stared in amazement at her striding about in her trademark black cape. Capes at the time were regularly featured in *Vogue* and a standard for fashionable women. However, it was the way Barnes wore them that counted: overtly masculine and with a flourish of poise and charisma—often topped off with an Alpine hat, trimmed with ribbon. Her effervescent-with-a-twist demeanor is described in a 1919 interview with Guido Bruno for *Pearson's* magazine: "Red cheeks. Auburn hair. Gray eyes, ever sparkling with delight and mischief. Fantastic earrings in her ears, picturesquely dressed, ever ready to live and to be merry: that's the real Djuna as she walks down Fifth Avenue or sips her black coffee, a cigarette in hand, in the Cafe Lafayette. Her morbidity is not a pose. It is as sincere as she is herself."

In Mary Lynn Broe's 1991 book, *Silence and Power: A Reevaluation of Djuna Barnes*, the pianist Chester Page remembers Barnes cutting a similarly magical dash on "a shopping trip to Altman's on Fifth Avenue,

Well, isn't Bohemia a
place where everyone
is as good as everyone
else—and must not a
waiter be a little less
than a waiter to be
a good Bohemian?

—Djuna Barnes, "Becoming Intimate with the Bohemians," 1916

Djuna Barnes, 1930s.

where she was an awe-inspiring figure with her cape and cane and regal posture." Like many fashionable inspirations, she found a look she liked and kept to it. Andrea Barnet notes in her book, *All-Night Party, The Women of Greenwich and Harlem, 1913–1930*, that the poet Mina Loy was also in awe of her friend Barnes's "supreme elegance of clothing." The friendship between the two modernists caught the eye of American artist Man Ray, who insisted on photographing the kindred spirits in 1920. They turned up for the picture in contrasting black and beige outfits, and, as Ray wrote in his 1963 memoir, *Self-Portrait*, they "posed as if the camera wasn't there." Barnes wore a high-collared cape shrugged onto her shoulders, a silk blouse, and a felt hat: effortlessly elegant. The photographer, Berenice Abbott, was Ray's assistant and was mentored by him; she went on to take many of the most illuminating images of Barnes. Her pictures show Barnes gracefully tranquil: dressed in tweeds and Lurex, polka dots and lipstick, she was the unflustered flip side to her raging and powerful prose.

E.E. Cummings was Barnes's next-door neighbor when she lived at Patchin Place in Greenwich Village. She lived at number five and he lived at number four. Cummings had a house there from 1923–1982 and Barnes from 1940–1982. Over the years, many writers have lived at Patchin Place, including Theodore Dreiser and John Cowper Powys.

Her 1936 novel, *Nightwood*, is about the desperate and hopeless, and Barnes makes their conditions so real and immersive that it's tricky not to be convinced by their bleak evaluation of life. The character Dr. Matthew O'Connor has a diagnostic perception of the world that is both creepy and compelling. He is a seer of the underworld, making sense and nonsense of the creatures he encounters. The novel breezes easily through a realm where unapologetic homosexuality is a fact of life and shifted souls meet and greet the siren call of 1920s Paris with coolly open arms. Trapeze artists, bogus barons and duchesses, bearded ladies, and left children weave in and out of Barnes's tale. T. S. Eliot compared the work to an Elizabethan tragedy, but *Nightwood* endures as a modernist collage of thoughts and personalities that search and find as many questions as answers to the dilemma of being alive.

ZADIE SMITH

The greatest lie ever told about love is that it sets you free.

—Zadie Smith, *On Beauty*, 2005

Tweeds, turbans, bangles, braids, Miu Miu, Marni, Céline: Zadie Smith has a savvy and street-wise sensibility when it comes to clothes. She's the Kate Moss of literature. She mixes and matches, throws an unexpected wardrobe together, and manifests effortlessly as an original. She's beautiful and has freckles. She wears stern glasses and glittery Louboutin heels. Fusing the different and disobeying the rules is the essence of the underground: British style magazines including *i-D* and *Dazed and Confused* have built up trendy territories in the same way.

Smith has been appropriated by the media as an empowering fashion icon, but in interview after interview she makes no bones about her lack of love for a system that can divide and cause disaffection. She has said that she "grew up with a mother with no interest in any of that—makeup, magazines, anything—and I was really happy. So my feeling is, to be honest, I don't really want to be in those magazines. I don't really like those magazines. And I know it's a matter of representation and it's meant to be equality, but do you want to be equal with something that makes so many people miserable?"

Opposite:
Zadie Smith photographed for American *Vogue*, 2016.

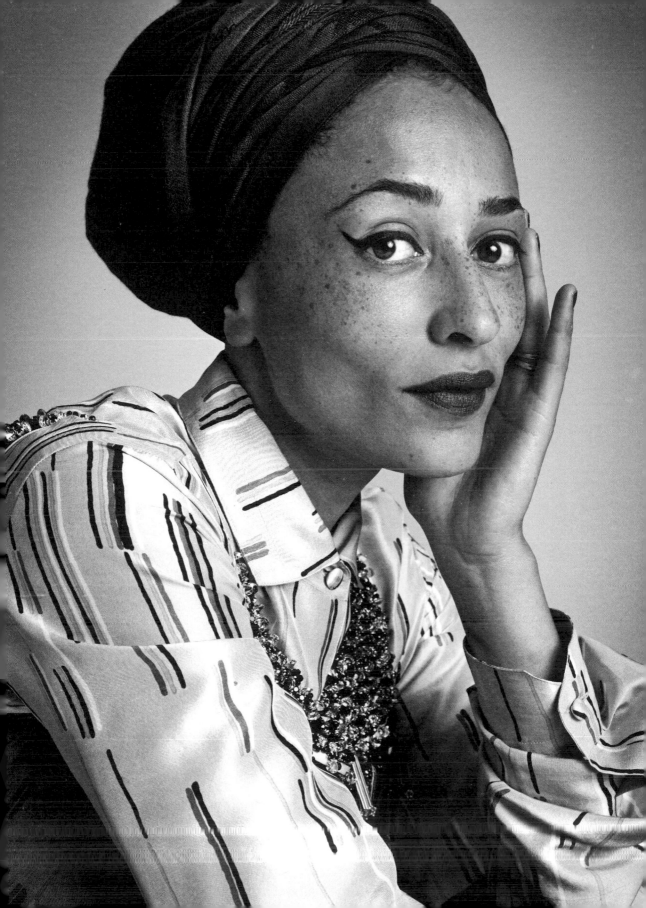

Whether she likes it or not, though, Smith is a favored member of the style literati of *Vogue*, in the front row at Stella McCartney launches, applauded by *Vanity Fair*, and at the top of its best-dressed list. The Smith dichotomy means that despite a dressing room full of designer clothing, she also loves non-designer, cheap, and cheerful fast

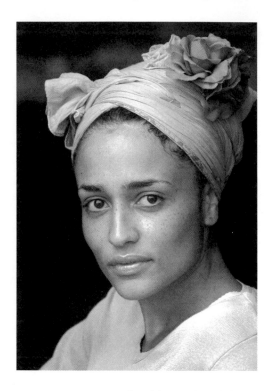

fashion from chain stores such as Top Shop, H&M, or Zara found on High Street in London. She firmly insisted, in a 2013 interview in *The Rumpus*, "I have a deep love for High Street clothes, that's what I grew up on. My mother always said I make expensive clothes look cheap and cheap clothes look expensive. And that's true . . . but there's something about High Street clothes, I don't know, I really like them." As if to prove her point, a vibrant celebration spread of the "aloha" vibe in *Vogue* featured celebrities including Nicole Kidman wearing Prada, Rihanna in Dior, and Naomi Watts in Michael Kors—and alongside them on a red carpet was Zadie, in a floral Hawaiian-print green ASOS dress, accessorized with a gold belt, gold shoes, and red lipstick. ASOS is a UK-based online site that sells chain-store chic—technically a little less upscale than the couturelike megafrocks the rest of the celebrities were wearing, but still cool enough to have made the final edit.

Smith's dress sense may be unengineered and intuitive, but it is exactly this kind of sartorial quirkiness that serves the imagination of designers and creators, who are often inspired by another way of looking at the world. Maturing in public with the spotlight on you can be difficult, but Smith's colorful engagement with clothes has sustained interest almost as much as her writing has. She admitted in the 2013 *Rumpus* interview, "As you become old . . . you appreciate the idea of

a beautiful fabric or a nice dress. I never cared about those things when I was young."

Since the publication of her first novel, *White Teeth*, Smith has won more than twenty acclaimed literary trophies, including the Man Booker Prize, the Orange Prize, and the Somerset Maugham Award, for her catalog of four books, a novella, short stories, and a 2009 compendium of essays titled *Changing My Mind*. With both words and style, Smith is able to spike modern culture in a convex way, and her thoughts are copious, comedic, and contemporary. She looks fabulous wearing a "black nerd" seventies tanktop, a Billie Holiday flower in her hair, or a vintage Land Girl army shirtdress. She is a twenty-first-century compound who sees and writes and absorbs the nuance of the recent past and present, just like her wardrobe does.

The book that inspired Smith to become a writer was *George's Marvelous Medicine* by Roald Dahl.

While at the University of Cambridge, Smith sang regularly at a jazz club.

❦

"Right. I look fine. Except I don't," said Zora, tugging sadly at her man's nightshirt. This was why Kiki had dreaded having girls: she knew she wouldn't be able to protect them from self-disgust. To that end she had tried banning television in the early years, and never had a lipstick or a woman's magazine crossed the threshold of the Belsey home to Kiki's knowledge, but these and other precautionary measures had made no difference. It was in the air, or so it seemed to Kiki, this hatred of women and their bodies—it seeped in with every draught in the house; people brought it home on their shoes, they breathed it in off their newspapers. There was no way to control it.

—Zadie Smith, *On Beauty*, 2005

OSCAR WILDE

Fashion is what one wears oneself. What is
unfashionable is what other people wear.

—Oscar Wilde, *An Ideal Husband*, 1895

Oscar Wilde had an appetite for beauty that almost literally killed him. Lord Alfred Douglas was the apple of his eye, but it turned sour; at the turn of the twentieth century, their relationship was enough to send Wilde to prison and perpetuate the disintegration of his life and livelihood. Wilde's wretched end, destitute in Paris—"dying beyond his means"—was hardly a fitting finale for the flamboyant Irish writer and poet who urged in his 1890 novel *The Picture of Dorian Gray*, "Live! Live the wonderful life that is in you! Let nothing be lost upon you. Be always searching for new sensations. Be afraid of nothing."

Heedlessly and hedonistically, Wilde embraced life. He was smart, and for a time there was equilibrium when the planet understood him—velvet cape, breeches, sunflowers, silk stockings, and all. He was open-minded and found beauty without cliché in the most unexpected of places; it was this originality that meant, for a time, that he was applauded and audiences found magic in the themes he discussed.

His attitude toward clothing was essentially more pragmatic than history suggests. For Wilde it was never simply a pose, but rather born

Opposite:
Oscar Wilde,
1882.

158

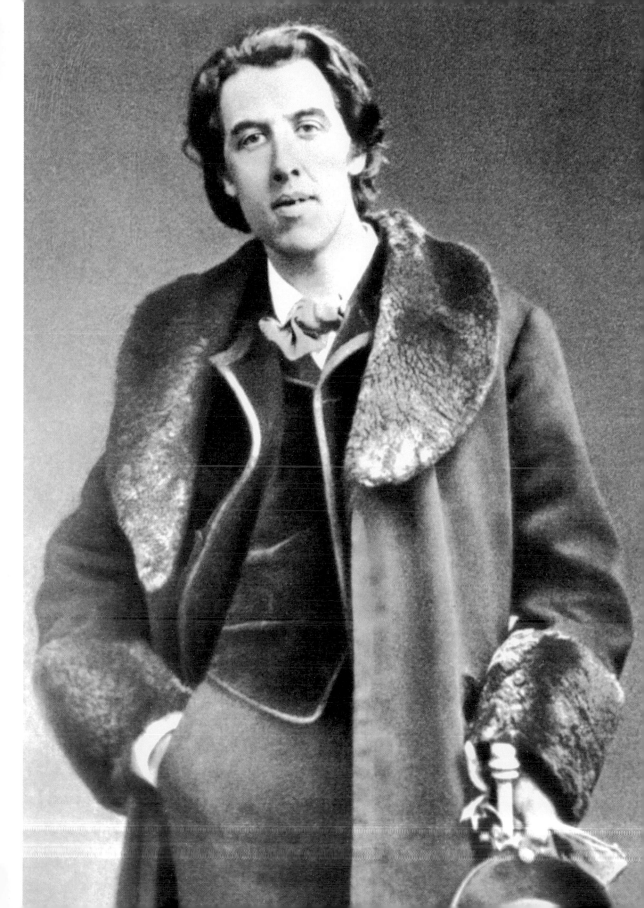

from a deliberated viewpoint. "The beauty of a dress," he said in his essay "The Philosophy of Dress," published in the *New York Tribune* in 1885, "depends entirely and absolutely on the loveliness it shields, and on the freedom and motion that it does not impede." He was never a slave to fashion, and one of his most famous quotes, again from the *Tribune* essay, underlines his wardrobe-wise way of thinking: "Fashion is ephemeral. Art is eternal. Indeed what is a fashion really? A fashion is merely a form of ugliness so absolutely unbearable that we have to alter it every six months!"

Wilde was a member of the Rational Dress Society, which saw no value in the corsetry and bustles of Victorian England. They asserted that clothing should marry practicality and beauty, and the association fought to release women from the restrictions of the flounces and furbelows of the belle epoque. In the same essay Wilde maintains: "A well-made dress is a simple dress that hangs from the shoulders, that takes its shape from the figure and its folds from the movements of the girl who wears it . . . a badly made dress is an elaborate structure of heterogeneous materials, which having been first cut to pieces with the shears, and then sewn together by the machine, are ultimately so covered with frills and bows and flounces as to become execrable to look at, expensive to pay for, and absolutely useless to wear."

Before his death at L'Hotel in Paris's St.-Germain-des-Prés area, Wilde reportedly said: "This wallpaper and I are fighting a duel to the death. Either it goes or I do."

Wilde always lied about his age, even on his marriage certificate in 1884—he is listed as being twenty-eight, two years younger than he actually was.

Wilde was a heartfelt intellectual, and this, combined with a first-class education at Trinity College Dublin and Oxford, enabled him to articulate with precision an artistic and profound vision, through a body of poetry and words. His dress sense was an extension of his life flow, and as natural as his ability to entertain at the dinner table. For a time, he was the doyen of the Aesthetic movement, known in London society as a wit and an entertaining connoisseur of life. He was friends with Lillie Langtry, the mistress of Albert Edward, the prince

It is absurd to divide
people into good and bad.
People are either charming
or tedious.

—Oscar Wilde, *Lady Windermere's Fan*, 1892

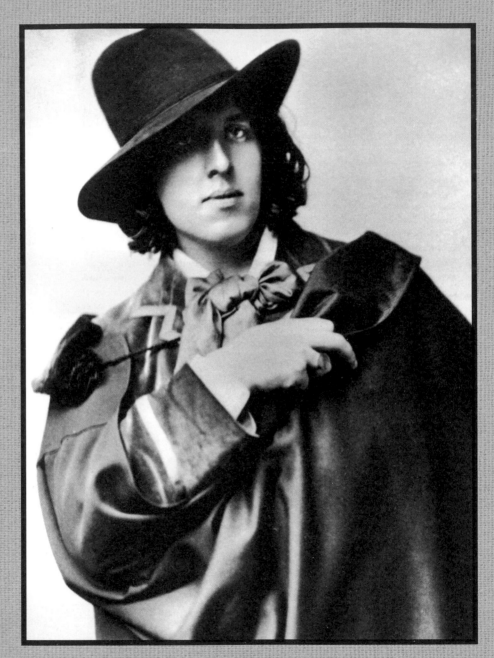

Oscar Wilde, circa 1880.

of Wales, and one evening in the 1870s the prince invited himself to a séance at Wilde's house, allegedly with the excuse: "I do not know Mr. Wilde, and not to know Mr. Wilde is not to be known."

The Aesthetic movement he embodied believed in free, unbound expression and revered organic, natural beauty, and Wilde practiced thoroughly what he preached. In the preface to his novel, *Dorian Gray*, he wrote: "Those who find ugly meanings in beautiful things are corrupt without being charming. This is a fault. Those who find beautiful meanings in beautiful things are the cultivated. For these there is hope."

In 1882, Wilde reached the high point of his love affair with Aesthetic fashion with the clothing he wore on a trip to America. An 1882 article, "Ten Minutes with a Poet," in the *New York Times* described in detail Wilde's lavish costume: "He wore a low-necked white shirt, with a turn-down collar of extraordinary size, and a large light-blue silk neck scarf. His hands were in the pockets of his fur-lined ulster, and a turban was perched on his head. He wore pantaloons of light color, and patent leather shoes. . . . The only jewelry displayed by him was a seal ring on a finger of his left hand." The Wildean style was a talking point decades after his death.

No one appreciates more fully than I do, the value and importance of Dress, in its relation to good taste and good health.

—Oscar Wilde, from *Constance: The Tragic and Scandalous Life of Mrs. Oscar Wilde*, by Franny Moyle, 2012

SIGNATURE LOOKS
HATS

Hats equal suave. They are debonair in a way that no other fashion piece can aspire to. Completely unnecessary but with a je-ne-sais-quoi all of their own, hats guarantee an entrance the way only a red carpet can. As a signature style they are really something special and these authors' headgear trumps all.

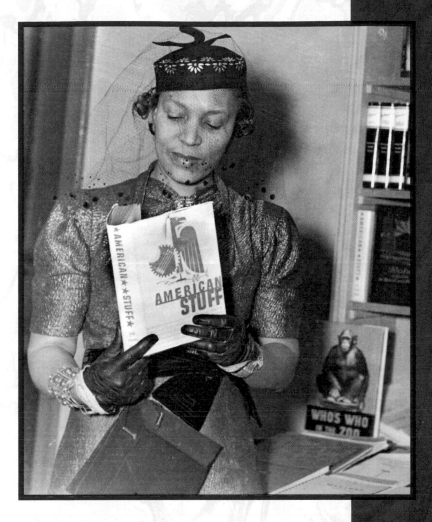

ZORA NEALE HURSTON

The fashion styling of Zora Neale Hurston, the feminist voice of the Harlem Renaissance, was synonymous with a hat. In the 1920s, as a young girl, she didn't just stick to flapper cloches. She wore ribboned garden hats decorated with a feather and brimless toques pulled low. The author of the hugely successful autobiography *Dust Tracks on a Road* and novel *Their Eyes Were Watching God*, among others, didn't feel dressed without a hat. Although that was part of the era she lived in, her elegant fanfare for headwear more uniquely mirrored her polished charisma.

Above:
Zora Neale Hurston,
New York City, 1937.

EDITH WHARTON

Edith Wharton, author of thirty-eight books, was born on West Twenty-Third Street in New York City, in 1862. She lived the life of an aristocrat and wore hats befitting her status in life. At the end of the nineteenth century, hats were ever-growing piles of feather and trim. In her novel *The House of Mirth*, Wharton talks about "sallow-faced girls dressed in preposterous hats." However, Wharton's own hat-wearing was of the most tasteful and genteel kind. Beautifully made bonnets by expert milliners adorned her every outfit. Wharton knew how to dress to impress: she was not nouveau riche.

SAUL BELLOW

Saul Bellow's fantastic panache as a writer was always mirrored in the way he wore a hat. He wrote in his 1956 novel, *Seize the Day*, that "when a man is smoking a cigar, wearing a hat, he has an advantage; it is harder to find out how he feels." Hats weren't a disguise for Bellow, though: they were the icing on the cake of a man who lived and wrote about the pageant of existence. He usually wore an Italian Borsalino fedora and, more often than not, a bespoke suit to match. He didn't care if he looked overly flamboyant or even a little bit like a gangster. He wore it easily and with just a tiny saunter. When he collected his Nobel Prize he wore a top hat, and in his later years, in his own inimitable style, took to wearing all-American baseball caps from time to time.

TRUMAN CAPOTE

Nicknamed a "pocket Merlin" by his friend Harper Lee, who based her *To Kill a Mockingbird* character Dill on him, Truman Capote had a magical taste in hats. Fully grown at 5 feet 3 inches, he was an iconic figure with a wide social circle and many parties to which he could wear his glamorous headwear. These included the bash of the century, his Black and White Ball, held in New York in 1966. On a day-to-day basis, Capote's favored shape was the louche fedora, but as a handsome young man he loved wearing sailor hats askew. He revealed he wrote only in longhand and only while lying down, preferably while drinking tea or sherry and smoking a cigarette.

Opposite, top: Edith Wharton at her home in Pavillon, Colombes, France, with her two Pekingese, 1920s. Opposite, bottom: Saul Bellow, mid-1970s. Right: Truman Capote, date unknown.

WILLIAM S. BURROUGHS

You can't fake quality any more than you
can fake a good meal.

—William S. Burroughs, *The Western Lands*, 1987

William S. Burroughs is the original beatnik and king of the underground. Patti Smith called him the godfather of punk, while for Kurt Cobain he was a grunge muse. Today's Generation Z might consider him the Daddy-O of normcore, though, and when you look at the "junkie gentleman," he is undoubtedly a conservative picture to behold. Typically Burroughs wore a three-piece suit, shirt, tie, and fedora hat, and occasionally a trench coat when the weather demanded it. In his *Telegraph* obituary, he is referred to as a "Giacometti sculpture in a demob suit." He's especially known for the fedora, and it has become sewn into the signature of Burroughs's personal panache. It was a piece of headwear that respectable men in the 1940s put on as a matter of course: nothing out of the ordinary. But Burroughs put one on and decided to work it throughout the decades: biker jackets and denim in the 1950s or loon pants and tie-dye in the 1960s were not for him. He was a maverick sartorially—he refused to follow fashion, and his ideas, writings, and design for life inspired and subverted style on the street and stirred those in the know.

Opposite:
William S. Burroughs
at his desk, 1959.

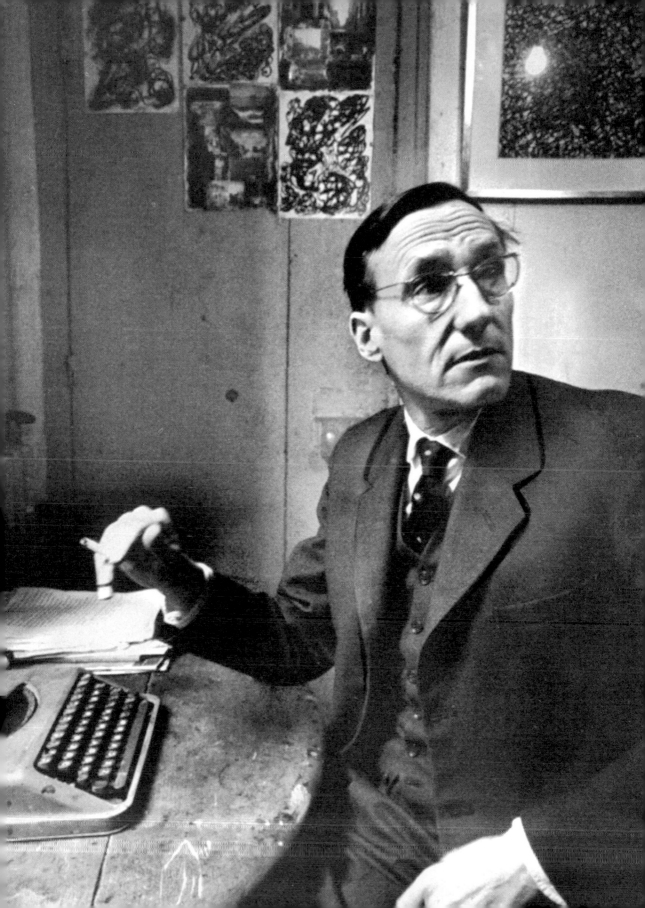

In director Howard Brookner's 1983 film, *Burroughs: The Movie*, wardrobe traditionalist Burroughs admits to a phase of dressing up in drag as an "old lesbian" while playing charades with Allen Ginsberg— his dress sense was informed by Edith Sitwell's Plantagenet look. This was back when the cult of beatnik was getting baptized in the early 1940s. Burroughs's daywear, however, was always suit and tie, and although it conflicted with his on-the-edge lifestyle, it was a perfect fit. While he was hanging out in South America in the mid-fifties, local kids used to call Burroughs "el hombre invisible." The name worked for him. He wanted to assimilate; he didn't want to attract attention when all the while he was shooting heroin and guns.

Kurt Cobain asked Burroughs to appear in the video for Nirvana's "Heart-Shaped Box." Cobain wanted him to play Jesus, but Burroughs refused the invitation.

As a young man, Burroughs enjoyed listening to Viennese waltzes and Louis Armstrong.

Before moving to New York, Burroughs worked as an exterminator in Chicago.

Interviewed for a Burroughs exhibition at the Lawrence Arts Center in Kansas in 2013, John Waters said of him: "He branded himself; he always had that look. He kept one look all his life, which is very important to do. He was gay and a junkie and he *didn't* look the parts. . . . Everybody read his books, especially when you're a young kid trying to rebel. . . . As a young gay man I thought, '*Finally*, a gay man who isn't square.' That was very influential, to realize that there really was a bohemia. Didn't matter if you were gay or straight. I just wanted to be in Bohemia, because I lived in Lutherville, Maryland, then. Burroughs was my imaginary friend."

Burroughs has not just been an imaginary friend to disenfranchised youth. He also gave a voice to the counterculture, when it needed someone to articulate its ideals. With his writing and words, Burroughs defined and gave insight into new-age cultural shifts and recalibrated the mind-sets of a generation. To many today, Burroughs was the man who prophesied, through his slash-and-paste word sequences, the oppressiveness and out-of-control consumerism of the twenty-first century.

Burroughs was born in 1914 in St. Louis, Missouri. He wrote from an early age, but it wasn't until 1951, when he accidentally killed his wife, Joan Vollmer, during a drunken game with a gun, that he believed his writing became a soul-searching release. In *Conversations with William S. Burroughs*, he is quoted as having said: "I am forced to the appalling conclusion that I would never have become a writer but for Joan's death, and to a realization of the extent to which this event has motivated and formulated my writing. I live with the constant threat of possession, and a constant need to escape from possession, from control. So the death of Joan brought me in contact with the invader, the Ugly Spirit, and maneuvered me into a lifelong struggle in which I have had no choice except to write my way out." The "word hoard" he had been penning while drifting, taking drugs, and

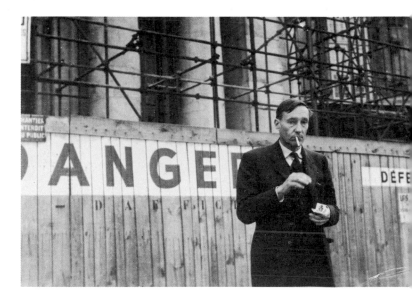

Above:
William S. Burroughs
in France, 1964.

living in Paris and South America was reassembled with the help of Allen Ginsberg and Jack Kerouac into his book *Naked Lunch*, which was published in Paris in 1959 and eventually in the States in 1962. Burroughs credits Kerouac with coming up with the title, which has now, of course, become an ultrareality motto. Burroughs, Kerouac, and Ginsberg met in New York City in 1943, and all three men are recognized as being the heartbeat of the beatniks and their work an expression of the unconventional.

JAMES JOYCE

Joyce, when he was frisky, could put together
a sentence as intricate and as glittering as
a necklace for Cleopatra.

—Kurt Vonnegut, "How to Write with Style," 1980

T hough he may be an inadvertant style protagonist, James Joyce did have a way with bow ties, and you can tell that he is a man to whom appearances communicate character and echo emotion. Joyce's clothes reveal an accidental narrative of the great writer. He suffered from iritis and glaucoma, and in order to relieve his eyes he wore a patch; in later years he began wearing a white suit that he believed helped reflect the words on the page in front of him when he wrote.

Born in 1882 in Rathgar, near Dublin, Ireland, Joyce was the eldest of ten children. His parents' financial state was on the downslide but when Joyce was six they had enough money to commission a photograph of their "Sunny Jim," dressed to impress in a spruce sailor suit. As detailed in the 2011 biography by Gordon Bowker, when Joyce's wife first met him, on June 10, 1904, she thought he might be a "sailor," and the dashing appeal of the nautical remained with Joyce. In his semiautobiographical novel *A Portrait of the Artist as a Young Man*, he writes about his protagonist, Stephen Dedalus, in the school

Opposite:
James Joyce,
mid-1920s.

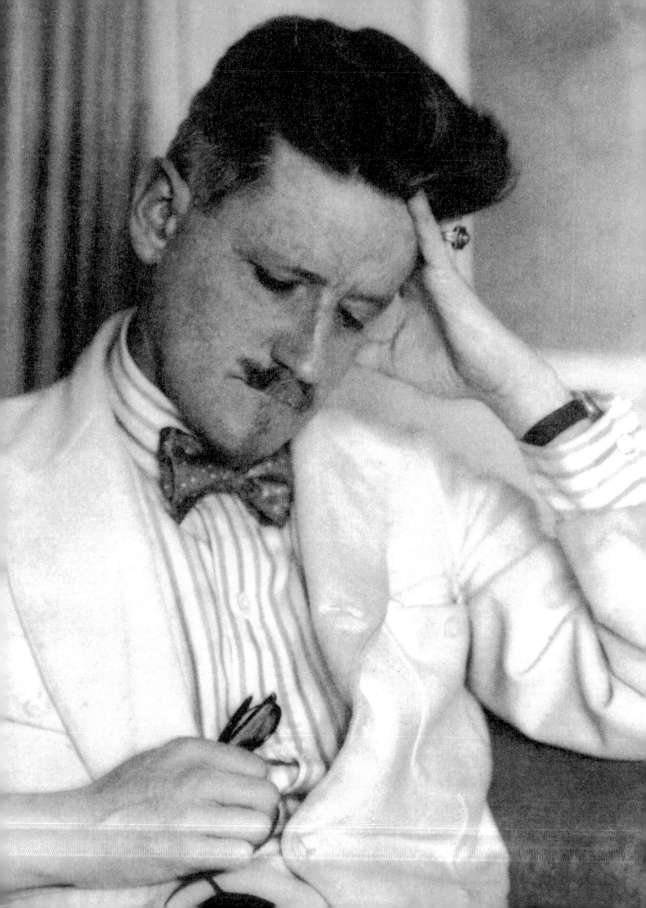

classroom and how a classmate's "little silk badge with the red rose on it looked very rich because he had a blue sailor top on. Stephen felt his own face red too."

Joyce composed new ways of writing, and his work centers on the minutiae of the minute. As he is a paradigm of modernist literature, it is fascinating and fitting that he should notice and explore the significance of fashion. In *Ulysses*, he sees his character Gerty MacDowell through the prism of what she is wearing, broaching the subject of her underwear with microscopic interest. Joyce makes three-dimensional the concept of modernity through his meticulous eye for clothing—using it as a conduit for hopes, dreams, aspirations, and delusion.

The classification of class and clothes is keenly saturated in Joyce's work, and he felt it in reality, too. In 1920 in Paris, Joyce met T. S. Eliot, who had brought him a parcel from their mutual friend Ezra Pound. It contained clothes and a pair of brown shoes for the writer, who had reportedly spent the summer in dirty tennis plimsolls for want of anything else. Joyce rose above the embarrassment by treating Eliot to a supper he could ill afford. Times were often lean. At one point, in a reply to a letter from his mother in March 1904, he wrote, Bowker says, that his "shirt was indescribable, one boot was worn through and his flies were held together with safety pins."

```
Joyce was terrified of thunder
and lightning because when he
was a child, his governess told
him that when there was thunder,
it was God being angry.

Joyce had more than twenty-five
surgeries on his eyes during
his lifetime. His ocular problems
were varied and among other
complications he suffered from
iritis, a painful inflammation
of the iris, synechia, a
condition where the iris
becomes stuck to the cornea
or the lens, and glaucoma.

After living in Italy, Joyce
continued to speak Italian at
home; he was an impressive
linguist and learned Dano-
Norwegian while at University
College Dublin so that he
could read Henrik Ibsen in
the original language.
```

People say of James Joyce
that he looks both sad
and tired. He does look
sad and he does look tired,
but it is the sadness of
a man who has procured some
medieval permission to
sorrow out of time and in
no place; the weariness
of one self-subjected to
the creation of an over
abundance in the limited.

—Djuna Barnes, "A Portrait of the Man Who Is, At Present,
One of the More Significant Figures in Literature," 1922

Gerty was dressed simply but with the instinctive taste of a votary of Dame Fashion for she felt that there was just a might that he might be out. A neat blouse of electric blue, selftinted by dolly dyes (because it was expected in the *Lady's Pictorial* that electric blue would be worn), with a smart vee opening down to the division and kerchief pocket (in which she always kept a piece of cottonwool scented with her favourite perfume because the handkerchief spoiled the sit) and a navy threequarter skirt cut to the stride showed off her slim graceful figure to perfection. . . . As for undies they were Gerty's chief care and who that knows the fluttering hopes and fears of sweet seventeen (though Gerty would never see seventeen again) can find it in his heart to blame her? She had four dinky sets, with awfully pretty stitchery, three garments and nighties extra, and each set slotted with different colored ribbons, rosepink, pale blue, mauve and peagreen, and she aired them herself and blued them when they came home from the wash and ironed them and she had a brickbat to keep the iron on because she wouldn't trust those washerwomen as far as she'd see them scorching the things.

—James Joyce, "Nausicaa" (Episode 13), *Ulysses*, 1922

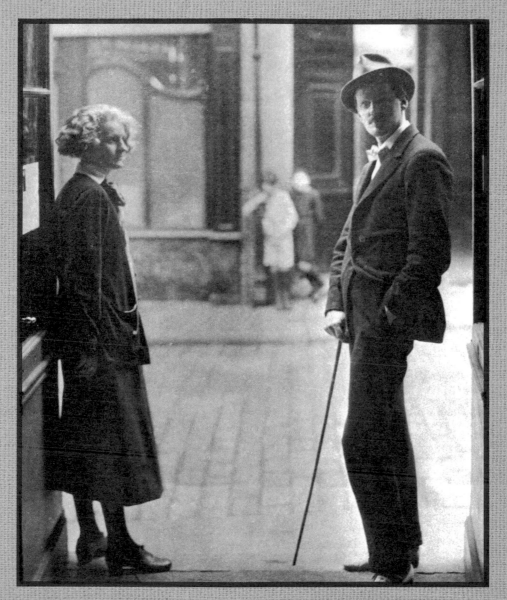

Sylvia Beach and Joyce standing in the entranceway of Shakespeare and Company, Paris, 1920.

NANCY MITFORD

Life is sometimes sad and often dull, but there are currants in the cake, and here is one of them.

—Nancy Mitford, *The Pursuit of Love*, 1945

Nancy Mitford was one of the Bright Young Things—a carefree gang of upper-class creatures who partied and shrieked their way through 1920s London. "We hardly ever saw the light of day, except at dawn; there was a costume party every night: The White Party, The Circus Party, The Boat Party," she affirmed in 1966, according to a biography of her, *Life in a Cold Climate*. The Bright Young Things' lives and loves were captured by one of her best friends, Evelyn Waugh, in his novel *Vile Bodies*, and to many, the larks and frolics of this group of aristocrats were a discordant hum in the background of postwar routine.

The Mitford style has become code for an "eccentric English" way of dressing—understood both by those fueled by fashion and those without insider intelligence. It means thick wool cardigans and stout walking shoes, wellingtons worn with silk ball dresses and fur tippets, and tweedy coats thrown over floral tea dresses. When living in England, Mitford habitually wore velvet suit jackets and wool skirts in town, and tweeds and shaped, darted blouses in the

Opposite:
Nancy Mitford,
1970.

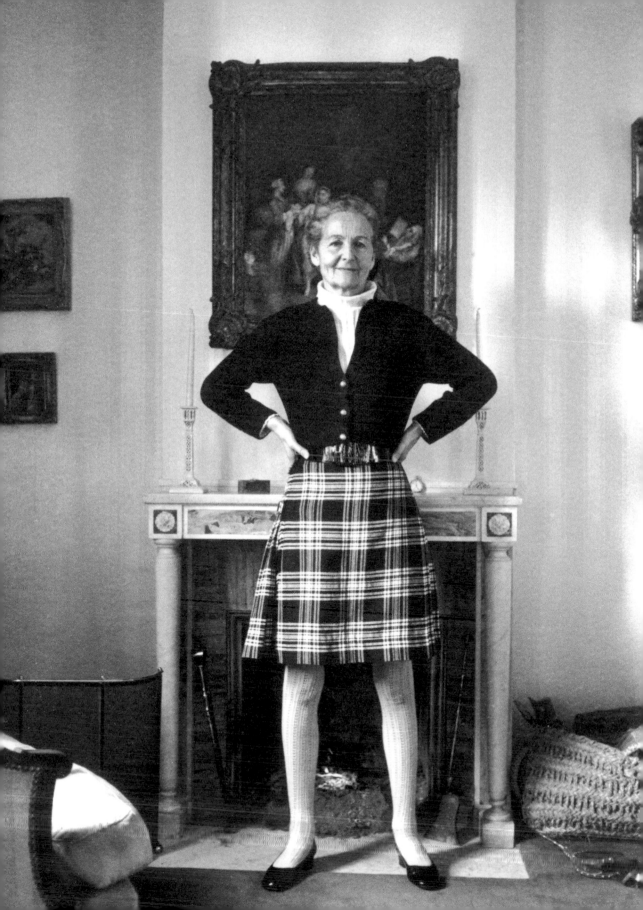

country, accessorized with sturdy brooches, a china-white complexion, threadlike eyebrows, and lustrous pearls. Ironically for a clotheshorse known for quirky British flair, Mitford spent her life disparaging the way English ladies dressed, and she insisted in her 1963 collection of essays, *The Water Beetle,* that the suits they wore were "deplorable, they are of tweed thick and hard as a board, in various shades of porridge." For society's in crowd, "nothing was considered as common as to be dressed in the height of fashion."

In her essay "Chic—English, French and American," published in 1951 in *Harper's Bazaar,* she contended that the British woman's wardrobe rested on "a contempt of the current mode and a limitless self-assurance." She decried what was to her the almost instrinsic, fundamentally bad dress sense of English women. "I saw Rosamond. . . . Oh the dowdiness of English women—has it always been the same or are they worse now—I can't remember. It is so fundamental that I suspect the former. The London New Look made me die of laughing—literal chintz crinolines. Apparently Dior went over *et lorsqu'il a réfléchi que c'est lui qui a lancé tout ça il était prêt à se suicider* [and when he realized it was he who had started it all, he was ready to commit suicide]."

During World War II, Mitford worked as an ambulance driver and a canteen assistant.

In 1967 Mitford moved from Paris to a house near the Palace of Versailles in France, and she lived there until she died.

For Mitford, Paris was fashion nirvana. Her first couture dress was from Madam Grès, a French house that the *New York Times* called, in the 1930s, "the most intellectual place in Europe to buy clothes." The gown was made from black velvet with a chiffon waistband, and cost £200. However, it was Christian Dior's clothes that she fell hard in love with. When his 1947 collection hit the catwalk, she wrote to her sister, Diana, in England: "Have you heard about the New Look? You pad your hips and squeeze your waist and skirts are to the ankle. It is bliss." She hurried to get fitted and revealed: "I stood at Dior for two hours while they moulded me with great wadges of cotton wool and built a coat over the result. I look exactly like Queen Mary.

Mother, of course, takes a lot of exercise, walks and so on. And every morning she puts on a pair of black silk drawers and a sweater and makes indelicate gestures on the lawn. That's called Building the Body Beautiful. She's mad about it.

—Nancy Mitford, *Christmas Pudding*, 1932

Nancy Mitford in her Paris apartment, 1956.

Think how warm though. . . . All the English newspapers are on to the long skirts and sneer. But all I can think is now one will be able to have knickers over the knee."

In 1945's *The Pursuit of Love*, she writes of her heroine: "Linda had one particularly ravishing ball-dress made of masses of pale grey tulle down to her feet . . . and made a sensation whenever she appeared in her yards of tulle, very much disapproved of by Uncle Matthew, on the grounds that he had known three women burnt to death in tulle ball-dresses." Humor is a thread that runs through all of Mitford's fiction. She was untrained and largely uneducated, apart from learning to write and speak French as a girl, but she nevertheless had a confidence that animated her writing with a voice that rang true. The worlds she wrote about fascinate the outsider; she gave a rare glimpse of what exactly went on in the drawing room. Her first-ever article in American *Vogue* in 1929 was titled "The English Shooting Party," and it reveals the mysteries of a blue-blood weekend in the country. She advises: "Wear a little coat over your dinner-dress; chattering teeth and goose flesh do not add very materially to the feeling of good cheer that is supposed to pervade the dinner table the first evening and there are few houses where it is good form to rise during dinner and beat the breast in order to stimulate circulation and enthusiasm."

Mitford's favorite fashion tip was: never wear a pencil skirt with a slit in it, as it makes calves bulge in an unflattering way.

One day . . . you'll be middle-aged and think what that must be like for a woman who can't have, say, a pair of diamond earrings. A woman of my age needs diamonds near her face, to give sparkle.

—Nancy Mitford, *Love in a Cold Climate*, 1949

MAYA ANGELOU

Seek the fashion which truly fits and befits you. You will always be in fashion if you are true to yourself, and only if you are true to yourself.

—Maya Angelou, *Wouldn't Take Nothing for My Journey Now*, 1993

Maya Angelou spoke words of gratitude and freedom in her prose, poetry, and civil rights speeches. She had a forgiving, joyful heart and lived her life doing the right thing. Releasing an album called "Miss Calypso" in 1957, she wrote and performed her own music in 1957 and sang and danced around America.. Today her voice resonates still. Maya died at the age of eighty-six in 2014, and the planet mourned the passing of an extraordinarily gifted and loving life inspiration.

From her character to her clothes, Angelou was always interesting. As a young girl in the '50s, working as an actress and singer, she strode out in chic cocktail dresses and kitten heels, beatnik leotards, and capri pants. She performed in Jean Genet's *The Blacks* off-Broadway, studied modern dance with Martha Graham, and in 1952 went on the road around Europe with a *Porgy and Bess* production in which she played the part of Clara. Angelou's sense of self always manifested in her wardrobe, and that wardrobe was always elegant. She forever looked together.

Opposite:
Maya Angelou and Gloria Steinem en route to the March on Washington, 1983.

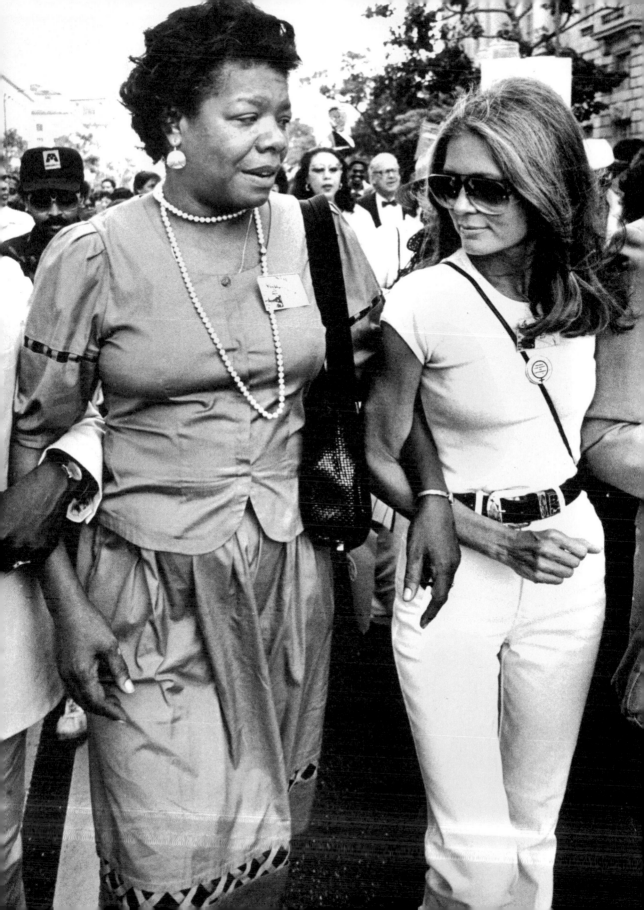

When she moved to Cairo in 1960 with her husband, the civil rights campaigner Vusumzi Make, she worked on an Arabic newspaper as the English editor, and she then went on to Ghana, where she found time to learn several languages, including Arabic and Fanti. Brilliant print and patterned sarongs and scarves became her signature style in the African heat. This look evolved into loose-fitting batik sundresses accessorized with statement beaded necklaces when she moved back to the States in 1964 to help Malcolm X and later Dr. Martin Luther King Jr. with their work. Her proud cultural dress conveyed a dignified and significant unity with traditions.

Above:
Maya Angelou,
2005.

In 1993, when Bill Clinton was elected president of the United States, she became the first female writer to recite a poem at a president's inauguration. She read her poem "On the Pulse of Morning," a heartfelt testimony that all colors, creeds, and religions in America can stand firm together. She spoke for everyone who was disenfranchised. In 2010, President Barack Obama awarded Angelou the highest civilian honor: the Presidential Medal of Freedom.

Looking smart and feeling good was one of Angelou's trademark attractions. A year before her death, she was photographed for the Cole Haan 1928 campaign and lay down the gauntlet for looking great at eighty-five years old. Clothes were important to Angelou. In the opening pages of her 1969 bestselling autobiography, *I Know Why the Caged Bird Sings*, she describes the awkward purple dress she is wearing and how desperately she wanted to feel like a "movie star," and instead realizes that she is wearing "a plain ugly cut-down." She intrinsically understood the shielding nature of clothes.

Angelou's poem "Phenomenal Woman" was first published in *Cosmopolitan* in 1978 and introduced the world to her style of feminism.

The words tell how proud she was of her body, her hair, and the "click" of her heels—and in writing them she empowered different shapes, sizes, and realities of women everywhere. As a public speaker, she dressed to impress. Little black dresses with elegant polo-neck sweaters accessorized with pearls and earrings were her favored outfit. She told not just women and black people to "ask for what you want and be prepared to get it"—it was a message for outsiders everywhere. She had high expectations for everyone, and she expected life to deliver decency.

Dr. Martin Luther King Jr. died in 1968 on April 4, Angelou's birthday. She didn't celebrate her birthday on that day for many years afterward.

The dress I wore was lavender taffeta, and each time I breathed it rustled, and now that I was sucking in air to breathe out shame it sounded like crepe paper on the back of hearses.

As I'd watched Momma put ruffles on the hem and cute little tucks around the waist, I knew that once I put it on I'd look like a movie star. (It was silk and that made up for the awful color.) I was going to look like one of the sweet little white girls who were everybody's dream of what was right with the world. . . . But Easter's early morning sun had shown the dress to be a plain ugly cut-down from a white woman's once-was-purple throwaway. It was old-lady-long too, but it didn't hide my skinny legs, which had been greased with Blue Seal Vaseline and powdered with the Arkansas red clay. The age-faded color made my skin look dirty like mud, and everyone in church was looking at my skinny legs.

—Maya Angelou, *I Know Why the Caged Bird Sings*, 1969

TOM WOLFE

You never realize how much of your background
is sewn into the lining of your clothes.

—Tom Wolfe, *The Bonfire of the Vanities*, 1987

Tom Wolfe is a dedicated follower of nonfashion. He has paved a
sartorial path that is as distinct and knowing as his epic novels
and New Journalism writings. He started wearing his legendary and
fabulous white suits as a matter of course in 1962 and explained in a
1980 *Rolling Stone* interview the value of being a square: "When I did
The Pump House Gang, I scarcely could have been in a more alien world.
I did the whole story in my seersucker rig. I think they enjoyed that
hugely. They thought of me as very old. I was thirty-odd years old, and
they thought of me as very stuffy. They kind of liked all that—this guy
in a straw boater coming around asking them questions. Then it even
became more extreme when I was working on *Electric Kool-Aid Acid
Test*. I began to understand that it would really be a major mistake to
try to fit into that world."

Wolfe's genteel day-to-evening wear of a three-piece cool suit is
the presumption of a man who always dresses with a classic twist and
gently echoes the tradition and spirit of his hometown, Richmond,
Virginia. Wolfe's fine wardrobe started out as a happy mistake, as he

Opposite:
Tom Wolfe,
circa 1980.

188

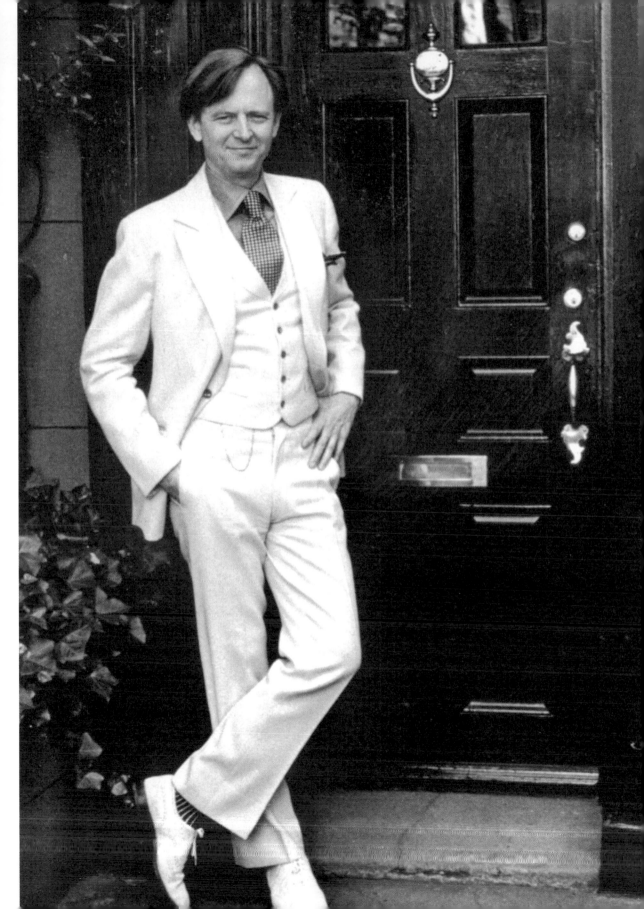

admitted in the 1980 *Rolling Stone* interview: "I went to a tailor here in New York and picked out a white material to have a suit made for the summertime. Silk tweed is actually a very warm material, so I started wearing the thing in the wintertime. This was the winter of 1962 or 1963, and the reaction of people was just astonishing. . . . The hostility for minor changes in style was just marvelous." Wearing a white suit suggests the delicate sashay of someone who is not going to get his hands dirty. Dressing in white is a serene and unflappable proposition.

Wolfe spent his life as a successful writer sitting on the edge, watching others get embroiled in life.

The New York Public Library bought 190 boxes of notebooks, letters, tailor's bills, Christmas cards, drawings, and manuscripts from Wolfe for more than $2 million. He said it made him feel "very important."

The only other career Wolfe considered, apart from being a writer, was to become an artist.

When in the middle of a piece, Wolfe sets a target of writing ten pages a day—approximately 1,800 words.

In Wolfe's writing, the devil is in the fascinating detail. And this is exactly how he sees value in his wardrobe. "The Secret Vice" was an essay he wrote for the *New York Herald Tribune* in 1966 in praise of "real buttonholes" and properly tailored suiting. Likewise, in his literary work it's not just the component parts of his characters' lives that are meticulously researched and held up for scrutiny: more often than not, their clothes are, too.

The psychology of modern Western life is wrapped up in consumer culture, and identity is frequently disclosed by dress. Wolfe delves into these rudiments in his writing, and in a 1991 interview in the *Paris Review*, he said: "I realized instinctively that if I were going to write vignettes of contemporary life . . . I wanted all the sounds, the looks, the feel of whatever place I was writing about to be in this vignette. Brand names, tastes in clothes and furniture, manners, the way people treat children, servants, or their superiors, are important clues to an individual's expectations."

Dark observation of casual dress is a classic Wolfe technique. His own closet of canes, homburg hats, spats, and coordinating vests are at direct odds with a culture of dressing down. Wolfe clocks casual and

Real buttonholes. That's it!
A man can take his thumb and
forefinger and unbutton his
sleeve at the wrist because
this kind of suit has real
buttonholes there.

—Tom Wolfe, "The Secret Vice," 1966

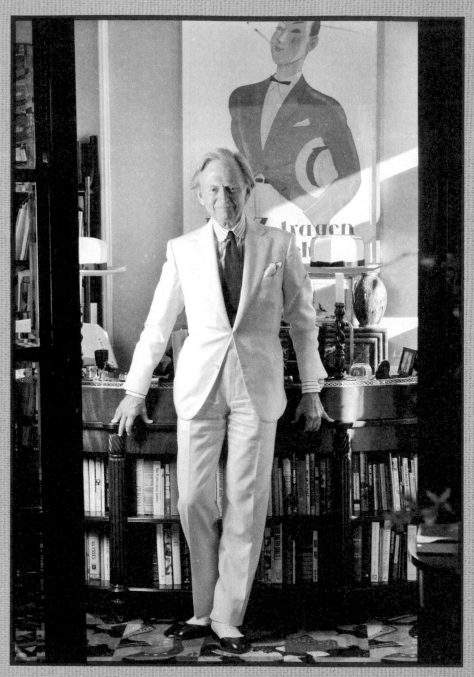

Tom Wolfe at his Upper East Side apartment, New York City, 2004.

dissects it in *The Bonfire of the Vanities*, using casual dress as a frenzied contrast to the ostentation of his Wall Street bond trader character, who calls himself the Master of the Universe. Sherman McCoy wears a "formidable rubberized British riding mac, full of flaps, straps and buckles . . . he had considered its aged look as just the thing, after the fashion of the Boston Cracked Shoe look." In comparison, travelers on the D train wear cheap sneakers: "Half the people in the car were wearing sneakers with splashy designs on them and molded soles that looked like gravy boats. Young people were wearing them, old men were wearing them, mothers with children on their laps were wearing them. . . . On the D train these sneakers were like a sign around the neck reading SLUM or EL BARRIO."

In Wolfe's 1970 article for *New York* magazine, "Radical Chic: That Evening at Lenny's," he satirizes the elegance of Park Avenue with a feature documenting a party given by the conductor Leonard Bernstein for his well-heeled friends in aid of the Black Panther cause. The minutiae of the moment centers on what is being worn.

The Panther women . . . are so lean, so lithe, as they say, with tight pants and Yoruba-style headdresses, almost like turbans, as if they'd stepped out of the pages of *Vogue*, although no doubt *Vogue* got it from them. . . .

What does one wear to these parties for the Panthers or the Young Lords or the grape workers? What does a woman wear? Obviously one does not want to wear something frivolously and pompously expensive, such as a Gerard Pipart party dress. On the other hand one does not want to arrive "poor-mouthing it" in some outrageous turtleneck and West Eighth Street bell-jean combination, as if one is "funky" and of "the people."

—Tom Wolfe, "Radical Chic: That Party at Lenny's," 1970

Acknowledgments

This book is dedicated to William, Freddie, and Andrew.

I'd also like to thank the following people for making this project come to life: Mischa Smith, Jennifer Sesay Barnes, Francine Bosco, Pippa Healy, Hayley Harrison, Catherine Vlasto, Jo Unwin, Lulu Guinness, Diane Rooney, Carrie Kania, Elizabeth Viscott Sullivan, Lynne Yeamans, Dani Segelbaum, and Tanya Ross-Hughes.

Bibliography

Adichie, Chimamanda Ngozi, and Zadie Smith. "Between the Lines: Chimamanda Ngozi Adichie with Zadie Smith." Event at the Schomburg Center for Research in Black Culture, March 19, 2014, 6:30 PM. Recording of live stream, 1:09:43. http://nymag.com/thecut/2014/03/heres-zadie-smith-chimamanda-adichie-talking.html.

Angelou, Maya. *I Know Why the Caged Bird Sings*. New York: Bantam Books, 1971.
———. "My mission in life . . ." Facebook post, July 5, 2011. https://www.facebook.com/MayaAngelou/posts/10150251846629796.

———. *Wouldn't Take Nothing for My Journey Now*. New York: Bantam Books, 1994.

Armitstead, Claire. "Robert Crumb: 'I was born weird.'" *The Guardian*, April 24, 2016. https://www.theguardian.com/books/2016/apr/24/robert-crumb-interview-art-and-beauty-exhibition.

Arneson, Krystin. "25 of the Best Fashion Quotes of All Time." *Glamour*, September 20, 2011. https://www.glamour.com/about/fashion-quotes glamour.com/fashion/2011/09/25-of-the-best-fashion-quotes-of-all-time/1.

Arnold, Rebecca. *Fashion, Desire and Anxiety: Image and Morality in the 20th Century*. New Brunswick, NJ: Rutgers University Press, 2001.

Attridge, Derek, ed. *The Cambridge Companion To James Joyce*. Cambridge, England: Cambridge University Press, 1990.

Bailey, Paul. *The Stately Homo: A Celebration of the Life of Quentin Crisp*. New York: Bantam Press, 2001.

Bair, Deirdre. *Samuel Beckett: A Biography*. New York: Harcourt Brace Jovanovich, 1978.

———. *Simone de Beauvoir: A Biography*. London: Touchstone, 1991.

Baker, Phil. *William S. Burroughs*. London: Reaktion, 2010.

Barnes, Djuna. "Becoming Intimate with the Bohemians." *New York Morning Telegraph Sunday Magazine*, November 19, 1916.

———. *The Book of Repulsive Women*. Manchester, England: Fyfield Books, 2003.

———. *Interviews*. Edited by Alyce Barry. Los Angeles: Sun & Moon Books, 1998.

———. *Nightwood*. London: Faber and Faber, 1936.

———. "A Portrait of the Man Who Is, At Present, One of the More Significant Figures in Literature." *Vanity Fair*, April 1922.

Barnet, Andrea. *All-Night Party: The Women of Bohemian Greenwich Village and Harlem, 1913–1930*. Chapel Hill, NC: Algonquin Books of Chapel Hill, 2000.

Bauer, Barbara, and Robert F. Moss. "Feeling Rejected? Join Updike, Mailer, Oates . . ." *New York Times*, July 21, 1985.

Beckett, Samuel. *The Letters of Samuel Beckett, 1929–1940*. Vol. 1 of *The Letters of Samuel Beckett*. Edited by Martha Dow Fehsenfeld and Lois More Overbeck. Cambridge, England: Cambridge University Press, 2009.

———. *The Letters of Samuel Beckett, 1941–1956*. Vol. 2 of *The Letters of Samuel Beckett*. Edited by George Craig, Martha Dow Fehsenfeld, Dan Gunn, and Lois More Overbeck. Cambridge, England: Cambridge University Press, 2011.

———. *The Letters of Samuel Beckett, 1957–1965*. Vol. 3 of *The Letters of Samuel Beckett*. Edited by George Craig, Martha Dow Fehsenfeld, Dan Gunn, and Lois More Overbeck. Cambridge, England: Cambridge University Press, 2014.

———. *Molloy*. London: Faber & Faber, 2009.

———. *Waiting for Godot*. New York: Grove Press, 1954.

Beevor, Antony, and Artemis Cooper. *Paris After the Liberation, 1944–1949*. New York: Doubleday, 1994.

Begley, Adam. *Updike*. New York: HarperCollins, 2014.

Bell, Matthew. "Revealed: Rimbaud, libertine linguist." *The Independent Newspaper*, September 17, 2011. http://www.independent.co.uk/arts-entertainment/books/news/revealed-rimbaud-libertine-linguist-2356586.html.

Beller, Thomas. "Interview with Fran Lebowitz." Mr. Beller's Neighborhood: New York City Stories, October 11, 2002. mrbellersneighborhood.com/2002/10/interview-with-fran-lebowitz.

Bellow, Saul. *Seize the Day*. New York: Penguin, 2003.

Bernier, Rosamond. "On Design: Fashion Week, 1947." *Paris Review*, September 12, 2011. theparisreview.org/blog/2011/09/12/fashion-week-1947/.

Bibesco, Marthe. *Marcel Proust at the Ball*. Translated by Anthony Rhodes. London: Weidenfeld & Nicolson, 1956.

Binelli, Mark. "The Amazing Story of the Comic Book Nerd Who Won the Pulitzer Prize for Fiction." *Rolling Stone*, September 27, 2001.

"Blink Q and A with Malcolm." Gladwell.com, http://gladwell.com/blink/blink-q-and-a-with-malcolm.

Bockris, Victor. *Patti Smith, The Unauthorized Biography*. London: 4th Estate, 1998.

Bowker, Gordon. *James Joyce: A New Biography*. New York: Weidenfeld & Nicolson, 2011.

Brinkley, Douglas, and Terry McDonell. "Hunter S. Thompson, The Art of Journalism No. 1." *Paris Review*, Fall 2000. http://www.theparisreview.org/interviews/619/the-art-of-journalism-no-1-hunter-s-thompson.

Brockes, Emma. "'Toni Morrison: 'I Want to Feel What I Feel. Even If It's Not Happiness.'" *The Guardian*, April 13, 2012.

Broe, Mary Lynn, ed. *Silence and Power: A Reevaluation of Djuna Barnes*. Carbondale: Southern Illinois University Press, 1991.

Bronfen, Elisabeth. *Sylvia Plath*. Plymouth, England: Northcote House, 1998.

Brookner, Howard, dir. *Burroughs: The Movie*. DPI, 1983.

Brown, Mick. "Worth Waiting For." Interview with Donna Tartt. *The Telegraph*, October 19, 2002. telegraph.co.uk/culture/4729011/Worth-waiting-for.html.

Bui, Phong. "In Conversation: Fran Lebowitz with Phong Bui." *Brooklyn Rail*, March 4, 2014. brooklynrail.org/2014/03/art/fran-lebowitz.

Burroughs, William S. *Junky*. New York: Ace, 1953.

——. *Last Words. The Final Journals of William S. Burroughs*. Edited by James Grauerholz. New York: Grove Press, 2001.

——. *The Western Lands*. New York: Viking Press, 1987.

Butscher, Edward. *Sylvia Plath, Method and Madness*. New York: Seabury Press, 1976.

Calder, John. "Samuel Beckett: A Personal Memoir." Naxos AudioBooks. web.archive.org/web/20071009184852/naxosaudiobooks.com/PAGES/beckettmemories.htm.

Campbell, James. "The Self-Loathing of Samuel Beckett." *Wall Street Journal*, December 12, 2014 (updated). wsj.com/articles/book-review-the-letters-of-samuel-beckett-1957-1965-1418421082.

Capron, Marion. "Dorothy Parker, The Art of Fiction No. 13." *Paris Review*, Summer 1956.

Caramagno, Thomas C. *The Flight of the Mind: Virginia Woolf's Art and Manic-Depressive Illness*. Oakland: University of California Press, 1992. University of California Press; New Ed. edition (May 3, 1996).

Carter, Angela. "Colette." *London Review of Books*, October 2, 1980. lrb.co.uk/v02/n19/angela-carter/colette.

Carter, William C. *Marcel Proust*. New Haven, CT: Yale University Press, 2000.

Caselli, Daniela. *Improper Modernism: Djuna Barnes's Bewildering Corpus*. Farnham, England: Ashgate, 2009.

Castle, Terry. "Desperately Seeking Susan." *London Review of Books*, March 17, 2005. http://www.lrb.co.uk/v27/n06/terry-castle/desperately-seeking-susan.

Champion, Laurie, and Emmanuel S. Nelson. *American Women Writers, 1900–1945*. Westport, CT: Greenwood Press, 2000.

Charters, Ann, ed. *The Portable Beat Reader*. New York: Viking, 1992.

Chisholm, Ann. *Nancy Cunard*. London: Penguin Books Ltd., 1981.

Cline, Sally. *Zelda Fitzgerald*. New York: Arcade Publishing, 2003.

Cochrane, Greg. "Q&A: Pulitzer Novelist Michael Chabon Reveals What It's Like to Work with Mark Ronson." *NME*, January 14, 2015.

Coleman, Emily Holmes. *Rough Draft: The Modernist Diaries of Emily Holmes Coleman, 1929–1937*. Edited by Elizabeth Podnieks. Newark: University of Delaware Press, 2012.

Colette. *Chéri*. Paris: Vintage Classics, 2001.

———. *Chéri and The Last of Chéri*. Translated by Roger Senhouse. New York: Farrar, Straus and Giroux, 2001.

———. *The Complete Claudine: Claudine at School; Claudine in Paris; Claudine Married; Claudine and Annie*. Translated by Antonia White. New York: Farrar, Straus and Giroux, 2001.

———. "Elegance? . . . Economy?" *Vogue*, August 1, 1958. First published in *Vogue Paris*, 1925.

———. *Gigi*. Paris: Hachette, 2010.

———. *Looking backwards / Colette*, translated by David Le Vay. Bloomington: Indiana University Press, 1975.

Collier, Peter. *Proust and Venice*. Cambridge, England: Cambridge University Press, 1989.

Cott, Jonathan. "Susan Sontag: The *Rolling Stone* Interview." *Rolling Stone*, October 4, 1979.

Cowley, Malcolm (Ed.). *Writers at Work – The Paris Review Interviews Vol 1*. New York: Viking Press, 1958.

Crawford, Anwen. "The Theology of Patti Smith." *The New Yorker*, October 5, 2015.

Crisp, Quentin. *How to Have a Lifestyle*. Los Angeles: Alyson Books, 1998.

———. Interview by David Letterman. YouTube video, 9:20, posted by user Declan John. Originally filmed by CBS for *Late Night with David Letterman*, 1985. youtube.com/watch?v=I3mYpugPfhI.

———. *The Naked Civil Servant*. New York: Quality Paperback Book Club, 2000.

Crisp, Quentin, and John Hofsess. *Manners from Heaven*. New York: Harper & Row, 1984.

Cronin, Anthony. *Samuel Beckett: The Last Modernist*. New York: HarperCollins Publishers, 1997.

Cronin, Gloria L., and Lee Trepanier, eds. *A Political Companion to Saul Bellow*. Lexington: University Press of Kentucky, 2013.

"Dame Edith Sitwell: Good Taste Is the Worst Vice Ever Invented." A. G. Nauta Couture (blog). September 21, 2014. https://agnautacouture. com/2014/09/21/dame-edith-sitwell-good-taste-is-the-worst-vice-ever-invented/.

Daniel, Lucy. *Gertrude Stein*. London: Reaktion, 2009.

Daugherty, Tracey. *The Last Love Song*. New York: St. Martin's Press, 2015.

Davenport-Hines, Richard. *A Night at the Majestic: Proust and the Great Modernist Dinner Party of 1922*. London: Faber and Faber, 2006.

de Beauvoir, Simone. *The Coming of Age*. Translated by Patrick O'Brien. New York: W. W. Norton & Company, 1996.

———. *Force Of Circumstance*. Translated by Richard Howard. New York: Paragon House, 1992.

———. *The Second Sex*. Translated by H. M. Parshley. London: Jonathan Cape Ltd., 1968.

de Botton, Alain. *How Proust Can Change Your Life*. New York: Pantheon Books, 1997.

DeCurtis, Anthony. "Patti Smith on Art." Interview with Patti Smith. PBS, December 30, 2009. www.pbs. org/pov/pattismith/patti-smith-on-art/.

DenHoed, Andrea. "Tom Wolfe Looks Over His Notes." *The New Yorker*, February 28, 2015.

Didion, Joan. *Blue Nights*. New York: Knopf, 2011.

———. "In Sable and Dark Glasses." *Vogue*, October 31, 2011.

———. *Slouching Towards Bethlehem*. New York: Farrar, Straus and Giroux, 1968.

———. *We Tell Ourselves Stories in Order to Live*. New York: Knopf, 2006.

———. *The White Album*. New York: Simon and Schuster, 1979.

———. "Why I Write." *New York Times Magazine*, December 5, 1976.

———. *The Year of Magical Thinking*. New York: Knopf, 2005.

Donaldson, Scott. *Fitzgerald and Hemingway: Works and Days*. New York: Columbia University Press, 2011.

Doumic, Rene. *George Sand: Some Aspects of Her Life and Writings*. Translated by Alys Hallard. Produced by Charles E. Keller and David Widger. Project Gutenberg: March 11, 2006. Updated January 26, 2013. Project Gutenberg. First published in 1910.

Drake, Alicia. *The Beautiful Fall: Fashion, Genius, and Glorious Excess in 1970s Paris*. New York: Back Bay Books, 2007.

Dreifus, Claudia. "Chloe Wofford Talks about Toni Morrison." Interview with Toni Morrison. *New York Times Magazine*, September 11, 1994.

Ebert, Roger. "Interview with Jacqueline Susann." RogerEbert.com. rogerebert.com/interviews/interview-with-jacqueline-susann. Originally published in the *Chicago Sun Times*, July 18, 1967.

Ellis-Peterson, Hannah. "Mark Ronson Collaborates with Author Michael Chabon on Latest Album." *The Guardian*, November 9, 2014.

Ellman, Richard. *James Joyce*. Oxford, England: Oxford University Press, 1983.

"Event marks premiere of Joe Orton's classic play, Entertaining Mr Sloane." http://www.leicestermercury.co.uk/event-marks-premiere-orton-s-classic-play/story-21310846-detail/story.html.

Fainlight, Ruth. "Sylvia Plath: Reflections on Her Legacy." *The Guardian*, February 8, 2013.

Field, Andrew. *Djuna: The Formidable Miss Barnes*. London: Secker & Warburg, 1983.

Fitzgerald, F. Scott. *"The Diamond as Big as the Ritz" and Other Stories*. Mineola, NY: Dover Publications, 1998.

———. *The Great Gatsby*. New York: Scribner, 1995.

———. *The Last Tycoon*. New York: Charles Scribner's Sons, 1941.

———. *A Life in Letters*. Edited by Matthew J. Bruccoli and Judith S. Baughman. New York: Simon & Schuster, 1995.

———. *This Side of Paradise*. Ware, Hertfordshire: Wordsworth Editions, 2011.

Fitzgerald, F. Scott, and Zelda Fitzgerald. *Bits Of Paradise: 21 Uncollected Stories*. Edited by Matthew J. Bruccoli and Scottie Fitzgerald Smith. London: Bodley Head, 1973.

———. *Dear Scott, Dearest Zelda: The Love Letters of F. Scott and Zelda Fitzgerald*. Edited by Jackson R. Bryer and Cathy W. Barks. New York: St. Martin's Press, 2002.

Fitzgerald, Zelda. *The Collected Writings*. Edited by Matthew J. Bruccoli. New York: Scribner, 1991.

Flanner, Janet, and Stanley Edgar Hyman. "The Talk of the Town." *The New Yorker*, February 22, 1947.

Flippo, Chet. "Tom Wolfe: The *Rolling Stone* Interview." *Rolling Stone*, August 21, 1980.

Foschini, Lorenza. *Proust's Overcoat: The True Story of One Man's Passion for All Things Proust*. Translated by Eric Karpeles. New York: Ecco, 2010.

Frankel, Susannah. "Isabella Blow: A Truly Original Style Icon." *The Independent*, May 8, 2007. http://www.independent.co.uk/news/people/profiles/isabella-blow-a-truly-original-style-icon-448083.html.

Freeman, John. "In Wolfe's Clothing." *Sydney Morning Herald*, December 18, 2004.

Fullbrook, Kate, and Edward Fullbrook. *Simone de Beauvoir and Jean-Paul Sartre: The Remaking of a Twentieth-Century Legend*. New York: Basic Books, 1994.

Gardiner, Juliet. *Oscar Wilde: A Life in Letters, Writing, and Wit*. London: Collins & Brown, 1995.

"Gertrude Stein Arrives and Baffles Reporters by Making Herself Clear." *New York Times*, October 25, 1934.

Goldman, Andrew. "Cornel West Flunks the President." *The New York Times,* July 22, 2011. http://www.nytimes.com/2011/07/24/magazine/talk-cornel-west.html.

Gompertz, Will. "Celebrating 50 Years of Joe Orton," *BBC News,* June 27, 2014. http://www.bbc.co.uk/news/entertainment-arts-28056359.

Gorman, Paul. *The Look: Adventures in Pop and Rock Fashion*. London: Adelita, 2006.

Graham, Sheilah. *The Real F. Scott Fitzgerald Thirty-Five Years Later*. New York: Grosset & Dunlap, 1976.

Greene, Richard. *Edith Sitwell: Avant Garde Poet, English Genius*. London: Virago, 2011.

Gruen, John. "Samuel Beckett talks about Beckett." *Vogue*, December, 1969.

Gussow, Mel, and Charles McGrath. "Saul Bellow, Who Breathed Life Into American Novel, Dies at 89." *New York Times*, April 6, 2005.

Hagman, Lyman. *Heart of a Woman, Mind of a Writer, and Soul of a Poet: A Critical Analysis of the Writings of Maya Angelou*. Lanham, MD: University Press of America, 1996.

Hale, Grace. Review of *Gonzo: The Life and Work of Dr. Hunter S. Thompson*, directed by Alex Gibney. *The Sixties* 2, no. 1 (2009): 79-82. doi: 10.1080/17541320902909599.

Hale, Kathleen. "'Yoga Pants Are Ruining Women' and Other Style Advice from Fran Lebowitz." *Elle*, March 24, 2015.

Hammond, Ed. "Small Talk: Michael Chabon." *Financial Times*, November 2, 2007.

Hanson, Barry. Interview with Joe Orton. Program notes of Peter Gill's Royal Court production of *The Erpingham Camp* and *The Ruffian on the Stair (Crimes of Passion)*, June 1967. http://www.petergill7.co.uk/pieces/joe_orton.html.

Harlan, Elizabeth. *George Sand*. New Haven, CT: Yale University Press, 2004.

Hartman, Darrell. "Style Icon Gay Talese: The Dean of Long-Form Journalism on the Necessity of Suits (and the terrors of normcore). *The Village Voice*, March 30, 2016. http://www.villagevoice.com/arts/style-icon-gay-talese-the-dean-of-long-form-journalism-on-the-necessity-of-suits-and-the-terrors-of-normcore-8450803.

Hastings, Selina. *Nancy Mitford: A Biography*. New York: Dutton, 1986.

Heimel, Cynthia. "Fran Lebowitz Isn't Kidding." *New York* magazine, September 14, 1981.

Heinz, Drue. "Ted Hughes, The Art of Poetry No. 71." *Paris Review*, Spring 1995.

Hemingway, Ernest. *The Green Hills of Africa*. New York: Scribner, 1935.

Hibbard, Allen, ed. *Conversations with William S. Burroughs*. Jackson: University Press of Mississippi, 2000.

Hilditch & Key. "Our Story." http://www.hilditchand-key.co.uk/our-story.aspx. 2016.

Hilton, Lisa. *The Horror of Love: Nancy Mitford and Gaston Palewski in Paris and London*. New York: Pegasus Books, 2013.

Hilton, Phil. "The Bret Easton Ellis Interview." *Shortlist Magazine*. http://www.shortlist.com/entertainment/the-bret-easton-ellis-interview.

Hirsch, Edward. "Susan Sontag, The Art of Fiction No. 143." *Paris Review*, Winter 1995.

Hitchens, Christopher. "Rebel in Evening Clothes." *Vanity Fair*, October 1999.

Hoby, Hermione. "Toni Morrison: 'I'm Writing for Black People . . . I Don't Have to Apologise.'" *The Guardian*, April 25, 2015.

Hook, Professor Andrew. *F. Scott Fitzgerald, A Literary Life, (Literary Lives)*. New York: Palgrave Macmillan, 2002.

Hughes, Robert. Transcript of a filmed interview with Vladimir Nabokov. Television 13 Educational Program, New York, September 1965. Last modified July 25, 1998. lib.ru/NABOKOV/Inter05.txt.

Humm, Maggie. *The Edinburgh Companion to Virginia Woolf and the Arts*. Edinburgh: Edinburgh University Press, 2010.

Hunt, Jemima. "The Didion Bible." *The Observer*, January 12, 2003.

Hussey, Andrew. *Paris: The Secret History*. New York: Bloomsbury, 2007.

Jack, Belinda. *George Sand: A Woman's Life Writ Large*. London: Vintage, 1999.

"International Best-Dressed Hall of Fame Inductees." *Vanity Fair*. http://www.vanityfair.com/style/photos/2014/08/the-international-best-dressed-list-hall-of-fame-2004-2014.

Jeffries, Stuart. "The Language of Exile." *The Guardian*, June 7, 2007.

Jones, LeRoi, ed. *The Moderns: An Anthology of New Writing in America*. New York: Corinth Books, 1963.

Joyce, James. *Dubliners*. New York: Modern Library, 1926.

———. *Letters of James Joyce*. Edited by Stuart Gilbert. New York: Viking, 1957.

———. *A Portrait of the Artist as a Young Man*. New York: Vintage, 1993.

———. *Ulysses*. New York: Modern Library, 1992.

Kamp, David. "A Style Is Born." *Vanity Fair*, October 21, 2011. http://www.vanityfair.com/news/2011/11/anderson-and-sheppard-201111.

Kaplan, James. "Smart Tartt." *Vanity Fair*, August 31, 1999. http://www.vanityfair.com/news/1992/09/donna-tartt-the-secret-history.

Kaplan, Joel H., and Sheila Stowell. *Theatre and Fashion: Oscar Wilde to the Suffragettes*. Cambridge, England: Cambridge University Press, 1994.

Kaprielian, Nelly. "Words of a Man." Interview with Rick Owens. Rick Owens (website). https://www.rickowens.eu/en/US/interviews/vogueparis-aug14. First published in *Vogue Paris*, August 2014.

Karbo, Karen. *The Gospel According to Coco Chanel, The World's Most Elegant Woman*. New Delhi: Om Books International: 2009.

Kasindorf, Martin. "Jackie Susann Picks Up the Marbles." *New York Times Magazine*, August 12, 1973.

Kirk, Connie Ann. *Sylvia Plath: A Biography*. Westport, CT: Greenwood Press, 2004.

Kot, Greg. "Patti Smith on Literary Heroes, Role Models, and Sinatra." *The Chicago Herald Tribune*, October 24, 2014.

Kuehl, Linda. "Joan Didion, The Art of Fiction No. 71." *Paris Review*, Fall–Winter 1978.

Kurutz, Steven. "Tom Wolfe's Tailor: A Man in Full Mastery." *New York Times*, November 28, 2004.

La Ferla, Ruth. "A Rare Spirit, A Rarer Eye. Interview with Patti Smith." *New York Times*, March 19, 2010.

Lahr, John. *Prick Up Your Ears: The Biography of Joe Orton*. New York: Knopf, 1978.

Lambert, Pat. "Talking with Donna Tartt, Cinderella Story." *Newsday*, October 4, 1992.

Lange, Maggie. "Here Are Zadie Smith and Chimamanda Adichie in Conversation." *New York* magazine, March 21, 2014.

Leader, Zachary. "'I Got a Scheme!'—The Moment Saul Bellow Found His Voice." *The Guardian*, April 17, 2015.

Lebowitz, Fran. *The Fran Lebowitz Reader*. New York: Vintage Books, 1994.

———. *Metropolitan Life*. New York: Dutton, 1978.

———. "The Social Life." *Vogue*, November 1, 1990.

———. *Social Studies*. New York: Random House, 1981.

Lee, Harper. *To Kill a Mockingbird*. New York: Grand Central, 1988.

Lee, Hermione. *Virginia Woolf*. New York: Knopf, 1997.

Lee, John M. "Beckett Wins Nobel for Literature." *New York Times*, October 24, 1969.

Les Misérables - 101 Amazing Facts You Didn't Know: Fun Facts and Trivia Tidbits Quiz Game Books. GWhizBooks.com, Kindle Edition, 2014.

Lewis, Michael. "How Tom Wolfe Became Tom Wolfe." *Vanity Fair*, October 31, 2015.

Li, Stephanie. *Toni Morrison: A Biography*. Westport, CT: Greenwood, 2009.

Lipsky, David. *Although Of Course You End Up Becoming Yourself: A Road Trip with David Foster Wallace*. New York: Broadway Books, 2010.

Lubin, Georges. *Oeuvres Autobiographiques*. Paris: Gallimard, 1971.

Machen, Peter. "Patti Smith's Most Personal Interview: 'The Things That Make Me Feel Strange—I've Transformed Them into Work.'" *Salon*, October 5, 2015. www.salon.com/2015/10/05/patti_smiths_most_personal_interview_the_things_that_make_me_feel_strange_ive_transformed_them_into_work/.

Mackenzie, Suzie. "Finding Fact from Fiction." *The Guardian*, May 26, 2000.

Mansfield, Irving, and Jean Libman Block. *Life with Jackie*. Toronto: Bantam Books, 1983.

Marchese, David. "The SPIN Interview: Patti Smith." *Spin* magazine, September 1, 2008. http://www.spin.com/2008/09/spin-interview-patti-smith/.

"Mark Twain in White Amuses Congressmen." *New York Times*, December 8, 1906.

Marling, William. "What Lies Beneath Djuna Barnes." Modernism: American Salons. 1997. http://www.case.edu/artsci/engl/VSALM/mod/brandelmcdaniel/index/library.htm.

Martin, Gwen, and Evan J. Elkin. "Ladies and Cigars: Aficionadas: Women and Their Cigars." *Cigar Aficionado*, Summer 1995.

Max, D. T. *Every Love Story Is a Ghost Story: A Life of David Foster Wallace*. New York: Viking, 2012.

McBee, Thomas Page. "The *Rumpus* Interview with Zadie Smith." *The Rumpus*, January 1, 2013. therumpus.net/2013/01/the-rumpus-interview-with-zadie-smith/.

McCaffery, Larry. "A Conversation with David Foster Wallace." *Review of Contemporary Fiction* 13, no. 2 (1993).

McGrath, Charles. "A Rigorous Intellectual Dressed in Glamour." Obituary of Susan Sontag. *New York Times*, December 29, 2004.

McKillop, Alasdair. "How Frank Sinatra's Cold Became Part of Literary History." *Scottish Review,* May 11, 2016. http://www.scottishreview.net/AlasdairMcKillop33a.html.

"Memorial for Dorothy Parker." *Associated Press*, October 23, 1988. http://www.nytimes.com/1988/10/23/us/memorial-for-dorothy-parker.html.

Menand, Louis. "Imitation of Life: John Updike's Cultural Project." *The New Yorker*, April 28, 2014.

Mendelsohn, Daniel. "Rebel Rebel: Arthur Rimbaud's Brief Career." *The New Yorker*, August 29, 2011.

Mitford, Nancy. *Christmas Pudding*. London: Hamilton, 1975.

———. "The English Shooting Party." *Vogue* (1929).

———. *The Nancy Mitford Omnibus*. London: Hamilton, 1956.

———. *Noblesse Oblige*. New York: Harper & Row, 1956.

———. *The Pursuit of Love*. New York: Random House, 1946.

———. *The Water Beetle*. New York: Atheneum, 1986.

Moyle, Franny. *Constance: The Tragic and Scandalous Life of Mrs. Oscar Wilde*. New York: Pegasus Books, 2012.

Noble, Joan Russell, ed. *Reflections of Virginia Woolf By Her Contemporaries*. Athens: Ohio University Press, 1994.

Orr, Lyndon. *Famous Affinities of History: The Romance of Devotion*. Charleston, SC: BiblioBazaar, 2006.

Orr, Peter, ed. *The Poet Speaks: Interviews with Contemporary Poets Conducted by Hilary Morrish, Peter Orr, John Press, and Ian Scott-Kilvert*. London: Routledge, 1966.

Orton, Joe. *The Complete Plays*. New York: Grove Weidenfeld, 1990.

——. *The Orton Diaries*. Edited by John Lahr. New York: Harper & Row, 1986.

Painter, George D. *Marcel Proust: A Biography*. New York: Vintage Books, 1978.

Parker, Dorothy. *The Collected Short Stories of Dorothy Parker*. New York: Modern Library, 1942.

——. *The Poetry and Short Stories of Dorothy Parker*. New York: Modern Library, 1994.

——. *The Portable Dorothy Parker*. New York: Viking, 1973.

——. "The Standard of Living." *The New Yorker*, September 20, 1941.

Pearce, Joseph. *The Unmasking of Oscar Wilde*. Ignatius Press; Reissue edition (6 July 2015).

Phanor-Faury, Alexandra. "Closet Envy: British Author Zadie Smith." *Essence*, June 1, 2010. http://www.essence.com/2010/06/02 closet-envy-zadie-smith.

Plath, Sylvia. *The Bell Jar*. New York: Harper & Row, 1971.

——. *Ariel*. New York: Harper Perennial Modern Classics Paperback, 1999.

——. *The Unabridged Journals of Sylvia Plath*. Edited by Karen V. Kukil. New York: Anchor Books, 2000.

Plimpton, George. "Tom Wolfe, The Art of Fiction No. 123." *Paris Review*, Spring 1991.

——. "Maya Angelou, The Art of Fiction No. 119." *Paris Review*, Fall 1990.

——. ed. *Writers at Work: The Paris Review Interviews*, Volume 4. New York: Viking, 1976.

Plumb, Cheryl J. *Fancy's Craft: Art and Identity in the Early Works of Djuna Barnes*. Selinsgrove, PA: Susquehanna University Press, 1986.

Proust, Marcel. *In Search of Lost Time* (Proust Complete - 6 Volume Box Set). Translated by C. K. Scott Moncrieff. Edited by Richard Howard. New York: Modern Library, 2003.

Quinn, Arthur Hobson. *Edgar Allan Poe, A Critical Biography*. Baltimore: Johns Hopkins University Press, 1997.

Raby, Peter, ed. *The Cambridge Companion to Oscar Wilde*. Cambridge, England: Cambridge University Press, 1997.

Ratcliffe, Susan, ed. *The Oxford Dictionary of Quotations by Subject*. Oxford, England: Oxford University Press, 2010.

Ray, Nicholas, dir. *Rebel Without a Cause*. DVD, Los Angeles: Warner Bros, 1955.

Rimbaud, Arthur. *Collected Poems*. Translated by Martin Sorrell. Oxford, England: Oxford University Press, 2001.

——. *Selected Poems and Letters*. Translated by Jeremy Harding and John Sturrock. New York: Penguin Classics, 2004.

Robb, Graham. *Rimbaud: A Biography*. London: Picador, 2000.

Salter, Elizabeth. *The Last Years of a Rebel: A Memoir of Edith Sitwell*. Boston: Houghton Mifflin, 1967.

Samuels, Charles Thomas. "John Updike, The Art of Fiction No. 43." *The Paris Review*, Winter 1968.

Sand, George. *The Devil's Pool and other stories*. Translated by E. H. Blackmore, A. M. Blackmore, and Francine Giguere. Albany: State University of New York Press, 2004.

——. *Indiana*. Translated by Sylvia Raphael, edited by Naomi Schor. Oxford, England: Oxford University Press, 2008.

——. *Jealousy, Teverino*. Translated anonymously. Fredonia Books, 2004.

——. *Story of My Life: The Autobiography of George Sand*. Edited by Thelma Jurgrau. Albany: State University of New York Press, 1991.

——. *Winter in Majorca*. Translated by Robert Graves. Chicago: Academy Press, 1978.

Schappell, Elissa, with Claudia Brodsky-Lacour. "Toni Morrison, The Art of Fiction 134." *Paris Review*, Fall 1993. theparisreview.org/interviews/1888/the-art-of-fiction-no-134-toni-morrison.

Schine, Cathleen. "People Are Talking About: Fran Lebowitz. The Wit." *Vogue*, January 1, 1982.

Schneider, Pierre. "Paris: Fresh Look at Colette's Work." *New York Times*, April 9, 1973.

Schreiber, Daniel. *Susan Sontag: A Biography*. Translated by David Dollenmayer. Evanston, IL: Northwestern University Press, 2014.

Scorsese, Martin, dir. *Public Speaking*. Documentary. HBO Documentary Films and American Express Portraits, 2010.

Scott, Bonnie Kime. *Refiguring Modernism. Volume 1: The Women of 1928*. Bloomington: Indiana University Press, 1996.

Seaman, Barbara. *Lovely Me: The Life of Jacqueline Susann*. New York: William Morrow, 1987.

Sebring, Steven, dir. *Patti Smith: Dream of Life*. Clean Socks and Thirteen/WNET, 2008.

Seymour-Jones, Carole. *A Dangerous Liaison: A Revelatory New Biography of Simone de Beauvoir and Jean-Paul Sartre*. New York: Overlook Press, 2009.

"Short Novels of Colette." Questia.com, https://www.questia.com/library/501356/short-novels-of-colette.

Simon, John. "Beckett Two Ways." Review of *The Letters of Samuel Beckett: Volume 3, 1957–1956* by Samuel Beckett, George Craig, Martha Dow Fehsenfeld, Dan Gunn, and Lois More Overbeck. *New Criterion*, April 2015.

Sitwell, Edith. *Fire of the Mind: An Anthology*. Edited by Elizabeth Salter and Allanah Harper. London: Michael Joseph, 1976.

——. *Taken Care Of: An Autobiography*. Hutchinson & Co. Ltd., 1965.

Sitwell, William. "Edith Sitwell, Eccentric Genius." *The Telegraph Newspaper,* March 11, 2011. http://www.telegraph.co.uk/culture/books/biographyandmemoirreviews/8373893/Edith-Sitwell-eccentric-genius.html.

Skerl, Jennie. *William S. Burroughs*. Boston: Twayne Publishers, 1985.

Smith, Joseph H. *The World of Samuel Beckett*. Baltimore: Johns Hopkins University Press, 1991.

Smith, Patti. *The Coral Sea*. New York: W. W. Norton, 1996, reissued 2012.

——. *Just Kids*. New York: Ecco, 2010.

——. *Salon.com*. interview with Peter Machen, 2015.

Smith, Zadie. *On Beauty*. New York: Penguin Press, 2005.

——. *White Teeth*. New York: Random House, 2000.

——. "Zadie Smith Talks with Ian McEwan." *The Believer*, August 2005. http://www.believermag.com/issues/200508/?read=interview_mcewan.

Sontag, Susan. *Against Interpretation*. London: Vintage, 1994.

——. *Reborn*. London: Hamish Hamilton, 2009.

Stein, Gertrude. *The Autobiography of Alice B. Toklas*. New York: Penguin Classics, 2001.

——. *Everybody's Autobiography*. Exact Change, 2004.

——. *Paris France*. England. Liveright; 1 edition (June 24, 2013).

——. "People and Ideas: Pierre Balmain—New Grand Success of the Paris Couture, Remembered from Darker Days." *Vogue*, December 1, 1945.

——. *Selected Writings of Gertrude Stein*. Edited by Carl van Vechten. New York: Vintage, 1990.

Stein, Sadie. "Greenwich Village 1971." *The Paris Review, The Daily,* May 12, 2016. http://www.theparisreview.org/blog/2016/05/12/greenwich-village-1971/.

Stendhal, Renate. *Gertrude Stein in Words and Pictures*. London: Thames & Hudson, 1995.

Susann, Jacqueline. *Once is Never Enough*. New York: Grove Press, 1997.

——. *Valley of the Dolls*. New York: Grove Press, 1997.

Tadie, Jean-Yves. *Marcel Proust: A Life*. Translated by Euan Cameron. New York: Viking, 2000.

Tang, Dennis. "Style Icon: John Updike." *GQ*, May 24, 2012. http://www.gq.com/gallery/john-updike-style-icon.

Tartt, Donna. "Donna Tartt: By the Book." *New York Times*, October 17, 2013.

———. *The Secret History*. New York: Knopf, 1992.

———. "Sleepytown: A Southern Gothic Childhood with Codeine." *Harper's* magazine, July 1992.

———. "This Much I Know." *The Guardian*, November 15, 2003.

"Ten Minutes with a Poet: A Reporter Greets Oscar Wilde on His Arrival." *New York Times*, January 3, 1882.

Thompson, Dave. *Dancing Barefoot: The Patti Smith Story*. Chicago, IL: Chicago Review Press, 2011.

Thompson, Hunter S. *Fear and Loathing in America: The Brutal Odyssey of an Outlaw Journalist. The Gonzo Letters, Volume II, 1968–1976*. Edited by Douglas Brinkley. New York: Simon & Schuster, 2000.

———. *Fear and Loathing in Las Vegas*. New York: Vintage Books, 1998.

———. *Hell's Angels: A Strange and Terrible Saga*. New York: Modern Library, 1999.

———. *Kingdom of Fear: Loathsome Secrets of a Star-Crossed Child in the Final Days of the American Century*. New York: Simon and Schuster, 2003.

———. *The Proud Highway: Saga of a Desperate Southern Gentleman, 1955–1967. The Fear and Loathing Letters, Volume One*. Edited by Douglas Brinkley. New York: Ballantine Books, 1998.

Thompson, Laura. *Life in a Cold Climate: Nancy Mitford, The Biography*. London: Head of Zeus, 2015.

Thorpe, Vanessa. "The Secret History of Donna Tartt's New Novel." *The Guardian*, July 28, 2002.

"Timeline: Katie Eary." *British Vogue*. February 4, 2014. http://www.vogue.co.uk/brand/katie-eary.

Torrey, Beef, and Kevin Simonson, eds. *Conversations with Hunter S. Thompson*. Jackson, MS: University Press of Mississippi, 2008.

Tosches, Nick. "Patti Smith: A Baby Wolf with Neon Bones." *Penthouse* magazine, April 1976.

Turnbull, Andrew. *Scott Fitzgerald (Vintage Lives)*. New York: Vintage Classics, 2004.

Twain, Mark. *The Adventures of Huckleberry Finn*. New York: Penguin Classics, 2003.

———. *Autobiography of Mark Twain: The Complete and Authoritative Edition*. Vol. 2. Edited by Benjamin Griffin and Harriet Elinor Smith. Berkeley: University of California Press, 2013.

———. "The Czar's Soliloquy." *North American Review* 180, March 1, 1905.

Updike, John. "A&P." *The New Yorker*, July 22, 1961.

———. *Rabbit, Run*. New York: Alfred A. Knopf, 1960.

———. *Rabbit at Rest*. New York: Alfred A. Knopf, 1990.

Viner, Katharine. "A Talent to Tantalise." *The Guardian*, October 18, 2002.

Vonnegut, Kurt. "How to Write with Style." Advertisement by International Paper Company in *IEEE Transactions on Professional Communication* PC-24, no. 2: June 1980.

Vreeland, Diana. *D.V.* New York: Ecco Press, 2011.

Wallace, David Foster. *Brief Interviews with Hideous Men*. Boston: Little, Brown, 1999.

———. *Consider the Lobster and Other Essays*. New York: Little, Brown, 2005.

———. *Infinite Jest*. Boston: Little, Brown, 1996.

———. *This Is Water: Some Thoughts, Delivered on a Significant Occasion, about Living a Compassionate Life*. New York: Little, Brown, 2009.

Waters, John. "John Waters on William S. Burroughs." Interview by Ben Ahlvers. Burroughs100.com, October 23, 2013.

Wenner, Jann S., and Corey Seymour. *Gonzo: The Life of Hunter S. Thompson*. New York: Back Bay Books, 2007.

West, Cornel. *Brother West: Living and Loving Out Loud*. New York: SmileyBooks, 2009.

Wharton, Edith. *The House of Mirth*. Mineola, NY: Dover, 2002.

White, Edmund. *Marcel Proust: A Life*. New York: Viking, 1999.

White, Edmund. *The Double Life of a Rebel*. London: Atlantic Books, 2009.

Whitestone, Cheryl, and Diana Cardea, dir. *Quentin Crisp: Final Encore*. Interview, July 1999. http://www.quentincrispfinalencore.com.

Wilde, Oscar. *The Complete Works of Oscar Wilde*. New York: Harper Perennial, 1989.

——. *Interviews and Recollections*. London: Palgrave Macmillan, 1979.

——. *Oscar Wilde on Dress*. Edited by John Cooper. Philadelphia: CSM Press, 2013.

"William Burroughs." Obituary. *The Telegraph*. August 4, 1997.

Wilson, Andrew. "Sylvia Plath's London." *ES Magazine*, February 22, 2013. http://www.standard.co.uk/lifestyle/esmagazine/sylvia-plaths-london-when-i-came-to-my-beloved-primrose-hill-with-the-golden-leaves-i-was-full-of-8505529.html.

Wilson, Elizabeth. *Adorned in Dreams: Fashion and Modernity*. New Brunswick, NJ: Rutgers University Press, 2003.

Winder, Elizabeth. *Pain, Parties, Work: Sylvia Plath in New York, Summer 1953*. New York: Harper, 2013.

Wolfe, Tom. *The Bonfire of the Vanities*. New York: Farrar, Straus and Giroux, 1987.

——. "The 'Me' Decade and the Third Great Awakening." *New York* magazine, August 23, 1976.

——. "Radical Chic: That Party at Lenny's." *New York* magazine, June 8, 1970.

——. "The Secret Vice." *Keikari.com*. Posted April 26, 2013. keikari.com/english/the-secret-vice-by-tom-wolfe/. Originally published in the *New York Herald Tribune*, 1966.

——. "The Twentieth Century's Greatest Comic Writer in English." *Wall Street Journal*, February 22, 2005 (updated). wsj.com/articles/SB110903593760860492.

Wood, Gaby. "Are ya still alive, Djuna?" Review of *Djuna Barnes* by Philip Herring. *London Review of Books*, July 4, 1996.

——. "Prime Time: 30s—Elements of Style." *Vogue*, August 1, 2006.

Woods, Sean. "Getting to Know David Foster Wallace: An Interview with *Rolling Stone* Contributing Editor David Lipsky." *Rolling Stone*, October 30, 2008.

Woolf, Virginia. *The Diary of Virginia Woolf, Volume 1: 1915–1919*. Edited by Anne Olivier Bell. Harmondsworth, England: Penguin, 1979.

——. *The Diary of Virginia Woolf, Volume 3: 1925–1930*. Edited by Anne Oliver Bell. San Diego: Harcourt Brace Jovanovich, 1980.

——. *The Letters of Virginia Woolf, Volume 1: 1888–1912*. Edited by Nigel Nicolson and Joanne Trautmann Banks. London: Houghton Mifflin Harcourt, 1977.

——. *The Letters of Virginia Woolf, Volume 2: 1912–1922*. Edited by Nigel Nicolson and Joanne Trautmann Banks. London: Harvest Books, 1976.

——. *Mrs. Dalloway*. London: Penguin Modern Classics, 2000.

——. *Orlando*. New York: Harcourt Brace Jovanovich, 1973.

——. *The Virginia Woolf Reader*. Edited by Mitchell A. Leaska. San Diego: Harcourt Brace Jovanovich, 1984.

Photography Credits

Alamy Stock Photo: Callister, Dan: 192; Colaimages: 73; Everett Collection Historical: 55, 83, 85, 137, 189; Granger Historical Archive: 23; 80, bottom; 166, bottom; Heritage Image Partnership Ltd: 173; INTERFOTO: 103; Photo Researchers Inc: 18; Pictorial Press Ltd/Alamy: 61, 115, 149, 162, 177; The Print Collector: 27; Sherratt, Adrian: 186; SPUTNIK: 159; Sykes, Homer: 131; Trinity Mirror/Mirrorpix: 94.

Cannarsa, Basso: 105, bottom: © Basso Cannarsa/Opale/Leemage.

Getty Images: Adoc-Photos: 143; Anderson, Ulf: 104; Beaton, Cecil: 64; Beckman, Janette: 50; 79, bottom; Bentley Archive: 91; Bettmann: 58, 81, 128, 152; Bloomberg: 105, top; Bryson, John: 138; Dean, Loomis: 169; DeAratanha, Ricardo: 47, bottom; Fadek, Timothy: 106; Felver, Chris: 122; Gay, John: 79, top; Galella, Ron, Ltd.: 88; Galella, Ron/Getty Images/ Handout: 17; Getty Images/Handout: 171; Goldsmith, Lynn: 39; Goode, Jeff: 47, top; Hewitt, Charles: 97; Hopkins, Thurston: 182; Hulton Archive: 33, 70, 127; Jarnoux, Patrick: 167; Kisby, Roger: 42; Lancaster, Reg: 179; Lovekin, Stephen: 87; Mauney, Michael: 166, bottom; McPherson, Colin: 156; Ochs, Michael: 121, 134; Photo 12: 67, 76, 118, 165; Rathe, Joanne/ The Boston Globe: 24; STF: 100; Theisen, Earl: 107; TIME Life Pictures Ullstein bild: 14; 146; Venturelli: 80, top; The Washington Post: 185.

Greenfield-Sanders, Timothy: 112.

Hannabarger, Gary: 49: © 2016 Gary Hannabarger.

Rex/Shutterstock: Dryden, Ian: 11; Everett Collection Harlingue: 30;

Mydans, Carl: 36.

Shutterstock: Text stocks used throughout: © shutterstock/Africa Studio, marbled paper; © shutterstock/Andy Magee, cardstock; © shutterstock/SCOTTCHAN; fabric.

Trunk Archive: Howe, Susanna: 109; Inez and Vinoodh: 155.

Wasser, Julian: book cover (portrait of Joan Didion): © Julian Wasser.

Wolman, Baron: 45, 46: © Iconic Images/Baron Wolman.

Legendary Authors and the Clothes They Wore
Text © 2017 Terry Newman

HarperCollins books may be purchased for educational, business, or sales promotional use. For information please e-mail the Special Markets Department at SPsales@harpercollins.com.

First published in 2017 by
Harper Design
An Imprint of HarperCollins*Publishers*
195 Broadway
New York, NY 10007
Tel: (212) 207-7000
Fax: (855) 746-6023
www.hc.com
harperdesign@harpercollins.com

Distributed throughout the world by
HarperCollins*Publishers*
195 Broadway
New York, NY 10007

ISBN 978-0-06-242830-1
Library of Congress Control Number: 2015939515
Book design by Tanya Ross-Hughes
Printed in China
First Printing, 2017

About the Author

Terry Newman has worked in the fashion industry for more than twenty-five years, both as an editor at *i-D*, *Attitude*, and *Self Service* and as a contributing writer for newspapers including *The Guardian*, *The Independent*, *The Times*, and the *Sunday Times*. She has also written and presented fashion programs in the United Kingdom for Channel 4 (*She's Gotta Have It* and *Slave*). A contributor to books including *i-D*'s *Fashion Now*, *Fashion Now 2*, and *Soul i-D*, she currently lectures at the University for the Creative Arts in Epsom, England. She lives in London with her husband and two children.